IN OUR OWN IMAGE

Treasured African-American Traditions, Journeys, and Icons

RUNNING PRESS
PHILADELPHIA · LONDON

9 8 7 6 5 4 3 2 1
Digit on the right indicates the number of this printing

Library of Congress Cataloging-in-Publication Number 01-087033
ISBN 0-7624-1075-2

Picture research by Karen Pugh
Additional photo research by Patrik Henry Bass
Cover and interior design by Frances J. Soo Ping Chow
Edited by Molly Jay
Typography: ITC Berkeley, Helvetica Light,
Schneidler Initials, and Type Embellishments

This book may be ordered by mail from the publisher.
Please include $2.50 for postage and handling.
But try your bookstore first!

Running Press Book Publishers
125 South Twenty-second Street
Philadelphia, Pennsylvania 19103-4399

Visit us on the web!
www.runningpress.com

Photo Credits

AP/Worldwide Photos: Gene Herrick, pg. 125; Jon Chase, pg. 128, #7; Mark Lennihan, pg. 140, #32. **Archive Photos**, pg. 64; pg. 110. **Atlanta University Center**: Kelly, pg. 66, #2. **Avery Research Center**, pg. 76; 88 (both). **Martine Barrat**, pg. 9; pg. 41; pg. 43, #8; pg. 48, #22; pg. 58, #6; pg. 142. **Anthony Barboza**, pg. 34, #10; pg. 53 (bottom-C); pg. 94, #29; pg. 106, #27; pg. 107, #1; pg. 133, #18. **Bass/Pugh Collection**, pg. 13; pg. 15 (top-R); pg. 37, #17; pg. 39, #25; pg. 42, #1; pg. 59, #9; pg. 60; pg. 62, #18; pg. 66, #1; pg. 68, #10; pg. 83, #3; pg. 98, #3; pg. 101, #9; pg. 102, #12; pg. 113, #4; pg. 127, #3; pg. 130, #11; pg. 136, #24. **James P. Beckwourth Mountain Club**, pg. 50 (both). **Valerie Bennett/Gloria Cheatham Collection**, pg. 14 (top-C); pg. 22, #14; pg. 32, #1; pg. 34, #6; pg. 52 (top-R); pg. 114, #7; pg. 141. **Kirt Bennett/Young Leaders Academy**, pg. 78, #30. **Black Star**: Bob Fitch, pg. 23, #19; Owen, pg. 52 (center); Griff Davis, pg. 52 (bottom-R); John Messina, pg. 59, #7; Lee, pg. 93 #26. **Phillip L. Brown**, courtesy *The Other Annapolis*, pg. 45. **Burton Historical Collection/Detroit Public Library**, pg. 102, #11. **Corbis-Bettman**: pg. 18, #1; pg. 48, #23; pg. 49, #26; pg. 53 (top-C); pg. 85, #7; pg. 114, #9; pg. 118, #17; pg. 124; pg. 126; pg. 127, #4; pg. 134, #20; Frank Driggs, pg. 138, #29; pg. 138, #30; pg. 139, #31. **Adger Cowans/Ken Barboza**, pg. 22, #11. **Kerry Stuart Coppin**, pg. 31; pg. 38, #21; pg. 49, #25; pg. 69, #11. **Gerald Cyrus**, pg. 43, #9. **Josephine Dutton/Marie Dutton Brown Collection**, pg. 14 (top-L; bottom-R); pg. 34, #8 & 9; pg. 44, #12; pg. 68, #7 & 11; pg. 99, #5; pg. 116, #15. **Sam Fellenz, Jr. Collection**, pg. 44, #10; pg. 112, #1; pg. 114, #5. **Roland L. Freeman**, pg. 23, #17; pg. 28, #27. **Jarvis Grant**, pg. 53 (bottom-L). **Monique Greenwood Collection**, pg. 16. **Vivian G. Harsh Collection/Carter G. Woodson Library**: French 008, pg. 91, #20; MSJ 212, pg. 91, #21; E. B. Thompson 006, pg. 91, #22; pg. 102, #14; pg. 127, #2; pg. 137, #27. **Leroy Henderson**, pg. 38, #18 & 22; pg. 42, #4; pg. 48, #19; pg. 53 (top-R); pg. 59, #10; pg. 63, #23; pg. 68, #8; pg. 105, #22. **Dr. Theodore Hudson**, pg. 44, #11. **Jerry Jack**, pg. 95, #31 & 32. **Terrence Jennings**, pg. 38, #20; pg. 105, #25; pg. 121, #29. **David Johnson**, pg. 61, #15; pg. 96; pg. 119 (both); pg. 131, #13. **Ermon and Blanche Jones Collection**, pg. 97; pg. 98, #2; pg. 130, #12. **Lou Jones**, pg. 58, #5; pg. 83, #2; pg. 94, #27 & 28; pg. 105, #26; pg. 121, #28. **David Lee**, pg. 94, #30; pg. 121, #30. **Library of Congress, Prints and Photographs Division**: pg. 27, LC-USW3-16700-C/Arthur Siegel; pg. 55, LC-USF34-43956-D, & pg. 59, #11, LC-USW3-823-D/Jack Delano; pg. 65, LC-USF33-11615-M3/Russell Lee; pg. 69, #14, LC-USW3-28026-C/Roger Smith; pg. 70, LC-USW3-17126-C/Gordon Parks; pg. 72, LC-USF34-50522-D/Marion Post Wolcott; pg. 73, #21, LC-USF34-44089-D/Jack Delano; pg. 74, #24, USNWR/PPLC-U9-1054-E9; pg. 77 (center), LC-USZC2-1124; pg. 80, LC-USW361-333/Alfred Palmer; pg. 84, #6, LC-USF34-52700-D/Marion Post Wolcott; pg. 85, #8, LC-USF-33-12983-MI-B/Russell Lee; pg. 89, #16, LC-USW3-12915-C/Arthur Siegel; pg. 121, #27 LC-USF34-38808-D/Russell Lee; pg. 129, #8, LC-USC4-6175. **Magnum**: Bob Adelman, pg. 105, #24; Henri Cartier-Bresson, pg. 63, #21. **Janice Marshall Collection**, pg. 14 (bottom-C); pg. 25, #23; pg. 32, #2; pg. 40; pg. 42, #2; pg. 46, #14; pg. 51. **Wade Hampton McKinney III Collection**, pg. 39, #23 & 24; pg. 49, #24; pg. 69, #13; pg. 73, #22 & 23; pg. 115, #10; pg. 128, #5 & 6; pg. 129, #9 & 10; pg. 137, #28. **Maryland State Archives**, pg. 45, courtesy, Phillip L. Brown, *The Other Annapolis*. **Michigan Chronicle**, pg. 95, #33. **Michigan State Archives**, pg. 84, #4. **Minnesota Historical Society**, pg. 36, #13 & 14; pg. 48, #20. **Emily Minton**, pg. 54; pg. 58, #4. **Elvin Montgomery Collection**, pg. 17; pg. 33, #4; pg. 62, #19; pg. 101, #10; pg. 103, #18; pg. 113, bottom; pg. 114, #6; pg. 115, #12. **Moorland-Spingarn Research Library/Howard University**: Fletcher, pg. 11; Hankins, pg. 33, #3; Pease, pg. 34, #5 & pg. 37, #16; pg. 74, #25; pg. 99, #4; Cabell, pg. 101, #7 & 8; pg. 112, #2; pg. 120, #24 & 26; pg. 136, #26. **Museum of American History/Smithsonian Institution**, pg. 18, #3; pg. 79; pg. 134, #22. **Museum of the City of New York**: Phyllis Shanks, pg. 52 (top-L); Abyssinian Baptist Church, NY, pg. 57, #3; Carl Van Vechten, pg. 113, #3. **National Afro-American Museum**, pg. 61, #14; pg. 105, #23. **National Archives**: 306-PS-51-3396, pg. 12; 306-PS-57-17929, pg. 19, #4; 306-PS-50-11509, pg. 23, #15; 208-PP-185, pg. 43, #5; 273-HNE-14-1 pg. 77, #27; 306-PS-55-2002, pg. 78, #28; 306-PS-48-2268, pg. 103, #15; 208-NP-6LL-11, pg. 114, #8. *Newsday*: Sune Woods, pg. 108, #30. **New York Times Archives**, pg. 57, #2; Tyrone Dukes, pg. 78, #29. **Michael Ochs Archives**, pg. 111; pg. 136, #25. **Gail Oliver Collection**, pg. 30; pg. 52 (bottom-L); pg. 109. **Gordon Parks**, pg. 63, #22; pg. 70 (LC-USW3-17126-C). **The Pinkney Family Collection**, pg. 25, #21; pg. 42, #3; pg. 56; pg. 67, #3. **P. H. Polk**, pg. 25, #24. **Helena Pugh/Gwendolyn Pugh Collection**, pg. 8; pg. 19, #5; pg. 20, #9; pg. 67, #5 & 6; pg. 104, #21; pg. 117; pg. 120, #23; pg. 132, #17. **Karen Pugh**, pg. 6; pg. 10; pg. 14 (center-R & L); pg. 19, #6; pg. 21; pg. 23, #18; pg. 24; pg. 28, #26 & 28; pg. 29, #29 & 30; pg. 34, #7; pg. 36, #15; pg. 38, #19; pg. 39, #26; pg. 47, #16 & 17; pg. 67, #4; pg. 84, #5; pg. 86, #11; pg. 116, #14; pg. 134, #21. **Karen Pugh Collection**, pg. 25, #22; pg. 46, #15; pg. 103, #16; pg. 106, #28; pg. 118, #18; pg. 120, #25. **Mr. and Mrs. Al Ridgely Collection**, pg. 22, #12. **Schomburg Center for Research in Black Culture**: James C. Campbell, pg. 43, #6; pg. 68, #9; Sam Reiss, pg. 90, #17; Nichols, pg. 91, #19; pg. 92, #23 & 24; Paul Parker, pg. 98, #1; pg. 102, #13; James Campbell, pg. 132, #16. **Scurlock Collection/Smithsonian Institution**, pg. 35, #12; pg. 62, #20; pg. 89, #15; pg. 93, #25; pg. 104, #19; pg. 131, #14 & 15. **Renee Sheffey Collection**, pg. 15 (bottom-L). **Audrey Smaltz Collection**, pg. 140, #33. **Beuford Smith**, pg. 59, #8. **Morgan and Marvin Smith**, pg. 49, #27; pg. 62, #17; pg. 82, #2; pg. 104, #20; pg. 133, #19. **Angela Spears Collection**, pg. 15 (bottom-C & R). **Jo Moore Stewart Collection**, pg. 7; pg. 15 (top-L); pg. 20, #7 & 8; pg. 22, #13; pg. 23, #16; pg. 26, #25; pg. 35, #11; pg. 81; pg. 89, #14; pg. 135, #23. **Tony Stone Images**, pg. 48, #21. **Barbara Summers Collection**, pg. 18, #2; pg. 43, #7. **Janice Sykes Collection**, pg. 69, #12. *Time Pix/Time-Life, Inc.*, pg. 106, #28. **Lana Turner Collection**, pg. 61, #16; pg. 71, #18 & 19; pg. 86, #9 & 10; pg. 90, #18; pg. 100, #6; pg. 103, #17; pg. 115, #11 & 13; pg. 120, #21 & 22; pg. 134, #22. **Watkins Flavor Company**, pg. 20, #10.

In loving memory of
Robert and Sarah Gibson Lytch
For showing me the way. . .

Thanks to all my friends and family, especially my mother, Sarah Louise Bass, who generously passed on a love of God, people, and words. This book would not have been possible without the support of the following people: Diane McKinney-Whetstone and Justin Loeber, guardian angels, who did what they said they would. Patricia Flowers, Malaika Adero, Tracy Tappan, Roje Augustin, Angela Spears, and Pauline Barfield for their early (and much needed) advice and counsel. Darren Kerr for helping me to see the big picture. Kent Davis, Piper and the staff at Diamond Kuts; Fred Hudson and the staff at The Frederick Douglass Creative Arts Center; and my spiritual family at Refuge Greene Avenue for providing me with sanctuary. Then too, Bonnie Marshall and Anne DeFranco Woodward for giving me a room of my own; Lynn Whitfield for caring more than anyone would ever know. Jo Moore Stewart, for your awesome spirit and enthusiasm. Yanick Rice Lamb for the opportunity of a lifetime. Mary Everette for introducing me to *Essence*, and the work of Vertamae Grosvenor and Toni Cade Bambara. Monique Greenwood, Susan L. Taylor, Robin Stone and the entire *Essence* family for their unyielding support, affirmation, and patience with my monologues. Evelyn Cunningham for answering the phone and blessing us with your presence. Mary Carlson, Yvonne Stanton, Dr. Edwin Bagley, and Dr. Pamela Thomas, for thinking I could do this before I could. Antoinette Dalton for the prayers, and Jane Best-Simpson for the camaraderie. Buz Teacher, Carlo DeVito, Jennifer Worick, and the wonderful team at Running Press for opening the door, welcoming us in, and making us feel at home. Frances Soo Ping Chow for your discerning eye and dazzling talent. Our talented editor Molly Jay has been a dream to work with—let's do it again. Vernadine of Wingate University, thank you for those kind words all those years ago. Many people have entered (and transformed) my life (and I am sure I will hear from most of you), but I must thank two who have never let go of my hand nor heart: Kate Blackburn, who believed in me when no one else would, and Marie Dutton Brown, my agent and dear friend, who I can always depend on for a "Tulip" intervention, a linguistics lesson, a belly-aching laugh, and the truth (not always in that order).

—PATRIK HENRY BASS

This book is dedicated to my parents, Mrs. Helena Pugh and the late Mr. Samuel M. Pugh; to my family, and to the African-American communities across the country which nurtured and shaped us for generations.

I would first like to thank God for the vision and endurance to complete this project; the families and individuals who have so painstakingly preserved their memories and, in turn, our history: Valerie Bennett and her mother, Mrs. Gloria Cheatam; Marie Brown, our agent, and her mother, Mrs. Josephine Dutton; Mrs. Blanche Jones, who was also my first-grade teacher and early role model; Samuel Fellenz, Jr.; Janice Marshall; Mr. Wade Hampton McKinney; Mr. and Mrs. Clarence Pinkney; Gwendolyn Pugh; Mrs. Helena Pugh; Mrs. Jo Moore Stewart; Lana Turner, thank you for trusting me with your keepsakes; and the photographers: Gordon Parks and Anthony Barboza for their support and generosity; Martine Barat; Kerry Stuart Coppin; Adger Cowans; Gerald Cyrus; Roland Freeman; Jarvis Grant; Leroy Henderson; Dr. Theodore Hudson; Jerry Jack; Terrence Jennings; David Johnson; Lou Jones; David Lee; Emily Minton; P.H. Polk; the Scurlock Studio; Beuford Smith; Morgan and Marvin Smith; Sune Woods; Milton Williams; and the many newspaper photographers whose work often goes unheralded. The archives: Archive Photos; Deborah Wright of Avery Research Center; Paul Crater of the Robert Woodruff Library at Atlanta University Center; Black Star; Corbis; the Burton Collection at the Detroit Public Library; the Library of Congress; Magnum Photos; Robert Schoberlein of the Maryland State Archives; Michael Ochs Archive; the *Michigan Chronicle* and the Michigan Historical Center; the Minnesota Historical Society; Elvin Montgomery; Donna Wells of the Moorland-Spingarn Research Center at Howard University; Eileen Morales of the Museum of the City of New York; Isabel Jasper of the National Afro-American Museum and Cultural Center; the National Archives; New York *Newsday*; the *New York Times*; Veronica Gerald of Penn Center; James Huffman of the Schomburg Center for Research in Black Culture; Dr. Alonzo Smith and David Haberstich of the National Museum of American History at the Smithsonian Institution; Time Pix; Tony Stone; the Vivian G. Harsh Collection at the Carter G. Woodson Library; World Wide Photos. I would also like to thank Janice White-Sykes of the Auburn Avenue Library on African-American Culture and History; Cynthia Wilson of the Tuskegee Institute; Watkins Products; Kirt Bennett, Young Leaders' Academy, Baton Rouge, LA; Mr. and Mrs. Al Ridgeley; James P. Beckwourth Mountain Club, CO; Monique Greenwood; Barbara Summers; Gail Oliver; Audrey Smaltz; Mrs. Monica Smith; Sylvia Simpson, Hawkins Studio; Renee Sheffey; Gail and Peter Albert; Drs. Evander and June Duck; Cynthia Givens; Betty Hopkins; Mr. and Mrs. Philip Brown; Aunt Peggy; Aunt Merce; Roadhouse Oldies in Silver Springs, Maryland; Todd Robinson of Sure Service Photo; Mr. Robert Lascaris; and to everyone who submitted their photographs and memorabilia to this project.

—KAREN PUGH

PREFACE

Who are we?

We are the embodiment of the American Dream, the architects of rock and roll, the builders of cities, and the artisans on the assembly line.

We are revolutionaries of style. We turn cornrows into a work of art. We reinvent ourselves when we wear our Sunday best.

We are pioneers of medicine and holistic healing. We are the mothers of invention and the fathers of funk.

We are soul survivors and style warriors. We are deep and real.

We're still here.

We manage to carry on in love and sorrow; in tragedy and triumph, and through setbacks and breakthroughs.

In our kitchen wisdom, we serve home-cooked love and deep-fried soul. We understand the importance of peach cobbler and homemade mint ice cream.

In our daily lives, we jump the broom at weddings, sweep the floors for choir practice, chair church committees and sing in the choir.

Now, let us say "Amen."

We carry on.

We've always known what it takes to survive in this world: att-ti-tude, some good marching shoes, and spoonbread to share.

We celebrate one another at family reunions and fish frys, weddings and Funerals, barbecues and baby showers, and blue-light basement parties.

We've won major awards. Far more than winners of gold medals and Nobel Prizes, we're local spelling bee champions and holders of winning raffle tickets.

This is a portion of who we are . . . in our own image.

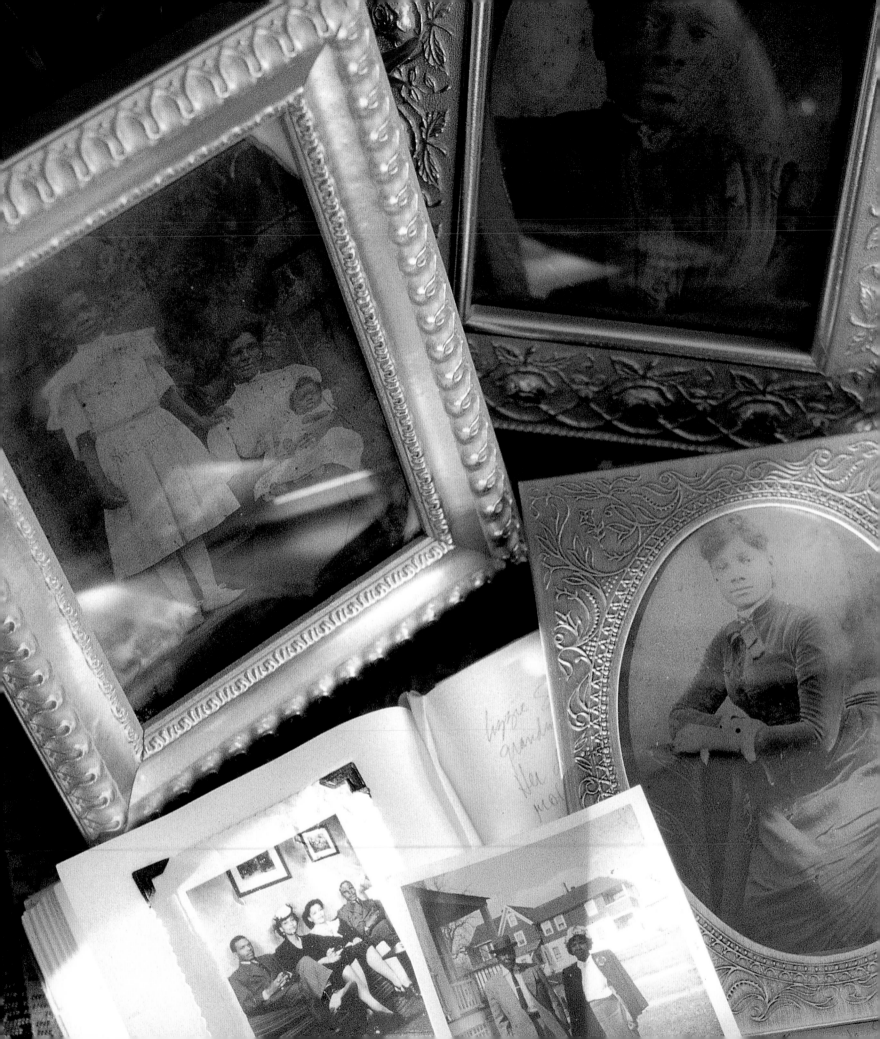

INTRODUCTION

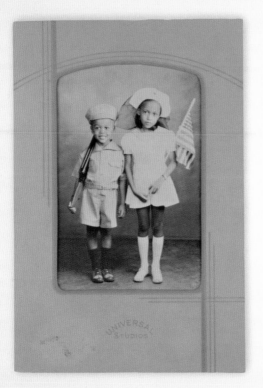

The truth must be told

 about black Americans.

For all the bad there is,

 it is already known.

—JAMES WELDON JOHNSON

THE HISTORY OF ordinary black Americans is captured in photographs, letters, and postcards that are meticulously stored in family albums and scrapbooks.

Pages of images—children, bright, their faces eager and open; elders beaming, their opal eyes deep and knowing; us being us, laughing, playing, living—reveal a story of uncommon grace and quiet love, lived out loud. There are other images, proud family members perfectly aligned on our walls and down-loaded on CD-ROMs. Combined, these images do more than make us smile; they complete us—linking our past, present, and future. Arguably, these images do more to tell the story of the black experience in America than does the mainstream media, in which regrettably, the daily activities and achievements of most African-Americans are sadly overlooked.

Whether framed beside our diplomas and certificates, or stored in shoeboxes under our beds, these visual and written documents are a powerful testament of the determined and loving breath that twelve generations of enslaved Americans— whose presence in the United States dates back as far as 1617— willed into future generations of Nobel Prize winners, military generals, astronauts, engineers, actors, designers, teachers, scientists, political leaders, artisans, writers, academics, photog-raphers, ministers, architects, doctors, and other talented folks who grew up in supportive and nurturing communities.

In Our Own Image is an illustrated chronicle of the black community during the last half of the twentieth century as seen through the lenses of various photographers, both well-known and unknown. It is an attempt to recover precious memories

of childhoods and adulthoods, dreams realized, enduring ceremonies and traditions, great people and simple pleasures that, given the context of our experience in this country, have enabled us to not only maintain our dignity, but to cherish our relationships with our family, friends, and neighbors.

In Our Own Image is not an academic or sociological treatise. We are neither art historians nor cultural critics. Quite simply, this is a collection of images and stories that we hope expresses our adoration of, and appreciation for, our cultural heritage during the last half of the twentieth century.

Growing up in black communities, we took separate personal and professional avenues that led us to the same crossroads. But once we were there, this intersection guided us to a lone road with many twists and turns, yes, but with an incredible scenic route brimming with breathtaking faces and places, many which are featured in this volume.

Having read many of the same books, magazines, and newspapers; watched similar television programs, movies, and Broadway shows; browsed through related museum collections, admiring every detail and artifact, we were influenced by an arsenal of images. Still, like so many of our friends and colleagues in black communities, our eyes hungered for more: a richer, fuller reflection of our people, of ourselves.

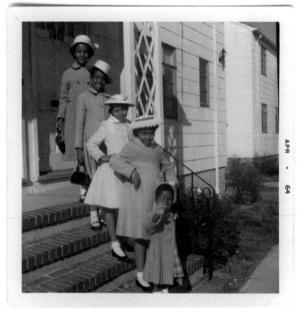

Sifting through the (now) priceless treasures and (now) exquisite remnants of lost tribes (found) and ancient civilizations in museums, we wondered, separately and together, about the unseen and unrecorded lives of, say, the devoted nurse and night watchman, the messenger and midwife. What do we know of their joy, or even of one afternoon of triumph, in their lifetimes? Better yet, what do we know of a meaningful moment in the life of a midwife or messenger today? Further, how will *we* be remembered centuries from now? Through whose eyes and words will we be defined?

This open-eyed look into the future concerned us, as we are certain it weighed heavily on the founders of black newspapers and on pioneering photographers during the first half of the nineteenth century. Indeed, besides our scrapbooks and photo albums, black newspapers and period photographs provide what may be the most detailed record of daily black life—in words, and just as important, in pictures—of nearly every major and minor achievement in our lives, including great mornings, ambitious afternoons, and enchanted evenings.

"We wish to plead our cause," wrote John B. Russwurm and Samuel Cornish in their inaugural edition of *The Freedom's Journal*, the first black newspaper, published in 1827. "Too long have others spoken for us." In fact, for two hundred years prior to the founding of *The Freedom's Journal*, newspaper publishers, editors, and cartoonists had spoken for African-Americans, whether as abolitionists or slave owners.

Although *The Freedom's Journal* was short-lived, it laid the groundwork for future newspapers, which provided a much-needed alternative to mid-nineteenth-century journals, many of whose publishers, perhaps disturbed by the presence of freed blacks in Boston, Philadelphia, New York, and other northern cities, unleashed scathing ad hominem editorials, reports, and caricatures about this population. Edward W. Clay's *Life in Philadelphia*, for instance, a series of caricatures that offered readers gross misrepresentations of black physicality and dialect, was so popular in mid-nineteenth-century journals that it, in part, provided the framework for minstrel shows, in which white performers acted out their own interpretations of black Americans as inferior, inept, and immoral: "Through its distortions and popular commentary on black life, the minstrel show became an influential factor in the messy and piece-meal negotiations that resulted in the question of whether newly freed blacks were treated as American citizens."

In an effort to express and reflect the views of the communities that it covered, newspapers began to sprout like turnips in black settlements. Thirty-two years after Russwurm's and Cornish's declaration to "plead our own cause," *The Weekly Anglo-African*'s New York-based founder, Thomas Hamilton, stated:

We hope to supply a demand too long felt in this community. We need a Press—a press of our own. We need to know something else of ourselves through the press than the every-day statements made up to suit the feelings of the base or the interests of our opponents. Our cause (for in this country we have a cause) demands our own advocacy. The powerful and influential journals around us certainly have but little special interest in, nor can they present our case as it should be presented— surely, as we can present it ourselves.

From their earliest origins, black photographers and newspapers have enjoyed a symbiotic relationship, each attempting to present its intended population from a particular point of view. While minstrel shows were playing to packed mid-nineteenth-century American audiences, Louis Jacques Mande Daguerre, a French theatrical designer, was revolutionizing the burgeoning craft of photography by reducing the exposure time of an image from eight hours to thirty minutes. By 1835, his invention, the *daguerreotype*, was an international cause for celebration. Five years later, Jules Lion, a black daguerrotypist introduced the process to New Orleans. By 1850, there were at least fifty black daguerrotypists operating studios in America. For the first time, individuals could see themselves as they really were. Photography presented a visible truth.

With the advent of this new technology and the advancement of black newspapers after the Civil War, freed blacks now more than ever had opportunities to define themselves in words and to see themselves in pictures.

Black photographers, many of whom advertised in the black press, secured images of "every social stratum in the black community, from the laborer and domestic, to the self-made entrepreneur and educated professional," living and dead. In fact, photographers were often "called upon to make a casket portrait when the family realized too late that no likeness of their loved one existed."

Between 1880 and World War I, the *Norfolk Journal and Guide*, *The Philadelphia Tribune*, *The Pittsburgh Courier*, the *New York Age*, the *Baltimore Afro-American*, the *Boston Guardian*, the *Chicago Defender*, and *The New York Amsterdam News* were introduced. Previous black newspapers, which folded due to mismanagement, money woes, and a combination of both, offered readers mainly current events and business news. The new breed of publishers were bolder; their papers vivid. The newspapers not only reported on political, economic, and social news but also contained writing from such notable "rabble-rousers" as W.E.B. DuBois, Booker T. Washington, Ida B. Wells, Jessie Fauset, and Monroe Trotter. Robert S. Abbott, the *Defender*'s publisher from 1905 to 1940, had the temerity to proclaim his paper, "the world's greatest."

Abbott was one of the most powerful publishers in the country. Credited with encouraging the migration of African-Americans from the south to the north, Abbott's *Defender* listed advertisements and departure schedules for folks making the journey up south. During this crusade, the *Defender* raised its circulation to unprecedented heights for a black newspaper— over 500,000 by the end of the war.

As hundreds of thousands of black folks began to settle into cities shortly before and after World War II, the black press became a crucial source of information. By 1940, at least 4 million black folks read a Negro newspaper every week. By the end of the war, there were more than five hundred black newspapers.

The second half of the twentieth century was a time of substantial social, political, and cultural change. Although African-American newspapers were a vital organ for the black community during the early stages of the modern Civil Rights Movement, during the mid-60s more black readers were gravitating to other media for information concerning the sweeping changes that were taking place around them.

Even the *Defender*, which published four issues a week, "could not compete with the electronic mass media in conveying the intensity of the struggle, violence, horror, and atrocities [of the Civil Rights Movement] as reported live on television with its virtual moment-by-moment news coverage." Although a few mainstream newspapers and magazines began to recruit writers and editors from the black press, "very few black journalists (and photographers) found work with the larger, mainstream magazines such as *Life*, *Look* or *Newsweek*, or with the major city daily and weekly newspapers." In fact, even today, African-American journalists represent less than 3 percent of the staff at mainstream newspapers.

Today, *The Louisiana Weekly*, *Carolina Peacemaker*, *Michigan Chronicle*, and *The Philadelphia Tribune*, among others, still offer us "an opportunity to see one of the family displayed with their name and picture, as a member of a club, a church, a committee, a high school class, or attending a bridge party or a sports event."

Alongside glowing grandparents holding Instamatic cameras at these "events," one could see Charles "Teenie" Harris and Vera Jackson of the *California Eagle*, Robert Sengstacke of the *Chicago Defender*, Fred Cooper, who brought city nightlife alive for daytime readers of *The Pittsburgh Courier*, and Morgan and Marvin Smith, whose suave and sophisticated portraits of such icons as Adam Clayton Powell, Nat King Cole and his wife Maria, and Lena Horne appeared in *The Amsterdam News*, clicking away with their cameras.

Photographs were something that I took for granted until my maternal grandparents passed away—Grandaddy the first day of winter, and Muther the first day of spring in 1989 and 1990, respectively. My entire family realized much too late that there were not any appropriate pictures of Grandaddy and Muther for their obituaries. Quietly, I asked my mother why we had not taken photographs—not just of our immediate family, but of my aunts, uncles, and cousins as well. There was such beauty in our family, quiet, tender, approachable beauty that we would never see in a photograph. My mother explained that a fire had destroyed my grandparent's first home, and along with burnt edges of report cards, birth certificates, insurance policies, rag dolls and slingshots were burned photographs, including bubbling, frayed pictures of my great grandparents, sweet-natured Great Grandaddy Jethro (whom I can only recall smiling) and charismatic Great Grandma Gertrude that would never see the light of day. The loss of these photographs set me on a mission to preserve whatever photographs of family members existed. And now, as my parents, aunts, and uncles face the other side of fifty, I'm determined to preserve our legacy in photos. It's becoming a challenge for my

parents to remember cherished stories that should be nurtured and caressed before they are passed on.

Six years ago, I met Karen Pugh at a Sunday after-church meetin'. The exact mission of this winter get-together escapes my memory. I recall a powerful opening prayer, folks in their Sunday best, and a warm Brooklyn apartment filled with family photographs. Our paths crossed at different Brooklyn functions involving art, fashion, and photography. We began to talk—at first, briefly, and then eventually, daily.

Like so many ideas in the black community, this project was born on the telephone. Over time, we were struck by our similarities: roots in the Carolinas (she, South Carolina; me, North Carolina), and New Jersey (she, Neptune; me, Paterson); and a passion for photography. We were both greatly influenced by the lifestyle photographs of black families and professionals in *Ebony*, *Our World*, *Essence*, *Black Enterprise*, and *Jet*, as well as by groundbreaking "firsts" on television: Bill Cosby on *I, Spy*, The Supremes on *The Ed Sullivan Show*, Ed Bradley on *60 Minutes*, and the mini-series *Roots*.

We talked about *In Our Own Image* before we knew its name. Growing up with parents who came of age in the shadow of World War II, we knew that we had a starting point. As Douglas Brinkley pointed out in the *New York Times* magazine, "It's rarely noted that the civil rights movement of the 1950s and 60s was a direct, even inevitable outgrowth of World War II."

During World War II, the great Duke Ellington and his band engaged in a process they named "The Blueprint Shows." Various

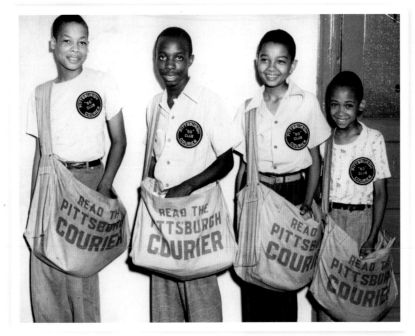

songs were laid on the floor, stretched out, tossed around, and shaken up to see what kind of story they would tell. Ellington and his band masterfully pieced them together and added a few

ingredients such as "dance, comedy, etc., until the songs became a plot, telling and weaving their own story."

In making *In Our Own Image*, Karen and I are, in a sense, producing a Blueprint Show; but instead of songs, we've pulled pictures from various black photographers known and yet-to-be-discovered, encouraged our friends and family members to go through shoeboxes, photo albums, and what-not shelves, in the hope that these images would tell us stories of black American communities from World War II to the present.

On the telephone, in coffee shops and fast food restaurants, and through countless meetings, we've looked for words to describe the essence of the people, places, and things that we wanted to highlight in this book. While many words were conjured, the themes of ambition and responsibility, courage and spirit, humor and humanity, creativity and style, and especially dignity and pride remained.

We are not interested in exploring our differences. We are not concerned with say, class or color distinctions, though we acknowledge that to some these are "issues" that demand attention. If anything, we are speaking to the silent majority within the black community—those unheralded heroes and heroines whom we see every day, walking their children to school, caring for their aged parents or grandparents, sharing warm conversation with friends and neighbors after work or church service.

As we searched through countless images, we were dazzled by the intensity of images recorded in the mid-nineteenth century, and the first half of the twentieth century, most notably from the photographers James VanDerZee, James Latimer Allen, Florine Perrault Collins, P.H. Polk, C.M. Battey, and Addison N. Scurlock. Still the World War II era allowed us

to chronicle the revolution of rising expectations and to honor the generation of brave African-Americans who fought at home and abroad for our freedom.

The story of nameless African-American Americans who served in the war is an important one. Many of these brave men and women had migrated north, some arriving hungry and homeless, but determined to make an honest living so that they could educate their children, and instill them with pride so that they, in turn, would support their communities and those who dwelled within them. For this dream, these men and women endured violence and exclusion, but on the other side of fear was hope—the flip side of adversity was prosperity.

Before they had a moment to rest their heads in homes that some of them built with their own hands, they postponed their dreams in search of an even bigger one: the American Dream and its promise of a better life. But their first taste of this dream came through the night-mare of war.

Yet they summoned the courage to not only survive The War, but to soar as Tuskegee Airmen, "breaking barriers against blacks in aerial combat"—and to sail on the *USS Mason* and the *SS Harriet Tubman*. At home, *The Pittsburgh Courier* initiated the Double V campaign, insisting that "Negroes" fight for victory over our enemies.

The Housewives Leagues picked up the mantel and pro-tested to ensure that those young

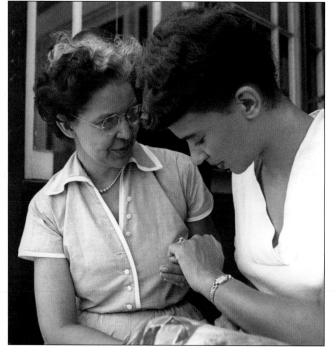

men left behind would find work. A. Philip Randolph threat-ened to organize a mammoth March on Washington to protest racial discrimination in labor. And we had our very own Rosie the Riveter in the guise of Rachel Robinson, who worked at Cali-fornia's famous Lockheed defense plant as a welder, one of many women who traded in their aprons for blue-collar uniforms in military factories.

Immediately after the war, many of our grandparents entered college on GI bills; their parents sent them to school with money saved in domestic handkerchiefs. They became architects and artists, bankers and business owners, doctors and dentists, engineers and electricians, lawyers and loan officers. They broke ground for modern black communities by building homes for their families in Langston, Oklahoma, Asbury Park, New Jersey, Prince George's County, Maryland, Vine City in Atlanta, Scotlandville, Louisiana, and Promiseland, South Carolina.

They survived so many broken promises, but found beauty in its remains. They had limited ways of being seen and viewed; but shined where there was no light. They bravely stood on the shoulders of our ancestors, and stepped aside as another generation came forward with the same determination, daring, and pride, to picket, protest, and litigate in the courts.

They formed new movements that insured that we could ride first-class or fly the plane if we chose. And although they endured slights, they would not be bitter—not these inventors and pioneers. They would only cry tears of joy as another generation trans-formed this nation, and built an even better world.

We want to highlight a few factors that make the black community a special place. We have divided the book into three parts: Family, Community, and Heroes and Headliners.

We begin Family with "Home," where our life and style come together in a wonderful way, inside those lemon-scented keepers of our souls. The home is where we share conversations—recreate ourselves, celebrate special occasions and each other. They are safe havens for our dreams, and the one place where we are allowed to be ourselves, freely and openly.

We felt that it was vital for readers to see African-Americans at work and in school. Our homes proudly display our degrees and certificates, honors and trophies, from kindergarten through doctoral programs. Our jobs are a constant source of fulfillment. As our parents and grandparents entered the workforce in record numbers, what child does not remember, with glee, the joy of watching Mom and Dad get dressed in their uniform—whether for the post office, auto plant, or as a nurse. At the same time, seeing doctors and dentists, lawyers and engineers, whether in the neighborhood, or in *Ebony* or *Jet*, told us, that we too, could be somebody, someday.

Our civic organizations provided us with halls of leadership and gave us a sense of purpose. Whether Masons or Eastern Stars, members of a sorority or fraternity, a Willing Worker in the church, or an Auxiliary committee member, our "clubs" have been instrumental in giving us voice and strengthening our communities.

Our "Diversions" and "Celebrations" allow some of us to unleash our passion for living—whether traveling to a resort like Idlewild or Oak Bluffs, or taking a day trip to the beach or lake. No one in the community can forget the first time they attended a wedding or family reunion; the unbridled laughter and joy; the beauty of family and friends, together, to toast our love for one another, and to offer good wishes for our loved ones.

In Part II, "Community," we take readers from our weekdays at "Work" and "School," and into our weekend activities in the black community, from beauty parlors/barbershops, which are a rite of passage from childhood to adulthood, for

all who enter their doors. On Saturday evenings, we entertained ourselves, we participated in "Civic Duty," and danced in the "Nightlife," and on Sunday mornings, in houses of "Worship," we offer praise and provide fellowship with our loved ones.

Following the Second World War, a number of trailblazers emerged, who were constantly covered in the black press and the favorites of black photographers. They are our "Heroes and Headliners" in Part III. Among them, we profile Jackie Robinson and Nat King Cole; Evelyn Cunningham and Ophelia DeVore; A. Philip Randolph and Muhammad Ali, Mollie Moon and Edward Perry. Not only did they pave the way, but they were the way. They rebelled by living well. The same will that helped them to endure societal insults and challenges, was the same will they used to present themselves— their best selves—at home, during any occasion from church to a social club.

They shared their talent with the world, unselfishly, and made our communities better places to live. They instilled us with confidence to live where we could, with whom we wanted.

There were other heroes: Families of great character and determination. They are the Marshalls, the Bennetts, the Stewarts, and others, whose images appear throughout this book with other families.

We hope that this "blueprint" will provide a view of life as we've lived and loved it over the past half-century, and that future generations will continue to tell our stories in words and pictures, whenever and wherever they can.

—PATRIK HENRY BASS

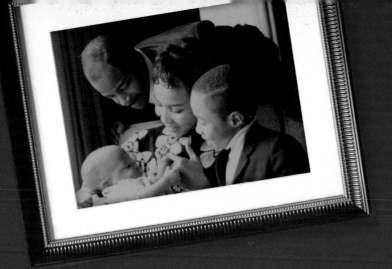

Family

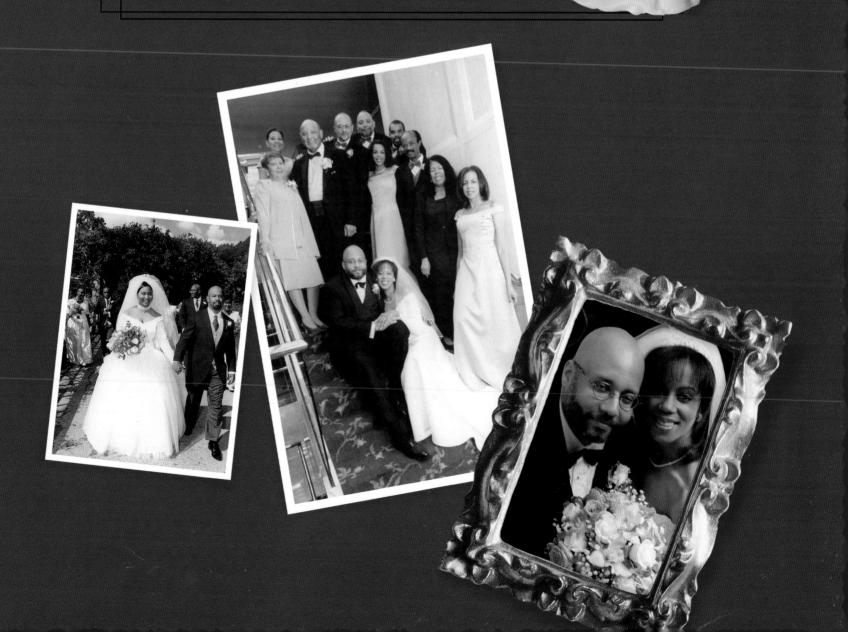

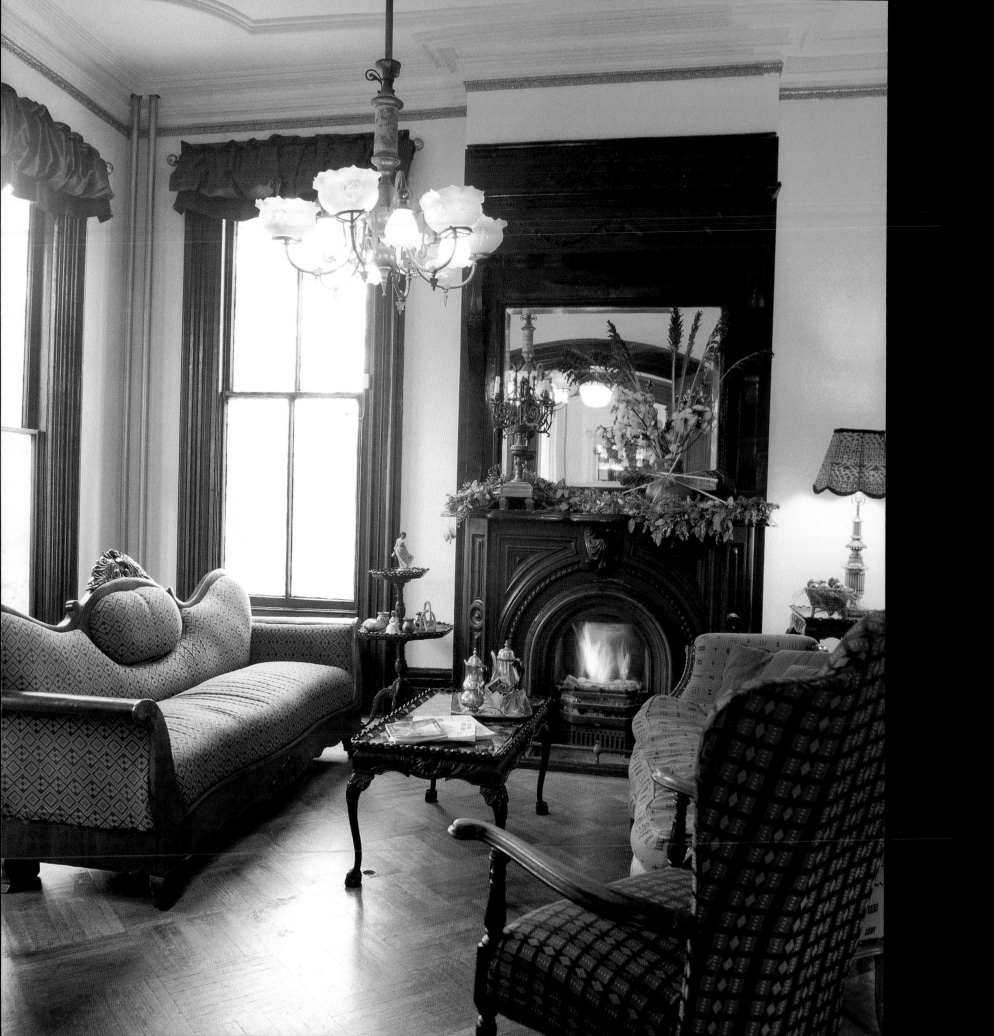

HOME

Whatever its outer circumstances, it was the inner life of the house that counted, because it was there, that one entertained one's lifeline to sanity—one's precious black friends. For them, only things that were truly beautiful, and lovingly made, would ever do. All of our passion and beauty could be freely indulged in the privacy of our home, because the home was the haven, the castle, the fortress, the only place where we could exercise complete freedom of choice.

—ELLEN HOLLY

OUR HOMES DEFINE US. A photograph tucked inside a mirror, a flawless front room, a shelf of books or bric-a-brac, all offer subtle clues of who we are, how we live, and what we love. Family and friends who pass through our doors inspire us. The details and experiences throughout our homes, no matter how small, make a significant impact. They leave us with feelings that are so embedded within the core of who we are, that no matter where we may go, they are with us.

"My father's room and my grandmother's front room and the parlor of my great-aunt's house that my brother and I were allowed in only one hour on Sunday—it was a room of settees, ferns, china cabinets, and photographs—are without a doubt the most influential and powerful rooms of my life," says playwright Adrienne Kennedy. "It is why I try to grow ferns that do not live; why I arrange every apartment with a clustering of photos. And why, finally, after searching for their environment, my characters live in powerful, influential rooms, almost to the exclusion of the outside world."

The desire to own a home is a cornerstone of the American Dream. During the last half of the twentieth century, black folks have made enormous progress in our effort to build and sustain homes. Not only are we represented in exclusive neighborhoods, but now, more than ever, many of us have the resources to live where we please.

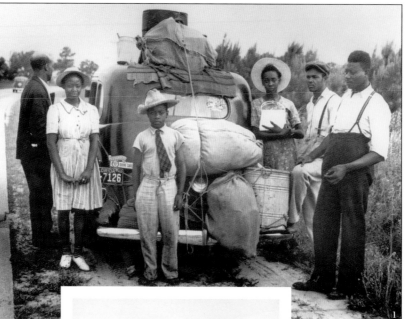

Anyone who has lived in, or driven past the impressive homes in Collier Heights in Atlanta, Honey Circle in Houston, Baldwin Hills in Los Angeles, Palmer Woods in Detroit, South Orange or Montclair in New Jersey, Greenhill Farms in Norfolk, or other equally impressive neighborhoods, might consider—under close inspection—these sculpted lawns and shining cars a blessing when remembering that many of these folks are descendants of people who first existed in America as property.

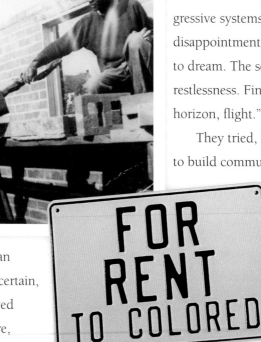

Where some of our ancestors found the faith and courage to up and run off to an uncertain fate, one can only wonder, but what is certain, is that they searched, from the moment they arrived on these shores, for land of their own. Long before, and immediately after the Emancipation Proclamation in 1863 legally ended two hundred years of enslavement, countless black folks, sometimes in groups, or alone, migrated from southern plantations with what little they owned in their blistered hands. They persevered in New York, Philadelphia, and Boston; in parts of Ohio, Michigan, Illinois, and Canada; to Oklahoma, Kansas, St. Paul, San Francisco, and Seattle, wherever they could, where freedom was possible, if tentative.

As with any exodus, "the impulse to go seemed to work like a fever." According to Arna Bontemps, this fever "had progressive systems. The first might be anger, disappointment, hope, or just a tendency to dream. The second was discontent and restlessness. Finally, to eyes that swept the horizon, flight."

They tried, Lord knows they did, to build communities on farms and in industrial cities, mainly Smoketowns and Mudtowns, which were scattered throughout the middle and greater West. Many of these all-black towns, which flourished for several generations, exist only in memory. Topeka, KS, lays claim to one of the original Mudtowns, where among those

1. Hands willing to work. A Florida family journeys "upsouth," joining 350,000 other families making the great migration between the wars. 2. Mamie Cooper hands a brick to her son-in-law Don Summers, as he builds a house for his four daughters in Hartford, CT. (1949) 3. A sign of the times: Rent for Colored.

struggling to find their way was "a sprinkling of educated Negroes, trying earnestly to inspire and maintain ideals and aspirations for their children in a community without a sidewalk; served by a single street lamp."

Kinfolk remaining in the South dwelled, for the most part in rectangular shotgun houses, named such, "because if one stood on the porch and fired a shotgun, its pellets would go straight through the house with ease." These houses had no more than three rooms, from front to back. Whether we decorated the walls with discarded newspapers or planted marigolds and four o'clocks in raked dirt, we made these homes work with us. In fact, on the small end of the front of the house, there was just enough room for folks to make front porches, an invention that our grandparents were no doubt, grateful.

During the Reconstruction, a consortium of African-Americans, concerned with overcrowded conditions in rental units in both the South and the North, created the Colored Mutual Investment Association, which aimed to "buy and sell real estate, build houses and establish homes." This was an enormous development and quite a necessary one, since the first half of the twentieth century would bring a migration that would hit cities like a wave.

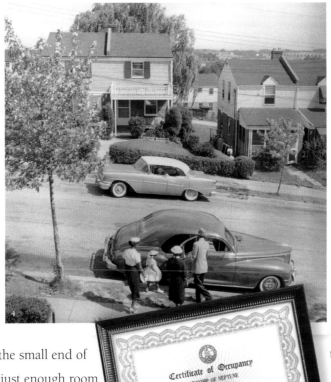

At the end of World War I, and shortly after World War II, great floods, a national depression, thirsty crops, and frozen wages drove hundreds of thousands of families from the South. "With little save their best clothes and a picnic lunch packed by their families, entire generations of folks boarded buses and trains, on 'The Chicken Bone Express', from Mississippi to Chicago, from Alabama to Detroit, from the Carolinas to Washington, or from Georgia to New York." Once in these cities, most families (or what was left of them) were piled into slums, but a few were able to secure bank mortgages through the assistance of such companies as the Afro-American Benevolent Society and the Black Loan Company. Even then, they were often confronted with a unique set of circumstances, from restricted covenants to mob violence. "In 1920, black occupied homes in Chicago were bombed at the rate of one every 20 days."

After World War II, the nation, while divided, collectively witnessed a housing explosion and subsequent housing crisis. The first, the post-war economic boom, created "one of the major storeholds of wealth in the American economy: $10 trillion worth of housing." The second, during the most intense moments of the Civil Rights Movement, was the implosion of cities, which held

4. A D.C. streetcar operator takes his children on a Sunday drive. 5. Home ownership certificate Neptune, NJ. (1970) 6. New Orleans shotgun house.

second generations of transplanted southerners, who were packed into apartments as tightly as the luggage that they carried to the North. By the mid 1960s, many folks reached the boiling point, and watched overcrowded areas in Newark, Watts, Chicago, New York, and Detroit ignite. Although the Civil Rights Act of 1968 made housing discrimination illegal, even thirty years later, according to joint studies by Cornell University and the Federal Reserve Bank of Cleveland, "blacks, who apply for mortgages nationwide, are inexplicably neglected, even when income, neighborhood and credit history are controlled, which indicates a persistent racial gap in housing loans."

From its inception, the black press widely reported on our valiant attempt to obtain housing. In addition to featuring stories of housing and economic prospects for former slaves, it listed classified advertisements for rental and housing properties. Indeed, the black press was ample in articles suggesting that middle-class blacks had a lively and meaningful social life and style throughout the decades leading up to the Civil War.

Nineteenth century black newspapers indicate that "northeastern black folks entertained often, mostly at home with their own sense of style, mainly using live piano and guitar music, played by the hostess or a guest. Dinner parties were usually over by ten or eleven o'clock in the evening, but were always prompted by 'formal invitation' or in return for others previously received."

During the first half of the twentieth century, newspapers such as the *Norfolk Journal and Guide*, *The Pittsburgh Courier*, the *Chicago Defender*, and Birmingham's *Reporter and Truth* not only "offered weekly accounts of birthday parties, informal gatherings of dinner, fun and games and get-togethers that took place in the home," but also followed middle-class blacks, when they traveled, "whether for business, social reasons, or familial obligation," and stayed at the home of well connected families in other towns. While this was viewed by some as following the travails of the "jet set," in actuality, wide-spread Southern segregation in hotels, motels, restaurants, and restrooms necessitated this twentieth-century Underground Railroad.

7. Give me shelter: *Eyes*, an Iowa Negro lifestyle magazine. 8. Home of a prominent architect in *Eyes*. 9. Evelyn Robinson, sister of Sugar Ray, on the cover of *Our Life*. 10. Mrs. Sugar Ray Robinson in cosmetics ad that was seen in black lifestyle magazines. (ca. 1940s)

Every Saturday night in the summer, with my less than able assistance, my grandmother made pots of greens, large trays of corn bread, buckets of rice and black-eyed peas, and a huge part of some meat—smothered pork chops, perhaps, or stewing beef, but meat, and a lot of it. We would eat our small amount and then she would ring a bell out in the back yard, and one of the children who lived in [a] white house would come running. My grandmother would tell her to go ask her mother if she would do Miss Bea a favor. "Ask your mother if she would be so kind as to help me keep all this food from wasting. If you wouldn't mind, you and a few of your brothers and sisters come back with some pots." A few minutes later, the oldest child would return with a gaggle of recruits behind her, each carrying a battered pot or chipped bowl. "Miss Bea," the oldest would say, "my mother says she would be glad to help you. Just put what's the leftovers in these pots and bowls." My grandmother would ladle out as much as she could, and the children would depart like a ragtag platoon, the pots and bowls hugged to their chests, up close to their noses. Gestures like these were frequent, and without comment.

—GWENDOLYN PARKER

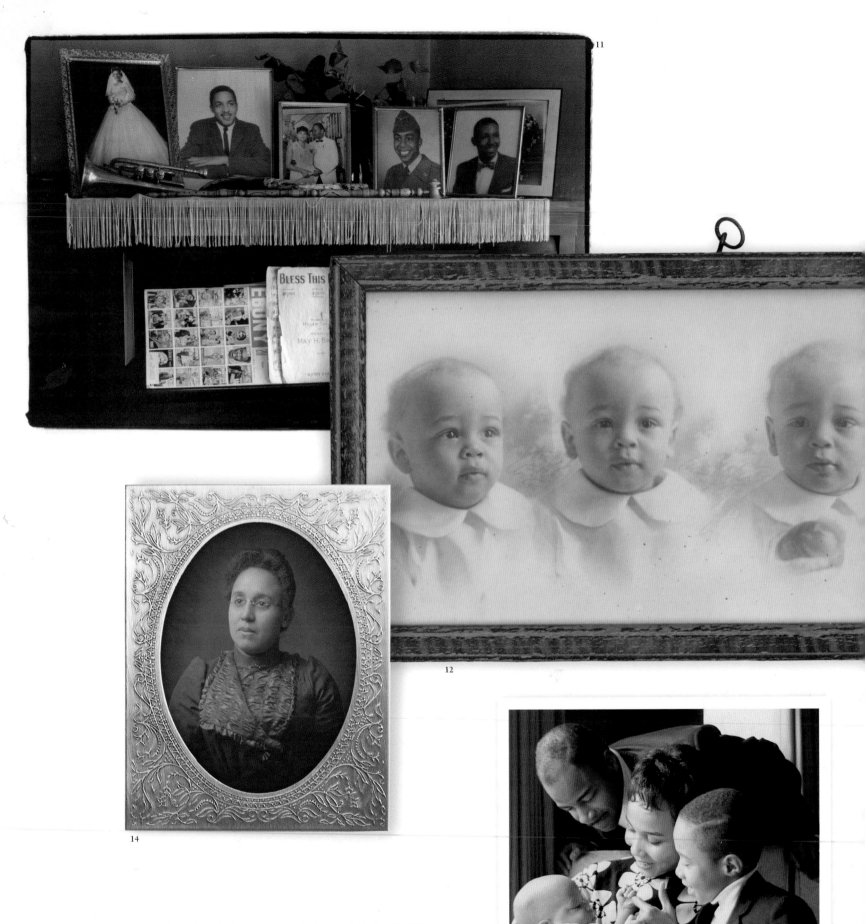

11. Bless This House: a mantle of cherished memories. **12.** Baby boy Ridgeley. (1923) **13.** Thomas and Amy Jackson of Mason City, IA, with their sons Tommy and Stephen. **14.** Nineteenth-century studio portrait.

15. Saturday morning chores, Greenville, MS. **16.** Uncle Russell Downey in Ottumwa, IA. **17.** The Cane River Creole Quilters Circle. **18.** Sunday morning tradition: laying out clothes for church. **19.** "My Greens," the pride of Vine City, GA. (1966)

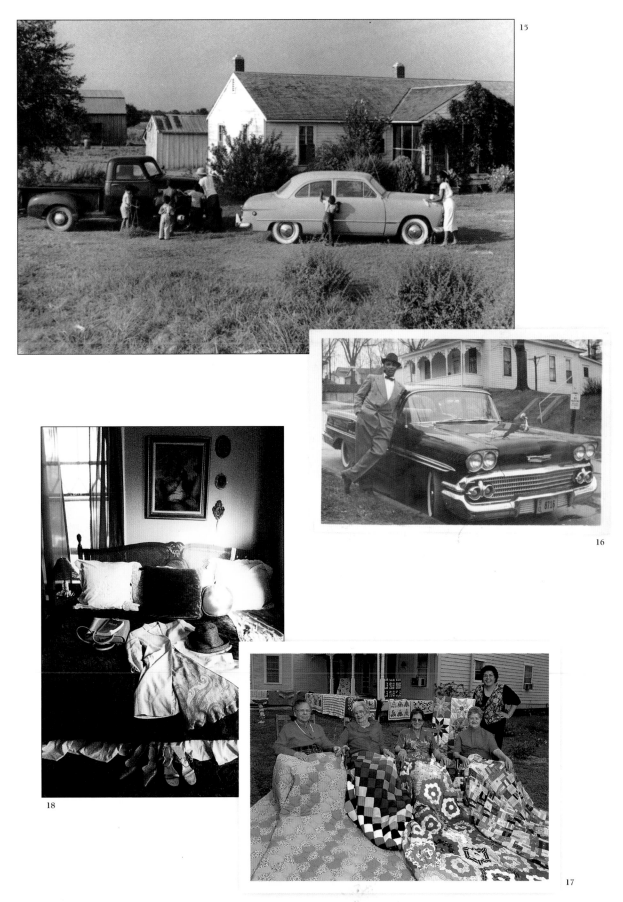

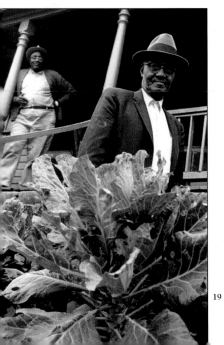

During the Era of Rising Expectations, such glossy lifestyle magazines as *Ebony*, *Sepia*, and *Our World* featured snapshots of famous and everyday folks, up close and at home. A family in Nebraska or Newark, NJ could see the Westwood, Los Angeles mansion of Judge David W. Williams, which was designed by architect-to-the-stars Paul Williams. Each month, these magazines featured professionals and trailblazers such as Judge Williams, posing in front of their brand-new pool, ultramodern furniture, and sparkling automobiles. Celebrities such as heavyweight boxing champion Sugar Ray Robinson, legendary baseball player Jackie Robinson, and top-selling vocalist Nat King Cole, were seen in a different light to black readers. In addition to appreciating their talents, we were inspired by their personal style and elegance.

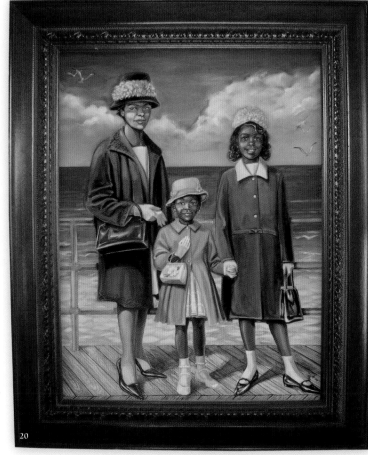

20

And we were invited not just into upscale neighborhoods, such as St. Albans, New York, "the exclusive Negro residential section, that counted Mercer Ellington, Roy Campanella, Count Basie, and Ella Fitzgerald as neighbors; but also to the Norfolk, colonial home of mortician Walter Riddick, who was an enthusiastic equestrian; or to the home of Portia McClenny, age thirty-one, a Virginia farm wife, who made "her own sausage, got the shortening from the hogs she and her husband killed for their five children, and made her own soap." *Our World* was careful

to mention that, "in five years, she has never bought a curtain, a sheet or pillow case."

Between each page were food and beverage advertisements that featured ordinary African-American families in various stages of domestic tranquillity, or famous wives such as Mrs. Jesse Owens, who showed readers how to make strawberry ice cream from Carnation milk. These articles and advertisements left a powerful impression on readers. If these scenes were not pitch-perfect reflections of our own lives, then they certainly gave us something to strive for in our homes.

Ebony, which mastered the shelter story, continues to feature interior views of black life, as does *Essence* and several other lifestyle magazines that emerged in the last few decades. They confirm our wonderful designs for living, and remind us, that in every home while there are daily challenges, those times never last for too long, and in fact, when the good times roll, they are often great.

During the height of the Black Power Movement, my family lived in a two-bedroom high-rise apartment in Paterson, New Jersey surrounded by schoolteachers, secretaries, nurses, and skilled blue-collar workers like my father, who had found opportunities in the city's then-

20. Sunday morning on the New Jersey shore.

booming manufacturing industries. After changing from his uniform and work-boots, sometimes he would either wear a jacket and tie, or a dashiki and blue jeans at my mother's get-togethers. Both of my parents are tall, my father more so than my mother. When my mother stopped pressing her hair and wore a cropped auburn natural, with a long black dress, decorated only with a brooch near her décolletage, she represented the height of cool chic to me. My parent's friends, all in their mid-thirties, formal and flamboyant, would dance till dawn on our red carpet, or lounge on my mother's long black couch through the night, as we listened to Isaac Hayes, Barry White, and Stevie Wonder records on vinyl in the bedroom, where we were supposed to be asleep.

Those parties, which were enlivened by various political discussions or the latest dances—especially The Bump—lively as they were, also went far in reinforcing the power of connections and friendships. For certainly after the party, Miss Sadie, a black woman who we remembered looked like Rachel on *Another World*, would come by as my mother did her housework, and talk about Watergate (and how it interrupted their soaps), but also my mother's desire to go back down south.

A picture window sealed the deal for our southern house: a three-bedroom, one-bathroom wood-frame green house, with a carport, a good-sized barn, and lots of room in the backyard. My two brothers, my sister and I have outgrown the house. Now our feet hang over the couch, and our knuckles scrape the ceiling when we stretch. But we can never outgrow what we experienced in the walls of our house nor the memories that existed in all of the homes where we have lived.

"When I turned nine, my parents bought a pink and white Lincoln, the same color as the bike I got that year, and we drove it slowly around town like eager peacocks," recalls Gwendolyn Parker. "When my cousin Pearl and her husband Ulysses got new living room furniture, everyone was invited over to see it. Easter Sunday was an orgy of new dresses and shiny patent-leather shoes and handbags, the display of them in morning church inevitably followed by afternoon calls to show them off some more."

In the kitchen, not only can we witness artists at work, making modern masterpieces, but we can, in the words of food anthropologist Vertamae Grosvenor, "get our thing together."

21. Joan Carter visits the Pinkney home. (ca. 1940s) 22. James and Bessie Jones on an afternoon visit. 23. The Marshalls. 24. Studio portrait of the Campbell family of Tuskegee, AL.

Miz Lucy McQueen, a beautiful, kindly gray-haired church woman who taught Sunday school, would spoil me with lemonade and biscuits and good beef stew and did not make me eat vegetables I did not like when I stayed in her welcoming, but decrepit old house. I don't remember much of what it looked like inside, but I do remember what it felt like: warm and loving. And I can smell the big gardenia bushes that blossomed profusely alongside the rose bushes in her yard. Their fragrance, and the perfect white petals that browned at my touch, are among the sweet smells of my childhood memory.

—MARIAN WRIGHT EDELMAN

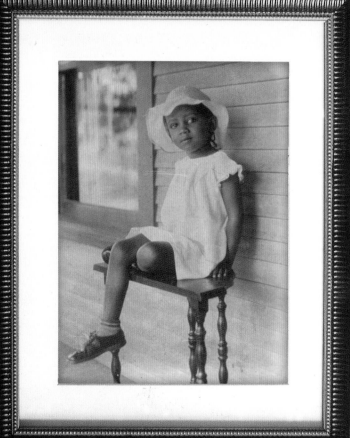

"I love kitchens," says Grosvenor. "My kitchen is full of things. The walls are covered with pictures. Pots hang from the ceiling; the shelves are filled with pottery; there are two tables and they are usually filled with papers, the typewriter, the sewing machine, the children's homework, the record player, the tape recorder, records, books I plan to read while I'm on the phone. It's a real mess. Sometimes we have to eat out of paper plates on our laps cause things are so bad. But I love my kitchen."

In our homes, we can see our parents in ways that no one else can, as their true selves: tender, sensitive, beautiful. Once they are home, the armor is often dropped; their hands and hearts are no longer as heavy. Here, we can, and do, rest.

"One of my fondest memories of my dad is watching him stand on the back steps of our home, shaking out the bedroom rugs. There he stood, in his dress pants and white shirt, open at the collar and his sleeves rolled up. He also had my mother's apron tied about his waist . . . although he took a good verbal razzing from the man next door about how my mother must have nagged him into doing housework, he wasn't the slightest bit embarrassed about being caught in the tangle of apron strings. Dad was helping my mother, who was at work as a nurse, and whom he dearly loved. He wanted her to come home to a clean house, and not have to worry about taking another job once there, but having time to sit back and relax," recalls Susan B. Griffiths.

As children, our bedrooms allow us to dream of movie stardom or non-stop flights to the moon, but also to feel so grown-up and adult. Deborah McDowell recalls that in her mother's room that she could "wallow on the canopied bed when Auntee wasn't looking or play dress up, opening crystal bottles with skinny stems that looked like church spires, golden tassels hanging from their necks. I squeezed the atomizers and squirted perfume behind my ears, in the dent of my throat, and the bend of my knees and elbows—just as Mother did."

Home, for us, is never one house, but a series of houses of cherished loved ones. From time to time, each of my cousin's houses became my favorite habitat, until we fell out, and traded up to other folks' houses. For me it was Mary Everett's house, where she fed me heaping plates of spaghetti and meatballs, the best Kool Aid in the universe, and unconditional love; followed by a warning not to sit too hard on her couch when I would watch her floor model television with her daughter, Andrea. More than

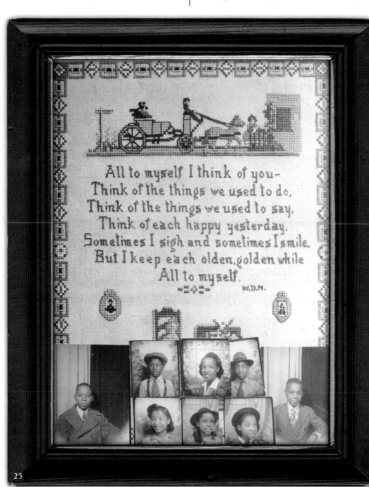

All to myself I think of you—
Think of the things we used to do,
Think of the things we used to say,
Think of each happy yesterday.
Sometimes I sigh and sometimes I smile,
But I keep each olden, golden while
All to myself.
W.D.N.

25. Needlepoint sampler woven with Detroit family images circa WWII.

twenty years later, Mary still warns me not to sit too hard on her couch.

Neutral territory for me was my grandmother's house. It's gone now, but when it was here, it was a white house with red shutters. At various stages, Grandma decorated the porch with orange and green furniture. Once she had red furniture painted with house paint.

My grandmother's porch was a Southern talk show. In her rocking chair, two-piece Carolina blue pantsuit and nurse shoes, she was a hostess, who enjoyed entertaining and being entertained. Throughout the afternoon, she had guests, including family and regulars, who talked about everything (and everyone) under the sun.

During the winter, the show moved into my grandmother's front room. How that room held as many bodies as it did, I don't know, but never, ever would Muther ever think of turning anyone away. Indeed, when she passed, her last request was that the home be inhabited by any family member who had none of

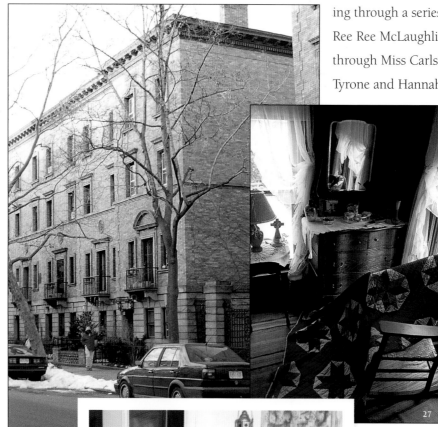

their own. There was not a family member who hadn't spent the night, or considerable time there. At night walking through a series of paths, passing by Ree Ree McLaughlin's house, cutting through Miss Carlson's yard, waving at Tyrone and Hannah Settles, Pete and Miss Settles, (they were brothers who lived next door to one another) and finally turning the corner of Miss Sister's and Mister Buddy's houses, I always knew that Grandma and Grandaddy would have that front light on—it meant come in, sit down, and "let's get a talk going." Grandaddy was asleep in the back room, and Grandma Sarah was in a bedroom just off the front room. It was a house that they built with their hands, or so they say. Six hands (including Great Grandaddy Jethro). It wasn't dissimilar from the other houses on her street. There was a picture of Uncle June on the wall, and the odd graduation or prom picture. In other words, major events. Then too, there were pictures of extended

26. Harlem's famous Striver's Row. (2001) 27. Quilts: Claire Carter's grandparent's bedroom. 28. Mother and child visit Edward Wilkerson's Fort Greene, Brooklyn, living room. (1995)

family, including Dr. Martin Luther King, Jr. and Coretta in mourning after his assassination. But there were also slight touches—place mats, trinkets on the piano, The Jackson Funeral Home calendar—remarkable kitsch that distinguished one house from the next. For my grandmother, it was her favorite 'sitting chair' and her table with her red telephone. We always thought The Commissioner from

My opinions were sought: "Pat, what do you think about so-and-so?" My conversations were completed, and heeded. I felt a true sense of belonging.

There was always a moment when it appeared that my ride wouldn't pick me up. By the time *Murder, She Wrote* began, I would drift into a panic. And my grandparent's would always shout, "Calm down, boy. You are

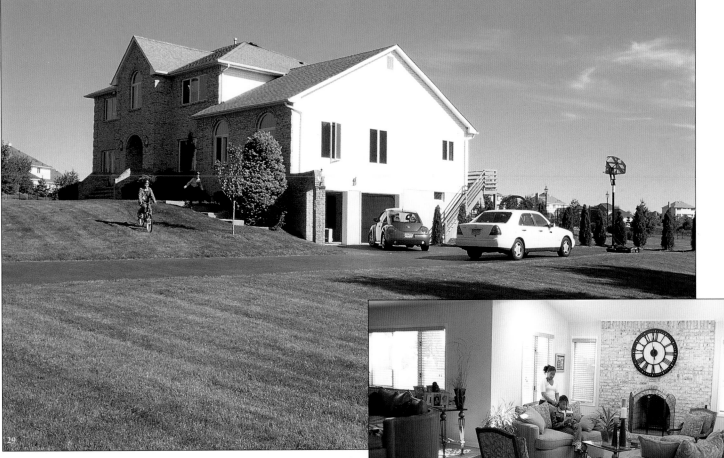

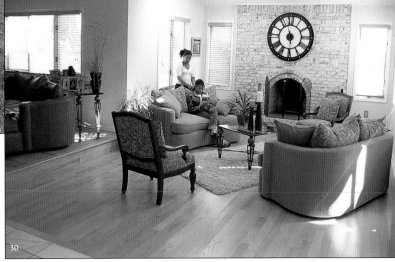

Batman was calling her, even after she replaced the phone with a beige one.

Once I went off to college, whenever possible, I would go home on the weekends. Every Sunday, before I returned to school, it was my preferred choice to wait for my ride at Muther and Grandaddy's. From the late afternoon until *60 Minutes*, we laughed and talked, and I felt so important.

29-30. Home sweet home: Drs. Evander and June Duck of Manalapan, NJ.

home. You can always spend the night. Now what were we talking about?" It never failed that Sam would arrive, but there was always the promise of a warm and loving place to rest my heart and mind.

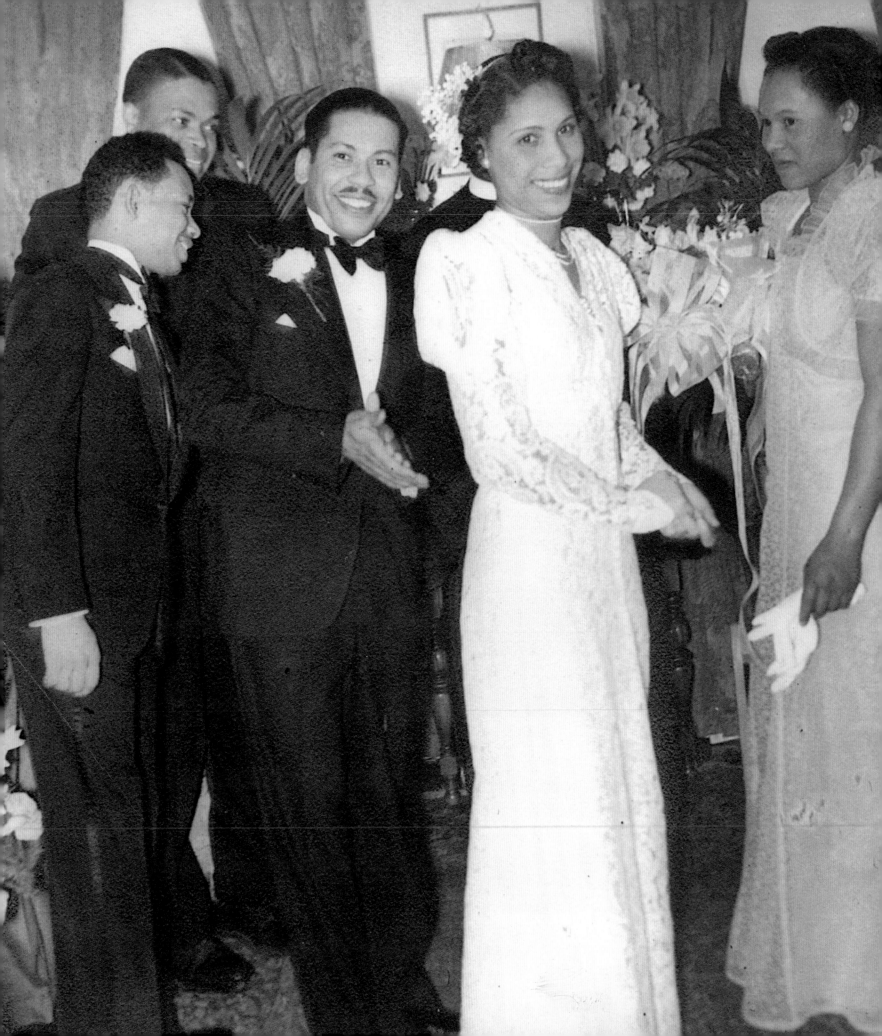

CELEBRATIONS

Black people arrive in pairs or whole families and fill up area hotels. They come from near—Alabama, Texas, Louisiana, and far—Michigan, California, Nevada, Illinois. Hugs go around, as do exclamations of joy when families and friends collide. It's the Fourth of July weekend in Vicksburg, a city of 25,000 that lolls among sun-seared pines on the banks of the Mississippi River. It's also Reunion time, and, if you're black and you're from Vicksburg, you drop what you're doing and you go home.

—SONYA ROSS,
THE LOS ANGELES SENTINEL

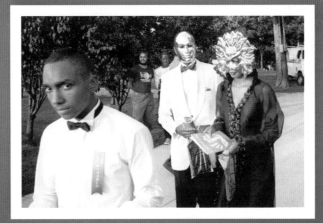

WHETHER INDOORS OR OUTDOORS, our gatherings are essential. Each Eastern Star meeting or cookout is a confirmation, recognition, and celebration of our connections to and love for one another. At a family reunion or fish fry, we revel in one another's company. During little league games and pageants, we cheer on our loved ones and applaud quietly enough for the best pitcher in elementary school (who is not our child), or the young miss lady whose mother has raised more funds than everyone else (including our daughter/ sister/niece/cousin) and as such has the debutante ball locked down. We know this because our neighbor beside us has dropped a dime and told us so.

When we meet for a Saturday evening game of Bid Whist (and brandy or beer depending on the friend) or for Sunday dinner at a relative's house, we know that the coming-together is a drama, mainly because it almost always never happens. Anyone who has made plans to meet has probably heard the following (and more): He/she took the car that is running. I got lost. Did you say we were meeting this Saturday?

But once we come together, separating is a major event. Between hugs and fond farewells, we try to balance ample slices of lemon pound cake or peach cobbler, which sit delicately atop a plate of leftovers that are cooked with so much love, that we can almost see the macaroni-and-cheese, baked chicken, yams, and collard greens in our mouths.

Weddings are a serious matter. Everyone is starched, sprayed and ready to be displayed. Thank goodness for the reception, where everyone can loosen up and release deep-hearted laughs from special places in our souls, particularly at those relatives who still haven't learned the Electric Slide. Missed the wedding because you were out of town? No never mind. Black newspapers and magazines will let us know exactly who was there (and in some cases, whether there was a wedding at all). The larger the name or event, the closer the likelihood that everyone in black

America will know about Your Big Day. The nuptials of Marion Patricia Stubbs (Patsy) to Harold Steadman Fleming, Jr., featured in *Ebony*, was an affair so lavish it made a Cecil B. DeMille epic look like an independent film. There were over eight hundred invitations mailed, twenty-five suites were reserved at Detroit's Gotham Hotel, members of Detroit's Symphony Orchestra serenaded guests, and afterwards, the couple joined guests on the bride's father's seven-acre Canadian estate. Still, folks who tiptoe to the Justice of The Peace can (and do) make an appearance in the small-town social news.

Perhaps, the most moving gatherings are the two that mark the greatest passages in our life: the christening and the home-going service. There is much promise in the former, and the hope for peace in the latter. We come together to celebrate a life just begun, and one that has ended for us, no matter the age, much too soon. But there we are: pearls and porkpie hats, haircuts hooked-up and clothes as sharp as the tip of the Pentagon; bearing gifts, flowers, and cards of congratulations or condolence.

There is something to cherish about our being together, since throughout most of our history we were torn apart.

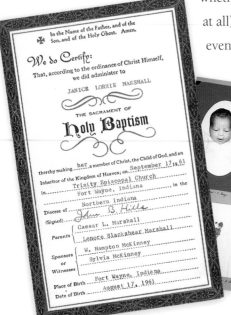

1. Vintage baby christening photo. **2.** "It's a girl!" Janice Marshall is born in Fort Wayne, IN. (1961)

During two centuries of enslavement, profit from our labor overrode any consideration for our familial, community and emotional bonds. Children, seen mainly as future profit, were routinely sold up from under their kinfolk, if they hadn't been sold to another plantation first. Those who ran away without their families understood that it was perhaps the last time that they would ever see them in the flesh.

Today, driving along a major highway and seeing motel signs that almost scream "McFadden Family Reunion" or "The Marriott Proudly Hosts The Johnson-Coleman-Robinson Family Weekend" is amazing. Nowadays, reunions are three-day affairs with T-shirts, mugs, speeches, contests, dances, genealogical lectures, and tons of food. These gatherings are but one indication of the incredible progress that we have made for keeping our families intact.

bustled about the kitchen, pulling together a big southern breakfast. As always, the morning sunlight cascaded into the room, just as it used to when I would go over to my grandmother's house for a second breakfast as a child. Outside the window I could see all that was so familiar to me and I looked at my friends, who were making themselves at home. We were laughing and teasing one another, and I saw us as we might have appeared from the outside . . . all of us black, all of us bright, our shades of color spanning all hues."

There are some encounters that are less informal, and based on tradition. Folks outside the Bayou don't really know the other teams in the Southwestern Athletic Conference (SWAC), but we all know the State Farm Bayou Classic, which pits Grambling State University against Southern University. Since Coach Eddie Robinson,

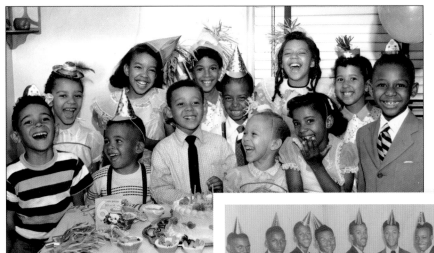

the winningest coach in the world, retired in 1997 after fifty-seven years, sixteen conference championships, and more than four hundred victories, it is almost as if the classic isn't the same. But just as the Greek step shows, Battle of the Bands competition, and the crowning of the Miss State Farm soldiers on, so too does the Classic.

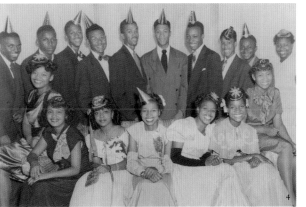

Debutante balls and cotillions, some will insist, are more for the enjoyment of parents and their friends than for the participants. Writer Deborah McDowell had almost forgotten her debut, until her mother sent her a newspaper clipping from the *Birmingham*

But not all of our gatherings are related to family. Indeed, time spent with friends is just as important as moments with kin. While a sophomore in college, Gwendolyn Parker brought three of her closest friends to Durham, North Carolina for a memorable weekend: "We all gathered in the large kitchen. My friends and I

3-4. Birthday parties. (ca. 1940s and 1950s)

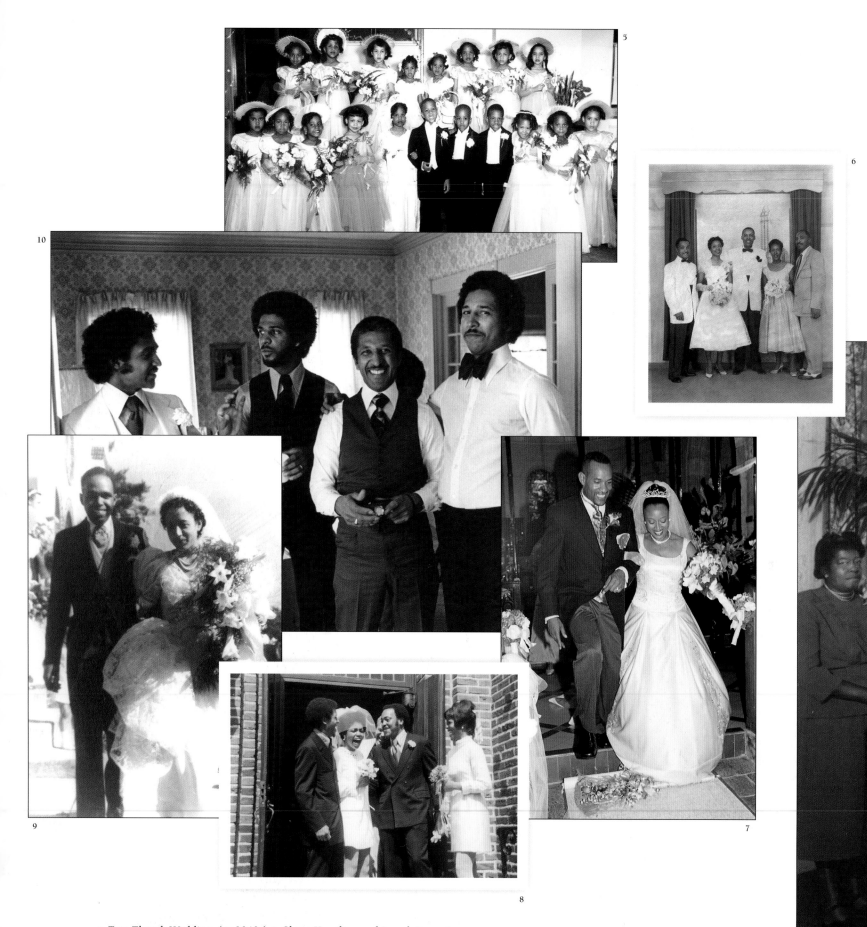

5. Tom Thumb Wedding. (ca.1940s) 6. Gloria Hamilton and Joseph Bennett marry in New York City. (1955) 7. Peter Stephen Albert and Gail Alleyne-Albert jump the broom. (2000) 8. Marie Dutton marries Kenneth Brown. (ca. 1960s) 9. "I do!" Josephine and Benson Dutton wed. (1934) 10. The Barboza men. (ca. 1970s)

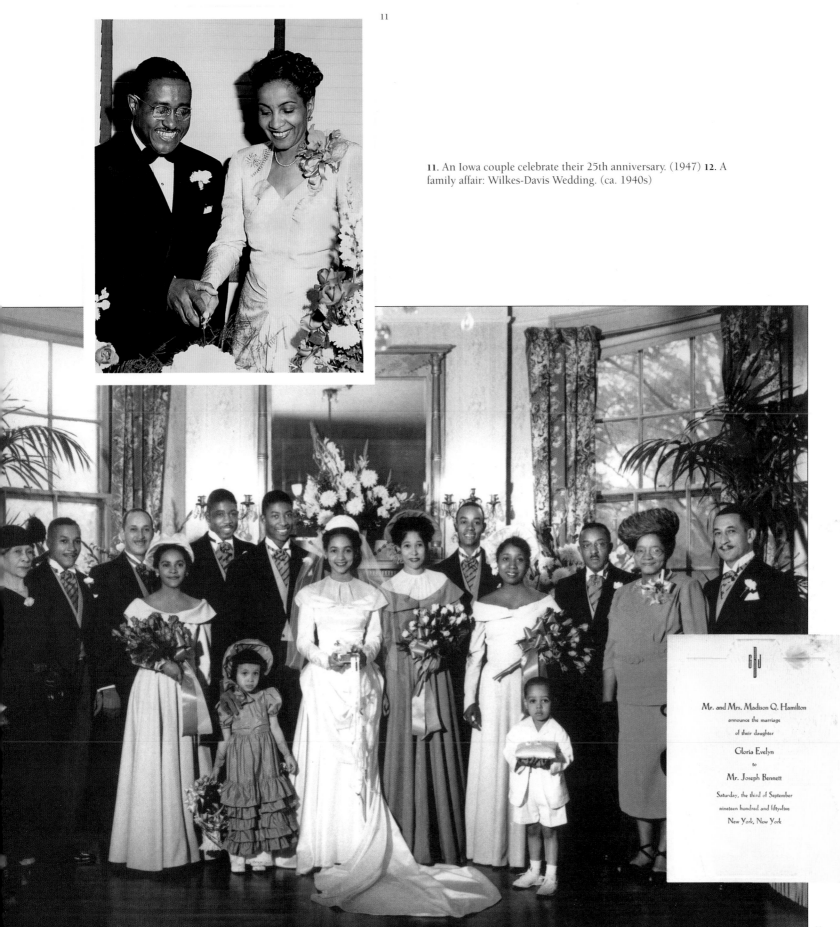

11. An Iowa couple celebrate their 25th anniversary. (1947) 12. A family affair: Wilkes-Davis Wedding. (ca. 1940s)

Mr. and Mrs. Madison Q. Hamilton
announce the marriage
of their daughter

Gloria Evelyn
to
Mr. Joseph Bennett

Saturday, the third of September
nineteen hundred and fifty-five
New York, New York

World: "18 Debs Make Formal Bow To Society":

They created a perfect picture of winter beauty in floor-length dresses of winter white and the traditional single strand of pearls. Geraldine Lancaster, the queen of this year's group, wore a headpiece of tulle and silk taffeta, ornamented with iridescent sequins. Miss Clara Oliver and Sonya Gamble lighted the eighteen candles, which cast a soft glow on the decorative background of red poinsettias. Mistress of ceremonies, Mrs. Mable Ravizee, presented the parents of the debs, who were themselves visions of grace and dignity as they took their places in the festive hall.

It was classic reporting for the *Birmingham World*. All the language and frippery of high society for a ceremony in a gymnasium, the orange basketball hoop high above Miss Ravizee's head.

For many of us who grew up far from debutante balls and cotillions, the simplest of pleasures could be transformed into a celebration. During the summer, while my grandmother and her friends shelled peas on her front porch, we'd run over to Miss Gracie Bell's for chopped barbeque sandwiches and root beer. Soon after, my cousin Hanky would spin records on his turntable, and we would have an "activity" as one family

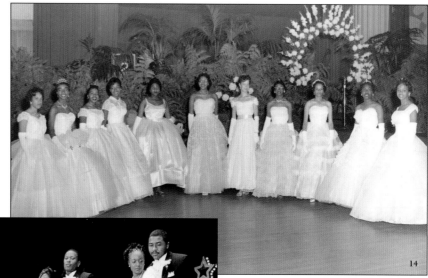

member after another dropped by, and joined in a nonstop conversation that could last well into the evening. When my Aunt Maxine married into the McNeill clan (a huge family from nearby Wagram, North Carolina) in the mid-60s, I don't think any of us were prepared for the thirty years of bacchanalia that would follow her wedding to Uncle Willie Amos, a tall, dignified man who showered his children and wife with flowers, candy, and gifts almost every time he walked through the door of their Brooklyn apartment. With the exception of Arbor Day, I don't think there was an occasion that the McNeills didn't celebrate. Although we were "outside family," my cousins and I were always welcome at their birthday parties, anniversaries, get-togethers, and cook-outs. There was a particular pride on display at their baby showers and engagement celebra-

tions. These were regular folks; salt of the earth people; municipal workers, who in the light of their city apartments became so much more. I always looked forward to a McNeill "event," especially my cousin Angie's macaroni salad. It was impossible to have a bad time in their presence. As a matter of fact, the one season where Aunt Maxine and

13. RSVP: An invitation to The Cameo Social Club of the Twin Cities' annual Cotillion. **14.** Cameo Social Club Cotillion, St. Paul, MN. **15.** 2000 Cotillion in Monmouth County, NJ.

Co. were subdued was Christmas, when they graciously allowed other folks to spread love while they took the day off.

Increasing numbers of us are celebrating Kwanzaa—held from December 26 to January 1—the holiday that combines African and African-American cultural traditions, instead of Christmas. The principles of Kwanzaa urge us to become keepers of our culture, wise in our decisions, active in our communities, noble to our elders, zealous in our efforts for progress, advocates for our children, and achievers in all our endeavors.

Over the years, I have been a part of countless beach trips, post-Mason induction parties, pre-theatre functions, post-Atlantic City gambling parties, rehearsal dinners, and bachelor parties.

As I travel, I am delighted to grab a spot on Main Street to witness various parades. Watching children in colorful costumes, wearing vibrant tribal make-up or headwraps the size of Australia, high school bands carrying on George Clinton's funk tradition, majorettes twirling batons, conjures memories of our small-town parade. As a member of the Junior Civitans, I represented "Africa" (no specific tribe or country—I wore a homemade dashiki made from khaki, blue jeans, and Pro-Keds) on the International Float, I remember throwing tiny packs of M&Ms to the crowd. Talk about globalization.

Juneteenth is a special celebration for Texans. On June 19, 1865, enslaved Americans in Texas learned that the Emancipation Proclamation had ended American enslave-

ment on January 1, 1863. Imagine the partying that folks did after they threw down those rakes and cotton sacks. In addition to parades and games, Texans serve up a "big mess of food," complete with strawberry soda.

Our get-togethers speak volumes of our diverse interests. Some of our mothers were bridge-playing members of garden clubs. We can pity the poor child who had to cut countless slices of bread for finger sandwiches and iron French laundered tablecloths and napkins. *Ebony* reported

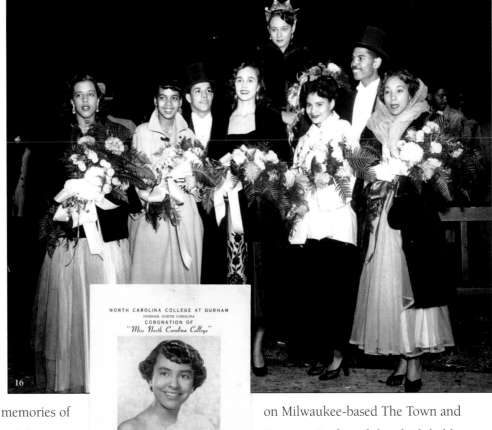

on Milwaukee-based The Town and Country Garden Club, which held monthly meetings, informal talks, and offered demonstrations on floral arrangement. Mrs. William Robertson won a total of eleven prizes at the 1959 Wisconsin State Fair. The group's first show, "Ode to the American Negro," which used posies and props to illustrate

16. Howard University Homecoming. (ca.1940s) 17. Janice Jones, Miss North Carolina College at Durham. (1955)

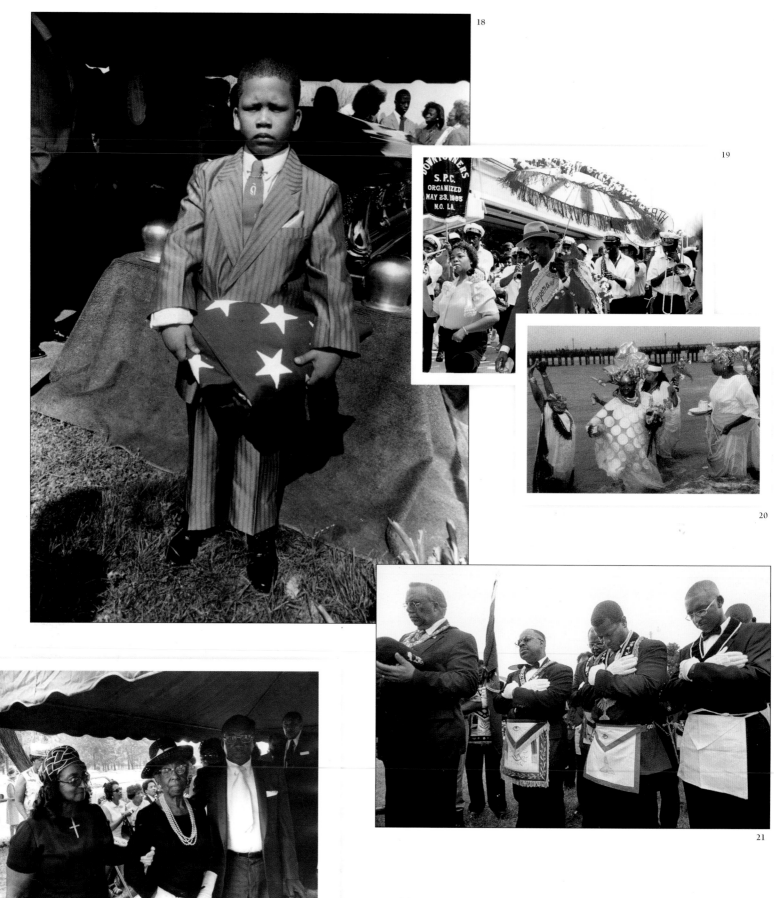

18. Death be not proud. 19. A New Orleans Jazz Funeral. 20. Honoring our ancestors at The Miaffa. 21. Masons in a moment of reverence. 22. "Do Lord, remember me."

18

19

20

21

22

black life, from plantation scenes, to pride in Africa was met with much fanfare.

Long before mall multiplexes, there was the Saturday matinee. During segregation, black folks congregated in the balcony, with the best view of Captain Fantastic, Roy Rogers and other heroes of serials. My parent's dressed us on Saturday nights to take us to see such classics as *The Man With Two Heads* and *Dr. Phibes Rises Again*. Even as a child, I knew not to look for these films at Oscar time, when we crowded around the television to count black presenters. We also gathered around the tube for any black person who ever hosted a television show from Lola Falana and Clifton Davis to *Tony Brown's Journal*. My mother vowed never to watch the Miss America pageant, after seeing one black woman after another lose to pantomimes and cloggers. Imagine the celebration that my neighbors up the street—Andrea and her mother Mary—had when we watched Vanessa Williams, the first black Miss America, get crowned.

What was more fun than going to a high school talent show, where folks sang into busted microphones or lip-synched to scratched records? Or the excitement of seeing Ella or Dinah, Miles or Dizzy at the Newport Jazz Festival? Is a Budweiser SuperFest complete without Frankie Beverly and Maze singing "Happy Feeling"? Who

can explain Freaknik, the Atlanta collegiate weekend that is so popular that chalkish author Tom Wolfe mentioned the celebration in his bestseller *A Man in Full*?

Is any cookout complete without a *Soul Train* line? And how many of us came out blurred or our heads chopped off in photographs taken with an Instamatic or a One Step, because a cousin had their finger on the flash? And there was no way to prove that the fish we caught was as big as Jaws, or we had a perfect golf or bowling game, because Uncle Nate forgot to put film in the camera. The only proof was in a trophy or a plaque. Minus that it was just another tall tale.

One of my favorite celebrations is one that doesn't cost a dime, but is priceless.

There is no specific holiday or Save The Date announcement. It has no particular time or place, but it happens almost every second. When we acknowledge family, friends, or strangers with a smile or a nod, with a "What's up, bro?" or a "How you doing girl?" or with a handshake or a high-five, we are celebrating a love that passes all understanding.

23-24. I'll make my own holiday season: Homemade Christmas cards—a necessity since black images were not included on commercial holiday cards shown here. **25.** The McKinney family's holiday card, during WWII; Pet and Bess, "Our Garden in Winter," 1955. **26.** Traditional Kwanzaa setting. (2001)

DIVERSIONS

"DON'T SLAM THAT SCREEN DOOR my grandmother used to yell, with her hands held over the telephone receiver, before me and my cousins went into her backyard to play together. Whether we played basketball (the goal was a bicycle tire rim that Grandaddy nailed to the barn), checkers (we played with grape and orange Nehi bottle caps that we bought from Miss Ju'Lann's Penny Candy Store) or golf (one club, and a miniature kickball), monopoly (Muther's giant Thimble served as substitute for the miniature game version), it was important that we were together; laughing, sharing.

Every summer, without fail, the elders in my family would tell me to get a hobby. "Boy, why don't you take up interest in something; find yourself a diversion other than sitting around grown folks," they would say. Little did they know that being in the company of my loved ones was my hobby, but I understood their point. All over my small town, from Cross the Creek to Bermuda Grass (Moody

and where do your parents summer?
she asked him.

the front porch, he replied.

—REUBEN JACKSON,
SUNDAY BRUNCH

Mrs. Violet Vickers Ford
presents
Her Pupils
in their Annual
Vocal and Piano Recital

ff

at
St. Mark's Auditorium
57 West 138th Street New York City

Sunday afternoon, October 15, 1939
at 4.30

USHERS
Dorothy Callender Ernest Harris
Alice Atkins Albert Hamilton
Catherine Ruffin
At Door: Cecil L. Ford, Stanley Goddard, Clawson Harris

Grass), Washington Park to Carolina Park, everyone could be at their best at some activity: horseshoes, stamp collecting, hopscotch, Red Light-Green Light, sewing, basketball, Chinese checkers, chess, spades, piano recitals, or dancing. Northern transplants introduced Double Dutch and stickball, not to mention Seven Minutes in Heaven, a game that brought our grandparent's favorite hobby: finding the biggest switch to spank us.

Whether a talent show or a Bid Whist tournament, a casual game of pick-up basketball, 21 or a round of golf, our diversions bring out our creative spirit. Weekly black newspapers show a young child or senior with a badge, medal or trophy for a range of activities from Boy or Girl Scout honors, bingo victories, or even the best rhododendron at a floral show. I appeared in the *Laurinburg Exchange* for a burgeoning hobby: public speaking.

CONGRATULATIONS

TONY SKIPWITH

Mother & Dad Grandmother
Grandmother Pearl George Bell
Aunt Nellie Aunt Mabel
Mr. & Mrs. Clarence Pinckney Uncle Reed
Miss Clyde Skipwith Mr. & Mrs. Oscar Hall
Miss Joan Carter Mr. & Mrs. Wm. N. Carson
Thomas Barber Shop Mr. & Mrs. James Kind
Tasty Treat Luncheonette Michel's Candy Shop, Inc.

CLARENCE PINCKNEY & RACKETS

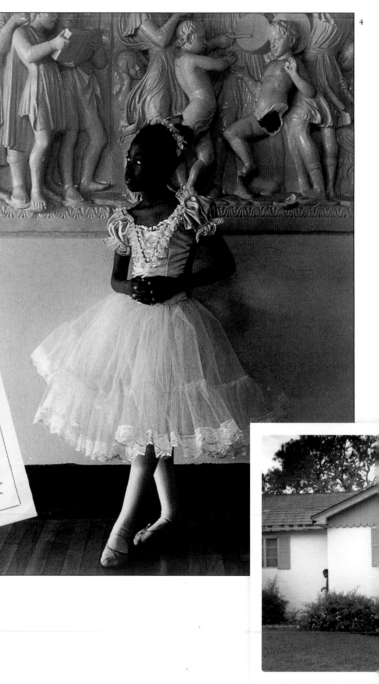

1. The music and the muse: a piano recital program. (1939) 2. A piano recital in Fort Wayne, IN. (ca. 1950s) 3. A dance recital ad. 4. A beautiful ballerina girl.

5. A 1940s sewing trio. 6. Fresh Air Fund, 1940s Harlem. 7. Break time: boys in Springfield, MA, including jazz musician Amaad Jamal. 8. Aicha dives in. 9. Hide and seek.

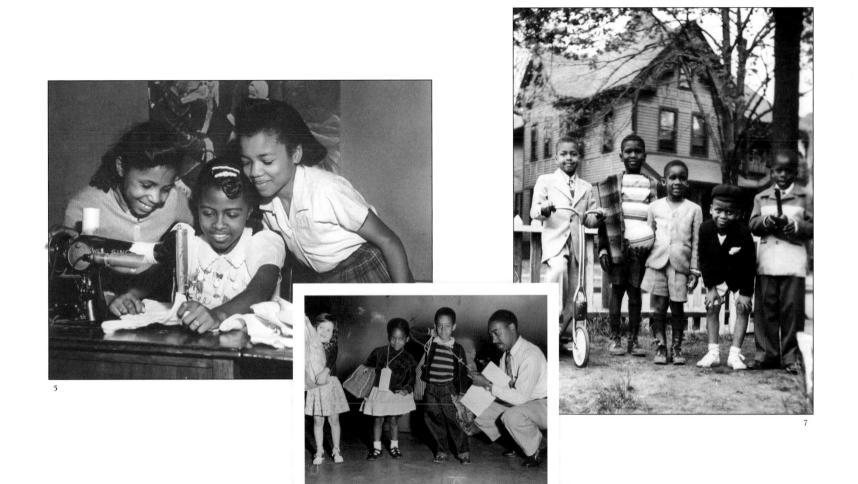

5

6

7

9

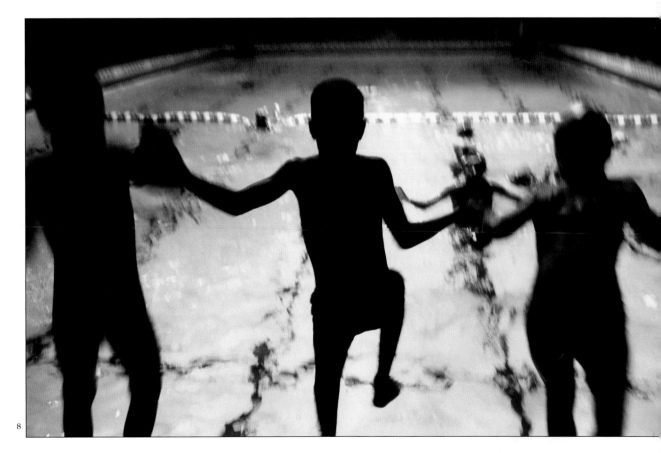

8

One of the favorite diversions for folks is a trip to the beach or a lake resort—a place to get our feet wet and to let our hair down. Today, such a getaway is more than a notion. An excursion to Paris or a Caribbean cruise, a luxurious spa vacation or cozy bed-and-breakfast weekend, are not only common, but necessary for some folks to combat the overworked blues or to keep up with the ever-present Jones'. Over the past few decades, black folks have witnessed more options than ever to travel to places that were once just names on a map. Not once during our current travels are we confronted with a sign that tells us "No Negroes" (or worse). Not

10. The Carver hotel on the Jersey shore. (ca. 1950s) 11. Highland Beach. 12. Young, single, and ready to mingle in the Caribbean. (ca. 1970s) 13. Sparrows Beach in Maryland. (ca. 1950s)

once will we see a bathroom designated "For Coloreds Only." In this respect, we've certainly traveled far.

An adventure isn't always a grand trip around the world. We travel far, and not so far at all, for the pleasure of an amusement park, a state fair, professional convention, or family reunion. For some folks, driving to the airport to watch planes depart, is just as exciting as boarding a plane. There are weekend warriors who ride motorcycles from one section of a state to the next. There are thrill seekers who scuba dive to the bottom of the ocean or hang glide in

of lunches (mustard or ketchup, bologna or luncheon meat, soda or water?), locating maps in cluttered glove compartments (where everything is stuffed tightly inside except for maps and gloves), visiting overcrowded rest stops, deciphering incomplete messages from loved ones (no, not Water Burger on the left, What-A-Burger on the right), and finally, finding that just-right radio station that can satisfy fans of bebop and hip-hop; by the time we reach our destination, it appears as if we have traveled around the world.

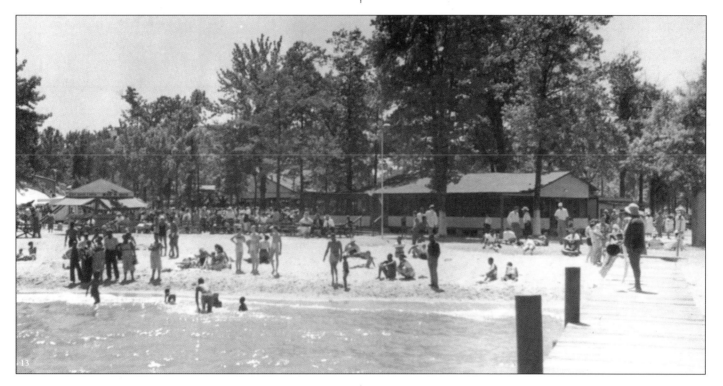

the high heavens. My grandfather's favorite getaway was to a pond, where he and some of his friends would fish for perch and mullet all day long. Travel isn't always a particular place, but a state of mind; experiences gathered when one separates ones self from a familiar environment.

The preferred mode of travel for many of us is still by car. Friends and family think nothing of gassing-up suburban mini-vans or our old reliables for a weekend of laughter and love. The experience of getting "there" is often "a trip," if you're not traveling solo. Between the packing

I have family who makes a trek to New York every two years or so from North Carolina by car. When I ask them when they are departing, if they tell me Wednesday, I know that I will probably see them on Saturday. This is not because they are slow drivers. On the contrary, my cousin has a lead foot. It's also not because they are visiting relatives between Charlotte and Harlem. No. Quite simply, they love motels. Every two states or so, just after sunset, it is not uncommon for them to check into a motel or hotel just off of I-95, sometimes with room service and a satellite

dish. I know this, because they have begun their own rating system to rival the AAA's. I know which hotel has the best beds for bad backs, as well as the most cable channels.

Travel is the ultimate sense of freedom. Before and immediately after the Civil War, the black community took to the road not only in search of a better life, but wherever we could, we traveled to places for leisure and labor. Resort towns were ideal places to rest our feet, hang our hats, and feed body and soul.

According Myra B. Youngstead, author of *Lord, Please Don't Take Me in August*, resort towns "first appeared in the antebellum period and then proliferated throughout the nineteenth century. Most resorts towns were concentrated in the East, along the Atlantic shore. In the Northeast, resort towns included Saratoga Springs, N.Y., Newport, Rhode Island, Bar Habor, Maine; Marblehead, Massachusetts; Niagara Falls, New York, and Oyster Bay, Long Island. In the South, there was Hot Springs, Virginia, Warm Springs, Georgia, Southern Pines, North Carolina; and Pensacola, Florida. Sunrise, Wisconsin, was a Midwestern tourist stop; and in the West, Salt Lake Springs, and Pasadena, California were among the health and resort centers. They provided a respite for the well-heeled and work for seafarers and drifters, and African-Americans, who figured in the social mixing and social sifting at resort towns both as tourists and as service workers." However, "records indicate the presence of African-Americans in coastal towns early in the

14

eighteenth century as "seamen, preachers, wise women and even sea captains.""

In 1892, Major Charles R. Douglass, the son of abolitionist Frederick Douglass, and his wife were refused a meal in a cafe at Bay Ridge, then a fashionable gathering place near Annapolis. Spurred by the insult, the Major purchased Arundel-on-the-Bay, forty-four acres of sandy, tree-covered waterfront land on the Chesapeake. The property, renamed Highland Beach, became a mecca for blacks seeking to own vacation homes.

Florida's first black beach was Manhattan Beach, which thrived from 1900 to 1940, offering cottages, pavilions, and an amusement park to black church groups and day-trip excursionists. From 1926 to 1958, Butler's Beach, near St. Augustine, FL, served as a retreat for black beachfront cottage dwellers.

BEACH SCENE AND CONVENTION HALL, ASBURY PARK, N. J.

15

On September 21, 1915, several men and women made an excursion to Idlewild in Michigan with the intent of building a black-owned resort. "Its pioneers lived in tents, made meals on fish and berries, and ventured into the real estate business to help sell the 1,160 acres of valuable resort land in 25 x 100 foot lots for as little as $4 down and $1 per

14. Sea hunt: Dr. & Mrs. Marshall scuba dive. **15.** Hot fun in the sun at Asbury Park, NJ.

month. The resort sold out of land in a very brief time for "idle" men and "wild" women, as the familiar joke intimated. Three years later, the resort had become so popular that Madame C.J. Walker wrote that she considered Idlewild "a great national progressive moment," and that she intended to build a home there.

Chicago and Birmingham and Charleston, arrived "by caravan halfway through the summer nights. The pocket hotels had bellhops to unload the luggage. Big-name bands and burlesque troupes played the clubs, and the restaurants were mobbed. Motels were booked up years

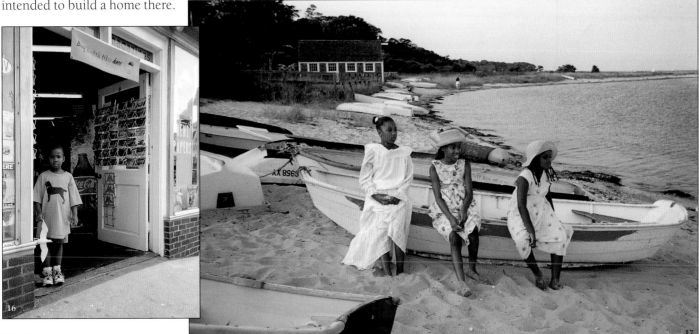

While her plans never materialized, during its heyday Idlewild attracted Louis Armstrong, Dr. Mary McLeod Bethune, Joe Louis and Pullman Porter organizer A. Phillip Randolph, as well as swells and sharp folk from Chicago, Cleveland, and Detroit.

In 1928, the Gulfside Association, a group of African-Americans, bought six hundred acres of land outside Biloxi, Mississippi. The sprawling gulfside resort eventually boasted an elegant hotel, summer cottages, campsites, and a mile of beachline.

In the 1930s, Afro-American Life Insurance Company president A. L. Lewis, one of Florida's first black millionaires, built American Beach, a town by the ocean, where blacks could enjoy, "recreation and relaxation without humiliation." For four decades, folks from Atlanta and

in advance. Summer houses were inhabited by eminent people in the forefront of their generation in Jacksonville and the South—pioneering black dentists, doctors, lawyers, preachers, educators, undertakers, and as you might expect, insurance company executives."

On July 6, 1938, 6,000 folks from southeastern North Carolina celebrated the Declaration of Independence Day at Lake Waccamaw, arriving by truck, car, and busload. Throughout the bacchanalia they rename the site Sea Breeze, which became so popular that C.C. Spaulding, president of the North Carolina Mutual Life Insurance Company, purchased a lot at Seabreeze on the coast of Wilmington, N.C. and built a summer home. He was joined by other folk, who built "cottages, pavilions, hotels, cafes and clubs," alongside lovely groves of old oak trees, cedars and tall pines, with clean white sands of the beach nearby.

16. Summer on The Vineyard. 17. Portrait of three young ladies on Martha's Vineyard.

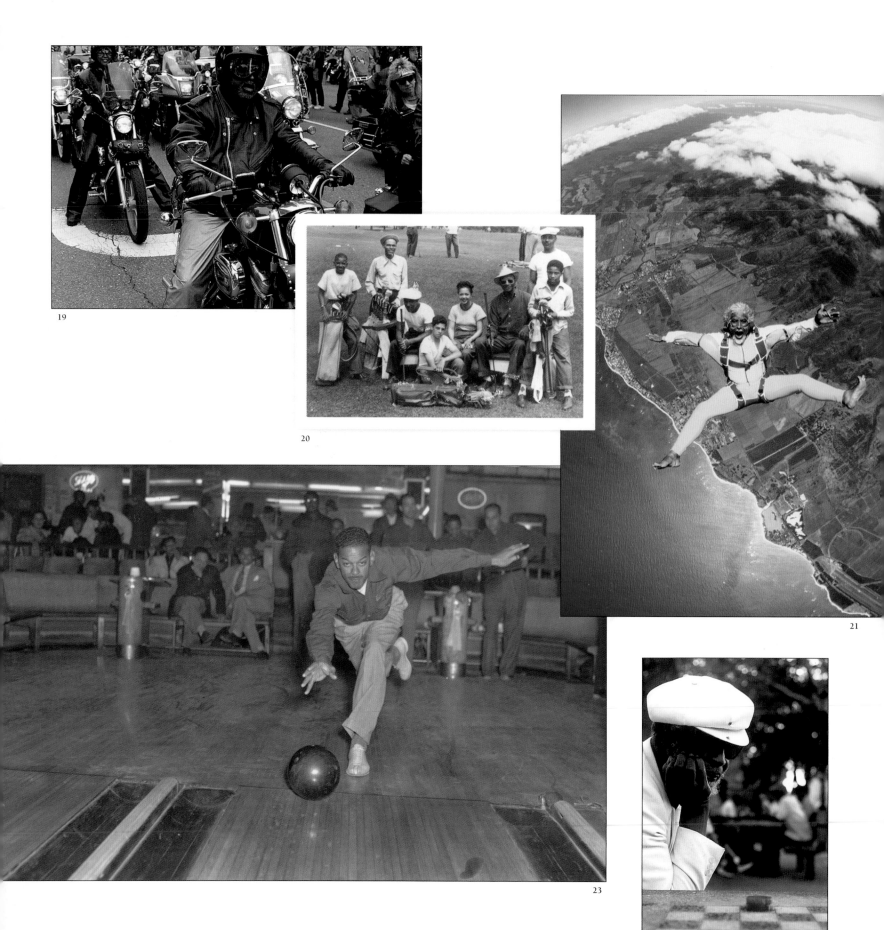

19. Weekend warriors. **20.** Weekend golf in St. Paul, MN. (ca. 1940s) **21.** Seeking thrills, by air or sea. **22.** Checking it out. **23.** Strike! A Harlem bowling alley. (ca.1950s)

24. Atlanta tennis camp. (ca. 1940s) **25.** Black cowboys of Nicodemus, KS. (1998) **26.** Harlem Horse Show, a benefit for the Urban League in the 1940s. **27.** New York Black Yankees vs. Philadelphia Stars during the Negro Leagues.

24

27

26

25

In the 1940s and fifties, African-Americans, seeking cool mountain air of the Catskills, in upstate New York, thronged the Peg Leg Bates Country Club, named for its owner, the well-known entertainer. In New Jersey, folks gathered at Cape May on the coast of the Garden State. On the west coast, blacks vacationed in the community of Lake Elsinore, CA, a cluster of private houses thirty miles inland from Laguna Beach.

Special travel guides informed African-American vacationers of the extent of services and facilities available. *The Traveler's Green Book*, began publication in 1936, and offered assured protection to the Negro traveler by listing motels, hotels, private homes, and inns open to black guests. As late as the mid-1960s, *The Green Book* was still printed.

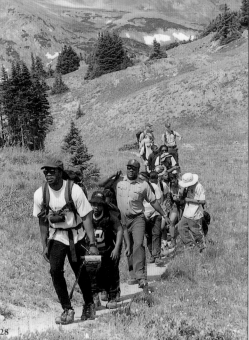
28

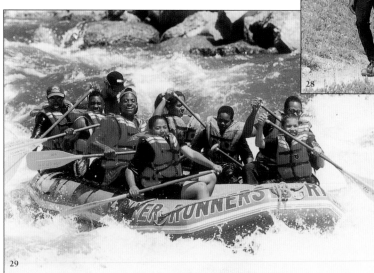
29

Today, "Highland Beach is one of three still thriving African-American resorts, all on the Eastern seaboard. Like Highland, the other two, Sag Harbor on Long Island and Oak Bluffs on Martha's Vineyard, have long served as popular vacation spots for blacks."

Tucked between Bridgehampton and East Hampton, Sag Harbor has offered "a safe, wholesome environment for

African-American families since the turn of the century, when blacks first arrived to work in the fishing industry." Presently, the town retains the same simple charm of yesteryear. About 500 summer residents play in Sag Harbor Hills, Azurest, Ninevah Beach, Chatfield Hills and Hillcrest Terrace. Sag Harbor was a favorite destination of *Our World* readers. The magazine breathlessly recorded on this "fast growing resort community," which catered to "the Eastern Seaboard's ultra set; a quaint history-loaded relic." Sag Harbor, *Our World* noted, was unlike other resorts. Homes there, were not "the sparse, come-and-rough-it quality of country homes," but filled with "glistening furniture, classy decorations, deep-freezes, and electric ranges."

Whether in *Ebony*, *Our World*, or *Sepia*, readers knew the couples, famous and not so, who "summered" and dwelled in these resorts. *Our World* noted that "Mr. and Mrs. Bill Pickens (she was former national president of Jack and Jill Clubs) formed the Sag Harbor Hill Improvement Association, which planned to protect their property and make Sag Harbor the top resort community in the country."

On the other side of the ultra set was Atlantic City, where *Ebony* noted that June through October, "entertained upwards of 50,000 vacationers on a dizzying round the clock whirl. Whereas the Inkwell at Oak Bluffs, Martha's Vineyard and Sag Harbor were noted for their pristine beaches, Atlantic City was crowded, cluttered, egalitarian, and fun." Atlantic City is many things to many people. A

28. The James P. Beckwourth Mountain Club goes hiking. **29.** White water rafting adventures.

cross section of the visitors, who pour into the resort via train, plane, bus and auto, will show every breed, from choirboys and Sunday school teachers, to numbers barons and professional con men. Shrewdly, dollar-wise business-men have tailored attraction that appeal to no one and all. And while Sag Harbor and Oak Bluffs were places that could be exclusive for the yacht and Cadillac set, Atlantic City was a place for everyone to let down their hair. Though giving way slighty to Oak Bluffs and Cape Cod in Massachusetts, and a few spas along the Long Island shore, any weekend could find a large gathering of the big city, big-moneyed crowd soaking up sunshine on Atlantic City's beach by day. By night their luxurious cars were pulled up alongside the resort's nationally-famous nightclubs, while they sipped $1.50 high-balls until the sun lifted itself out of the ocean.

Several resorts fell victim to natural and man-made disasters, mostly financial, including Idlewild, American Beach and Sea Breeze. Today, American Beach is not on the map. One day on American Beach, MaVynee Betsch, its most famous resi-dent, was approached by a white woman out on her jaunt from a neighboring resort who said to her, in an apparent effort to be helpful, "Why don't you people clean this place up?" "Lady," MaVynee shot back, "I've been to Athens and I've been to Rome. You have your ruins. These are ours."

Seabreeze was a part of Carolina Beach which we grew up hearing stories of along with White Lake, a popu-lar destination for church groups. Eventually, I made it to

30. Janice Marshall in Telluride, CO.

Carolina Beach as a sophomore in college. But for our entire family, our favorite vacation destination was far from a resort. Skeeter Lake is nestled near the Lumbee River, named after the Lumbee tribe of Native Americans, who called the land home. The lake was known for a persistent population of mosquitoes. On weekends, family and friends would pack fried chicken, luncheon meat, bologna, and pimento cheese sandwiches, and assorted candy for our trip to Skeeter Lake. Once there, we would have fish fries or barbeques. When my parents were children, Skeeter Lake was the site of a chicken bog, where two or three whole chickens were placed in a huge black cauldron with water, rice, and spices. Some of the adults washed the meal down with White Lightning, or "creek liquor." Over the years Skeeter Lake sustained erosion. Whenever we swam or played, we were always warned about deep spots in the water, which was black and deep. One summer, as everyone from my family splashed in the water, my cousin Wilton wandered away from us, and was caught in a current. We were maybe twelve, if not younger. My cousin "Boop," who was our age, watched as everyone panicked. He shouted for all of us to form a human chain with our hands to break the current, which would bring Wilt back to us. And we did. Or most of us did. We all joined hands. The sight of black, brown, yellow, and red faces; men, women, and tall chil-dren, holding hands, bringing my cousin back to us, left an important impression on me of the power that we create, when we work together. And it involved my favorite diver-sion, gathering with family on a cool summer day.

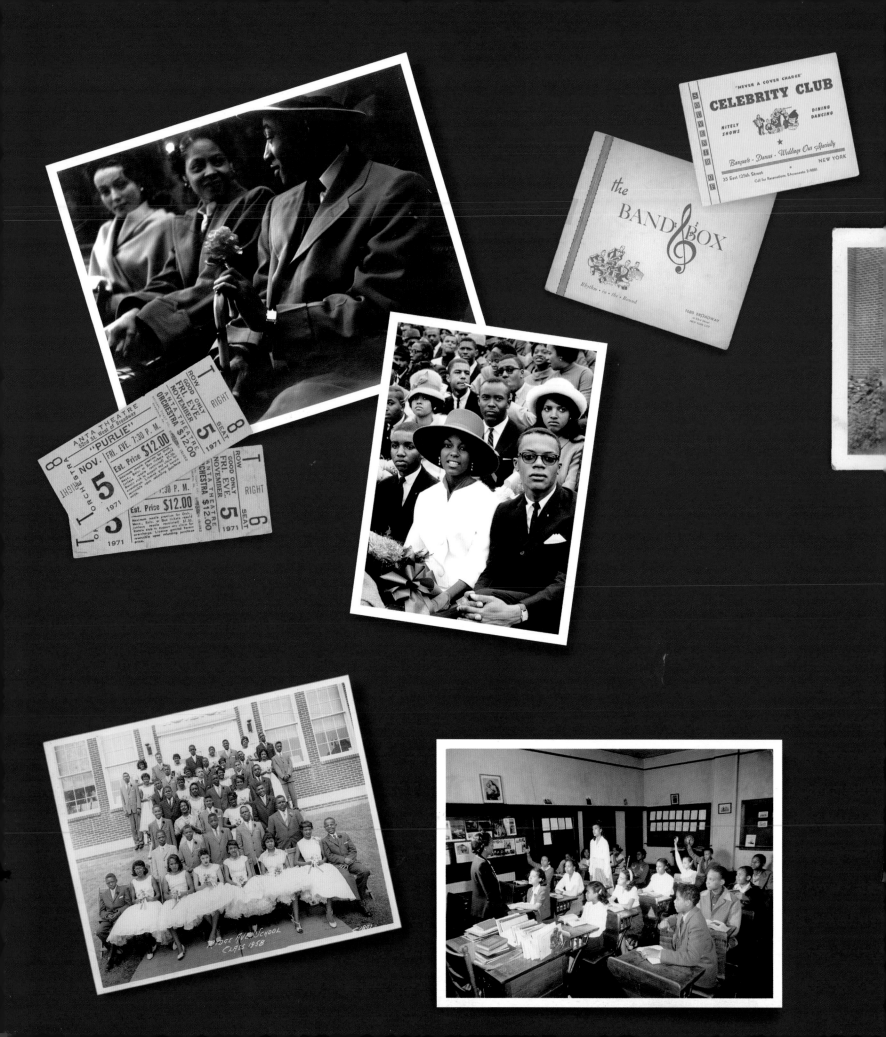

COMMUNITY

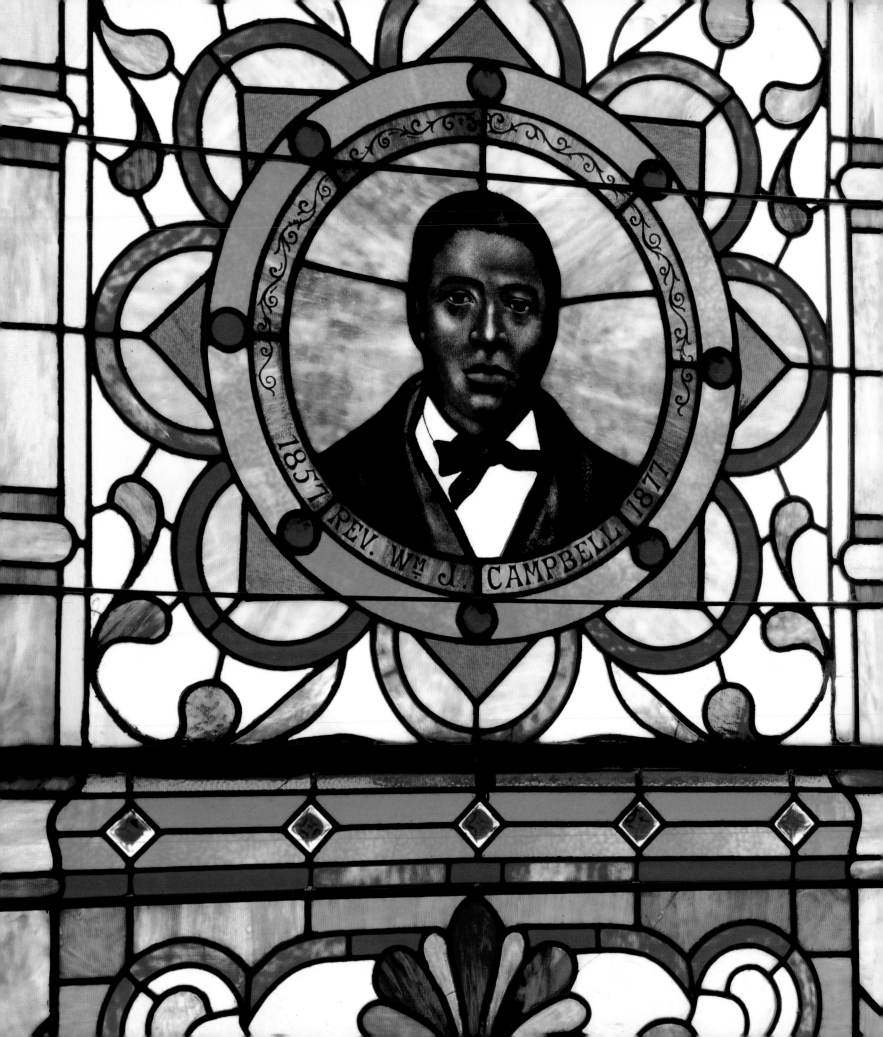

1851 REV. Wᴹ J. CAMPBELL 1871

WORSHIP

The church of my childhood is where I first, before birth, encountered my beloved community. I heard singing! The simplicity and sweetness of this structure, and the warmth of the human relationships fashioned within its walls and yard, have influenced every aspect of my life.

—ALICE WALKER

COME AS YOU ARE. And we do. Mighty and weak, loud and private, triumphant and conquered, we pour into houses of worship in cities and counties, near and far. We come for salvation against sin and for solutions to life's challenges, for music from our peers and for fellowship.

Nowadays, when an R&B singer such as Aretha Franklin or contemporary gospel star such as Kirk Franklin shouts, "It's time to go to church," the first vision that springs to mind for some folks is a holy-roller experience, complete with tambourines and washboards as background music.

But those folks who grew up in the "chutch" know that worship is more than preaching and singing. For some folks, church includes Sunday school, afternoon service, evening service, Bible study, Wednesday prayer service, and revival. For others, it's a mosque or moments of silence at home. No matter where church is, it's a sacred place in the hearts of most of us.

As James Traub concluded in "The Ascension of Deacon Olive" written for the New York *Times* magazine, while "blacks are not, as a group, more religious as whites, they are more 'churched'—more strongly affiliated with a denomination and a specific church." Indeed, in large cities, where storefront churches and grand cathedrals such as Abyssinian Baptist Church in Harlem coexist, "the church is often the only thriving and stable institution around— and certainly the only one that members feel they control, and responds to their wishes."

From our earliest days as Americans, the church has always been the backbone of our community. Is it any wonder? The church defines us. It is the place where we are baptized, married, and buried. It is a sacrosanct place that not only gives us our voices but allows us to use those

voices as speakers and singers, as leaders and laymen. For black folks, the church occupies a central, irreplaceable space in our lives.

"Traditionally, the black church has been a place where people who endure all kinds of insults at their station in life during the week can come and feel a sense of somebody-ness," says Rev. Raphael Wanock, assistant pastor at Abyssinian. "It is a place where their voices can be heard and where they count." Moreover, he says, "the

position of head usher or chairman of the deacon board or the president of a club or choir or auxiliary has meant more within the context of the black church than it might mean to the mainstream of society."

1. First Holy Communion. (ca. 1960s)

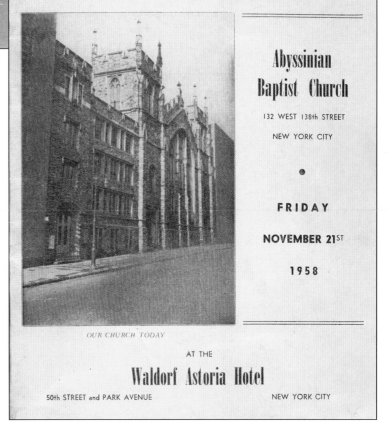

No matter where I am, if I'm in a city for a few days, I have to find a church. Whether I am in a quiet church, where the preacher speaks in a whisper, or in a holy-roller church, where the drums often drown out the choir, when I am in a church, I am at home. And there's always company. As Hamil R. Harris keenly observed in *Emerge*, at the end of the millennium, church attendance is at an all-time high: "Full Gospel African Methodist Episcopal (AME) Zion Church in Temple Hills, MD., has 21,000 members, West Angeles Church of God in Christ in Los Angeles, 15,000 members, the non-denominational Word of Faith

2. Storefront Baptist church: saving souls in the city. 3. Salute to Adam Clayton Powell at Abyssinian Baptist Church.

1808 1958

Sesquicentennial Celebration
and Salute to Dr. A. Clayton Powell

Abyssinian
Baptist Church

132 WEST 138th STREET
NEW YORK CITY

•

FRIDAY

NOVEMBER 21ST

1958

OUR CHURCH TODAY

AT THE

Waldorf Astoria Hotel

50th STREET and PARK AVENUE NEW YORK CITY

4. Interior of First African Baptist Church, built by 18th-century slaves in Savannah, GA. 5. "Come and go with me to my father's house." 6. Parishioner in his Sunday best.

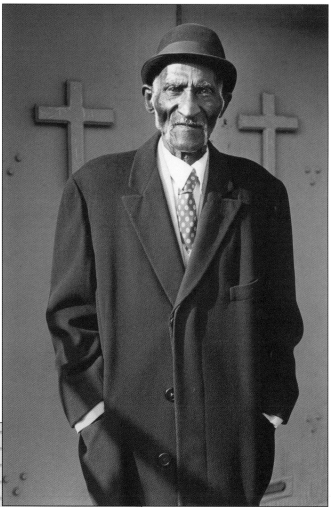

6

5

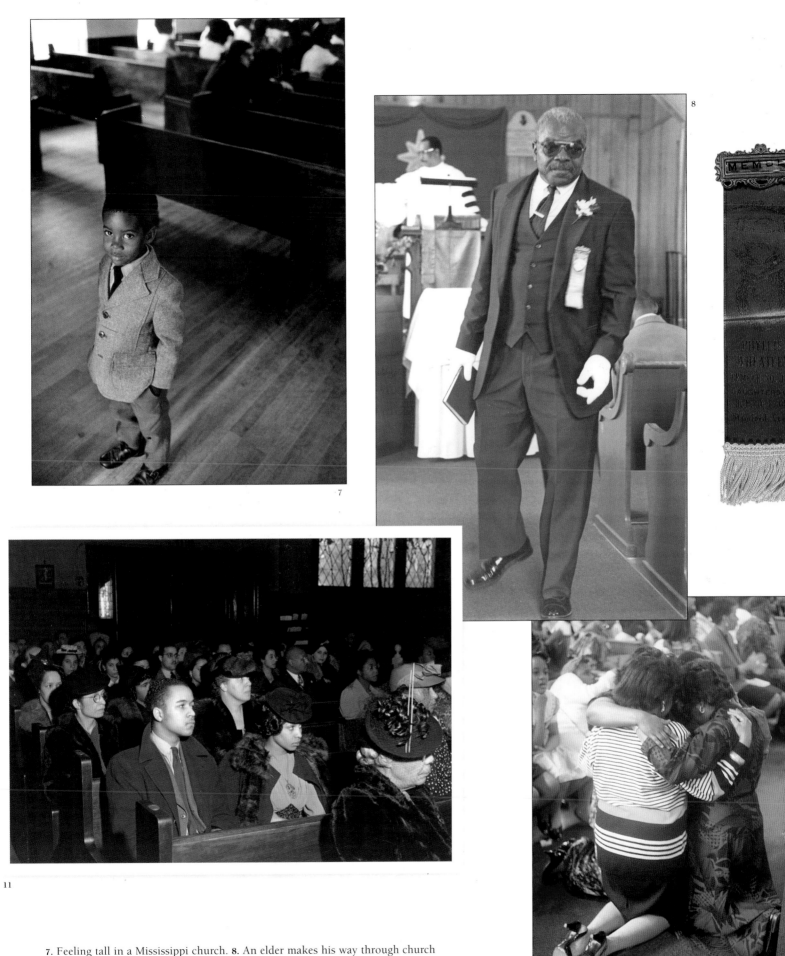

7. Feeling tall in a Mississippi church. **8.** An elder makes his way through church service. **9.** An usher tag. **10.** Women kneeling in a prayer circle. **11.** Church service during the war: we have so much to thank the Lord for.

International Christian Center in Redford Township, MI, 12,000 members, Bethel AME in Baltimore, 11,400 members, Windsor Village United Methodist Church in Houston, 10,200, and Crenshaw Christian Center in Los Angeles, 6,191."

When I miss church service, I know that I missed something important: the recognition of a member's anniversary, the thrill of a young person's first solo, or the pastor's sharp criticism of the hypocrisy that often rears its head throughout the congregation. I admire the ushers, standing tall against stained-glass windows, looking too serious in their starched white uniforms and gloves. I look at church hats in amazement, yellow, purple, pink and orange—they defy gravity. I dance to the music: "Come and Go with Me to My Father's House," "Oh, Happy Day," and "Great Is Thy Faithfulness." I love seeing families together, holding hands in prayer. I cherish the sounds of church: old folks clearing their throats or peeling back a mint wrapper, folks whispering their prayers under their breath, and the organist's underscoring the pastor's sermon. When I am not present, I miss that warm feeling of community, of being with folks who, like me, come to hear testimonies and bear witness.

It wasn't always that way. In fact, as a young child, like many, I was far from devoted to the church. In our house, church actually started on Saturday evening, where my mother scrubbed and scraped my and my three sibling's skin. We were whisked out of the tub like products on an assembly line, into the arms of our father, who trimmed our hair and nails. It was a noisy ritual, with the opening and shutting of doors and closets as we searched for missing shoes and matching socks. If we had to read a passage in church, or if my brother had to play a piano recital, there were endless rehearsals. "Uh-uh, do it again"/ "Say it with meaning"/ "Now, you know you can do better than that." By the time Sunday morning rolled around, we woke to several scents competing with one another in the kitchen. There was the big breakfast on the stove, as well as the grand after-service supper in the oven, which were accompanied by ol' time gospel preaching and music playing on the stereo. My father was partial to the sermons of Rev. C. L. Franklin, while my mother adored Mahalia Jackson.

We were in another place altogether. Sniffing the rolls rising, fried chicken and ham, the macaroni-and-cheese and the yams, the words to all that we had rehearsed left our minds and were replaced by the largest biscuit on the planet. We ate our breakfast in T-shirts to make sure that we didn't get jelly on our clothes. My mother and father clipped on our ties, stuffed us into our shoes, and off we went to join people who, in my young mind, looked like family, but weren't, in what seemed like the longest service on earth, but wasn't. At the time, I thought the speeches were endless. It seemed everyone had something to say. There was a Treasurer's Report, a Visitor's Welcome, a Special Announcement, and a deacon asking

12. Gospel great Mahalia Jackson featured on a familiar church fan with an ad from Wainwright & Sons funeral parlor.

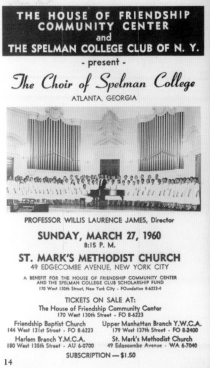

15

for cash offerings as opposed to checks to rebuke those "overdraft demons." And then there were the songs. Depending on the denomination, we could either be moved to tears, or put to sleep. To say the least, my mother was adventurous. At one time or another throughout our childhood, we attended Seventh-Day Adventist, African Methodical Episcopalian, Baptist, Methodist, Pentecostal, and Catholic services. Surprisingly, the effect was similar, mainly because Mom always involved us in a play or pageant, and no matter how awful we played our roles in a designated denomination, there was always some kind person to compliment us on a job well done.

As I grew, I began to understand the true meaning of church. Today, I see things in the church that I couldn't as a young child, mainly the pride in the faces of congregates,

14. The enormously popular Spelman Choir on tour. **15.** Lift every voice and sing. **16.** "We'll go sweeping through the city."

who have survived six days of obstacles, and for one day out of their lives, are gathering to simply say, "Thank you." Each Sunday, as the aromas of olive and Murphy's Oil furniture polish dance in my nose along with the pungent perfume and cologne from church members, I delight in the children's speeches at Easter, the Christmas pageants, the Youth Day Scholarship awards programs, and the Women's Day celebrations.

In church, we have our own holidays and anniversaries. Not a week goes by when we do not recognize Sister So-and-So's twenty-fifth year of

16

17. Hebrew service. (1939) 18. Image from a popular church calendar series. 19. Episcopalian procession in Harlem. 20. Elder Micheaux goes to the water.

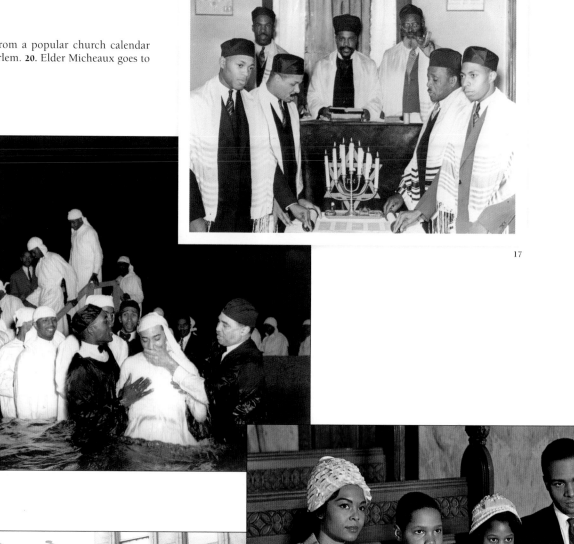

17

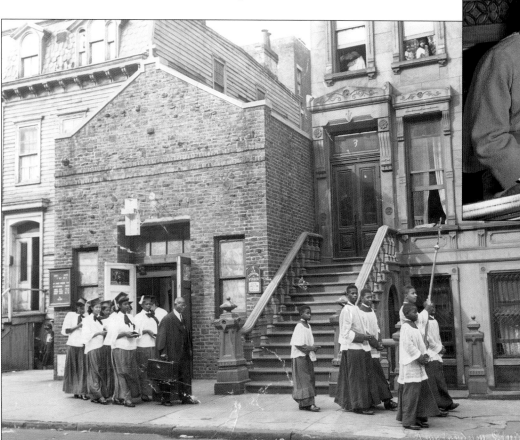

20

18

19

service or Deacon This-and-That's 50th year of wedded bliss. Back in the day, most adults were stern disciplinarians who made us dispose of our gum in their white-gloved hands, or spanked us if we laughed when someone was speaking. Today, I recognize that some of those women who never uttered a word at work, could speak with authority as the chairperson of the Welcome and Pastor's Aid Committees on Sunday. I have a deep respect for the men who may hold jobs at the bottom of the totem pole, but who are revered and called "deacons." Domestic workers who wear scarves on their heads can show off hats the size of flying saucers. The church is a place where we can name things. We are not choirs but rather the Voices of Triumph and the Celestial Singers. We can make a joyful noise. And we do.

This I know, as a member of Refuge Greene Avenue Church of Christ in Brooklyn. In an era of grand cathedrals and electronic halls of worship, our church is a throwback. We worship in a plain, white building. But, oh, the sounds of peace, prayer, and fellowship that come from this place. When I am away, I don't think anyone will take notice. But whenever I return to my seat on the back pew, Sister Alice (no last name is needed—that's what she'll tell you) will greet me during Offering Time, and say, gently, "I looked back there last Sunday. I didn't see you. We missed you."

And, as I kiss her cheek and hold her mighty hand, I'll say, with a smile, "I missed me, too."

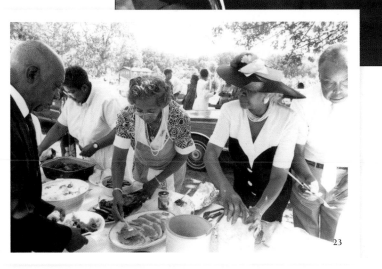

21. An elegant Easter procession. 22. Sunday morning, Fort Scott, KS. (ca. 1949) 23. After-church supper on a bright afternoon.

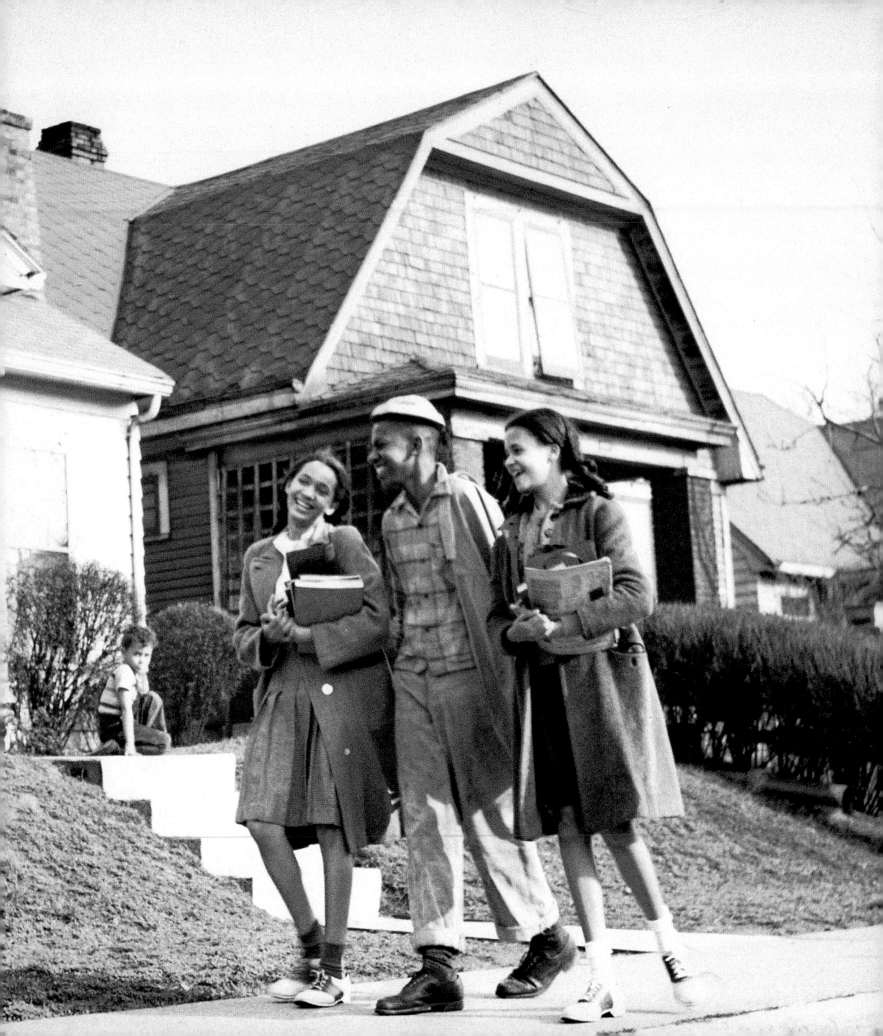

SCHOOL

EVERY MORNING AS she went to work in Mississippi to wash clothes, Oseola McCarty probably watched little children, holding rulers, paper-bag lunches, and a parent's or elder sibling's hands, march off to school, onto buses, or into cars. On a morning walk, she could see these small men and women, trotting, singing, in uniforms or hand-me-downs. Many were still in an imaginary world of fire engines and fairy tales. Their bright, spirited eyes looked forward; their heads, weighed down by barrettes, braids, or a baseball cap, looked upward. Did she see a parent gently rub specks of oatmeal or grits from their child's sweet cheeks, bearing the scent of Ivory soap? Did she notice that once the parent planted a soft good-bye kiss on the child's cheek, that they wiped it with the back of their hand, that is, if one of their classmates caught this display of affection? Through rinse and soak cycles, did she hear the elder siblings rushing out of their houses—letter jackets, band instruments, and makeup bags in tow—heading into the halls of ultramodern or timeworn

Few people who were right in the midst of the scenes can form any exact idea of the intense desire which the people of my race showed for education. It was a whole race trying to go to school. Few were too young, and none too old to make the attempt to learn.

—BOOKER T. WASHINGTON

American high schools? Did she know that between chemistry exams and English pop quizzes that these young men and women would laugh and smile at football games, through the prom and graduation? They share their stories of teenage heartbreak, those discreet tears shed over lost football games, elections, and homecoming crowns. But not for long. The students would overcome their disappointments and peer pressure and would emerge as confident college students, ready to change the world. Certainly, McCarty hoped so. For more than seven decades, she saved her washerwoman's salary. And when she finally retired, she used her entire savings—more than one hundred thousand dollars—to establish a scholarship so that a young man or woman could attend college.

McCarty, who was not able to continue with school when she was young, understood what so many folks of her generation knew. Old folks, sitting on rocking chairs, on the front row of church pews, in supermarket checkout lines, will tell any young person willing to listen, "Education is the only way." Indeed, an education has long been seen as a means to an end. By opening our minds, we could close the gaps in poverty and inequalities that have plagued our people for generations.

We are making strides in education. Over the five years ending in 1996, the number of African-Americans earning higher degrees grew by 6.1 percent. In 1992, African-Americans received 132,270 degrees in higher education; in 1996, we received 167,931 degrees, an increase of 30 percent.

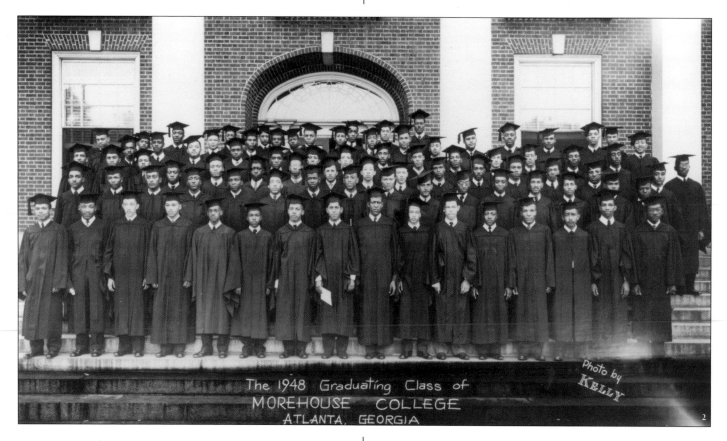

The 1948 Graduating Class of MOREHOUSE COLLEGE ATLANTA, GEORGIA

Photo by KELLY

Today, African-American professors and teachers, in the halls of the academy or kindergartens, continue to speak to eager, willing black minds. They are continuing a tradition—teacher to student—that has existed since the dawn of humanity. During enslavement, this practice was interrupted but not thwarted.

"There is one sin that slavery committed against me which I will never forgive: it robbed me of my education," once said a freed slave.

Due to the complex nature of racism and enslavement, it was unlawful for a slave to read or write. This is not to imply that all slaves could not read or write. However, in states that upheld enslavement, the majority of our ancestors could not read a newspaper or a statement of their ownership, a labor contract or an election ballot. They could not read a map, denying them an understanding of the land they inhabited. They could not read their children's names, or could not understand any of their vital statistics. Runaway slaves could not read their own "Wanted" posters.

If slaves were found reading, "they were punished with sixty or more lashes or their forefinger was cut off. In a few cases, slaves found reading or teaching other slaves to read were beaten to death." Still, literate slaves organized "steal the meetin'" gatherings. Deep in the night, after they'd labored all day under a brutal sun, they clumped together in slave quarters, where they shared every piece of knowledge that they'd collected with their brethren.

So deep was their desire to learn that by the end of the Civil War, "slaves and free persons of color had already begun to make plans for the systematic instruction of the illiterate through early black schools, which were established and supported largely through Afro-American efforts."

1. An elegant high school graduate. (ca 1930s) 2. Moorehouse Class of 1948, including Dr. Martin Luther King, Jr., [first row, left].

3. Young, gifted and black: the Class of 1945. 4. Graduation Day in Ocean Grove, NJ. (1993) 5. Nursery school graduation. (1964) 6. To sir with love: Mr. James Terrell of Whitesville School, Neptune, NJ.

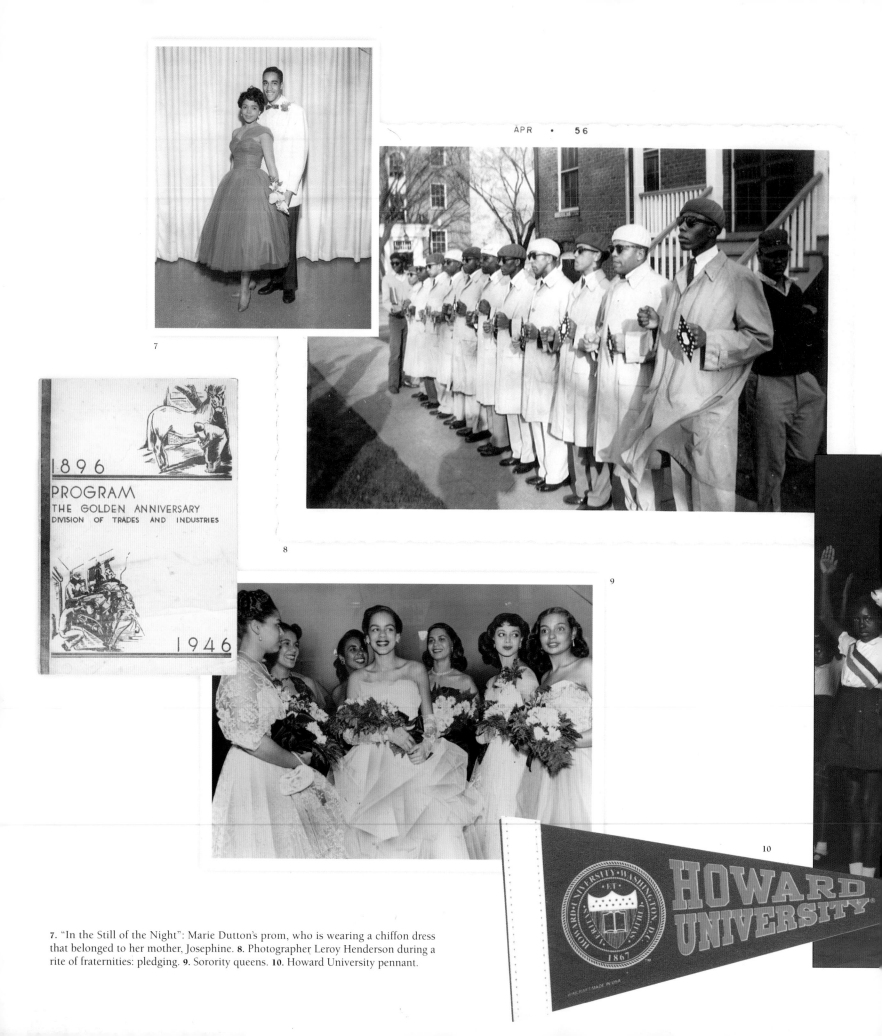

APR · 56

1896

PROGRAM
THE GOLDEN ANNIVERSARY
DIVISION OF TRADES AND INDUSTRIES

1946

7. "In the Still of the Night": Marie Dutton's prom, who is wearing a chiffon dress that belonged to her mother, Josephine. 8. Photographer Leroy Henderson during a rite of fraternities: pledging. 9. Sorority queens. 10. Howard University pennant.

11. And the band played on—young boys pose with instruments. **12.** Majorettes in Clarksdale, MS. (1954) **13.** Tuskegee Military Band. (ca. 1940s) **14.** World War II pep rally—victory through good health.

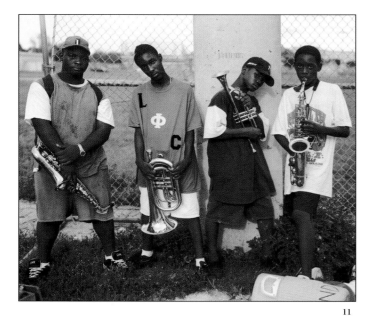

11

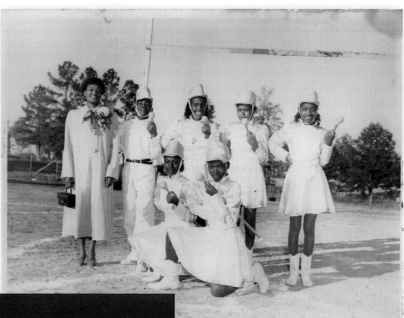

12

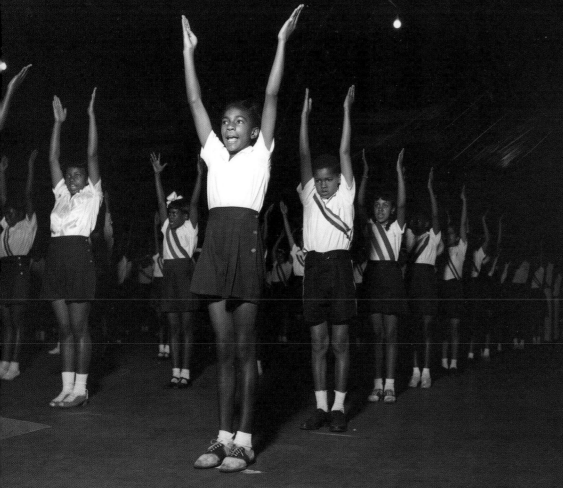

14

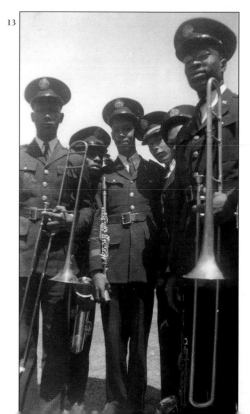

13

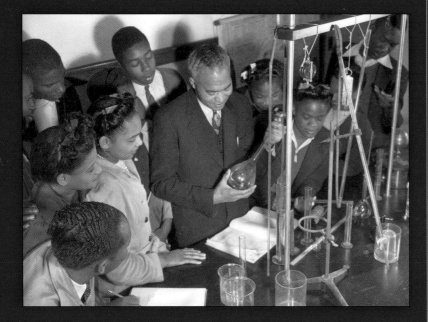

While most of our teachers did not stand up for children in the white world where they felt disenfranchised and on which they depended, many of them tried to compensate by giving each black child personal attention. They helped ground us in our history and culture through daily singing of the Negro National Anthem by James Weldon Johnson and his brother Rosamond. We memorized "Lift Every Voice and Sing," and oratorical contests in which we memorized and recited the song before the class (the winners recited before the whole school community). We also recited speeches by black historical figures and they brought in black speakers like Langston Hughes and other achievers to inspire us and to let us know we could go higher. They expected us to achieve and we did. Some served as our Sunday school teachers and were in and out of our homes on a regular basis. Today many teachers do not know the parents of the children they teach, visit their homes, or even live in the school district.

—Marian Wright Edelman

An education movement began early in the North. In 1820, separate schools for black children were introduced in Boston. Four years later, African Free Schools were established in New York. Schooling was not limited to elementary schools. In 1834, the Presbyterian Church introduced Ashmun Institute, which would later become Lincoln University in Pennsylvania. And while "Ohio (originally) excluded blacks from attending schools in 1829, they reversed that decision in 1855, when Methodist Episcopal Church launched Wilberforce University."

After the Civil War, Congress created the Bureau of Refugees, Freedmen and Abandoned Lands, or the Freedmen's Bureau, "which achieved its greatest success in education. Among the schools founded in this period that received aid from the bureau were Howard University, Hampton Institute, St. Augustine's College, Atlanta University, Fisk University, Storer College, and Biddel Memorial Institute (now Johnson C. Smith University.)"

The Freedmen's Bureau was met with disdain by belligerent southerners who were opposed to freed slaves having any rights whatsoever, especially education. "Besides their long held belief that slaves and their descendants were second-class citizens, southern planters and entrepreneurs had other ulterior motives for their opposition to universal public education: any schooling would remove children from the labor force, which would severely affect their bottom line."

As freed slaves gathered in makeshift schools across the country, their opponents retaliated by "evicting parents who allowed their children to go to school." Landlords refused to rent to white teachers who taught black children.

Sensing a momentum in black education and fearing that white and black children would have equal education, opponents to universal public education took their argument for keeping blacks out of white schools to the Supreme Court.

The Supreme Court dealt a blow to public education for blacks with the *Plessy v. Ferguson* decision of 1896, which "allowed states to establish racial segregation only if the accommodations and facilities in public institutions were equal." In a sense, the Supreme Court issued approval of separate schools for black and white children.

So, at the beginning of the twentieth century, "nearly two-thirds of black children of elementary school age were not enrolled in school, primarily because there were not enough school buildings or seating capacity to accommodate the majority of these children."

Dr. Charlotte Hawkins Brown founded the Alice Freeman Palmer Memorial Institute, a rigid school for young black women in Sedalia, North Carolina, in 1902. Two years later, Mary McLeod-Bethune, a generation

18. Mary McLeod-Bethune thanks a "supporter" of Bethune-Cookman College. 19. Flyer from George Washington Carver School.

removed from enslavement, founded the Daytona Educational and Industrial Institute for Girls. Bethune, who would become a member of Franklin Delano Roosevelt's "Black Cabinet," as well as start Bethune-Cookman College in Daytona, wanted to be a missionary. She wanted to travel to Africa but was rejected because of

crowded boxes that lacked indoor plumbing. Students came from all over the county, some walking up to five miles a day, after having worked in the fields, to attend these schools. These students subscribed to the motto of the postal service: neither rain, nor sleet, nor snow kept them from school.

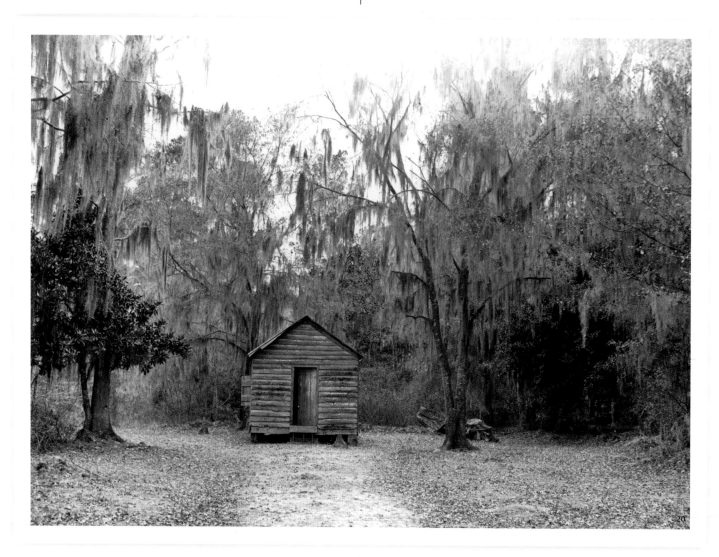

her race. Instead, she looked across the landscape and understood that there were black children in America—black children who needed an education.

"Long after common schools had become universal for other American schoolchildren," young black children had to make do in small country schoolhouses, two-teacher buildings where teachers taught several grades in over-

Financing for the schools came from the community, which raised money through concerts or community meetings where folks put their last penny into cigar, snuff and shoe boxes to ensure that their children would receive an education. Countless schools were built by hand.

20. One-room school: Summerville, SC.

"Men went into woods, cut down trees, hauled them to the saw mill and had them cut into lumber. Others cleared away the grounds, and even women worked, carrying water, and feeding the men while they labored."

Disciples of Booker T. Washington, founder of the Tuskegee Institute, arguably one of the most influential (if not complex) black educators, carried schoolbooks and lesson plans on the back of mules. They boarded trains throughout the south and broke ground on "normal" institutes of learning. In 1909, nine Washington disciples began the Laurinburg Institute in my hometown, Laurinburg, North Carolina.

21. The interior of a negro school in Haard County, GA. **22.** Postcard mailed from Tuskegee Institute. **23.** One-way train ticket to Tuskegee. (ca. 1940s)

Not long after World War II, fortified from the enormous wealth that was pumped into the American economy, sparkling new elementary and high schools began to anchor city blocks. In adherence to *Plessy v. Ferguson*, these schools were mainly segregated: No Blacks Allowed.

federal and local dollars were spent, were made by white folks who ran the towns.

The white schools received brand new books, pencils, and gym equipment. Black students not only had to share pencils and pens, but they were given discarded textbooks

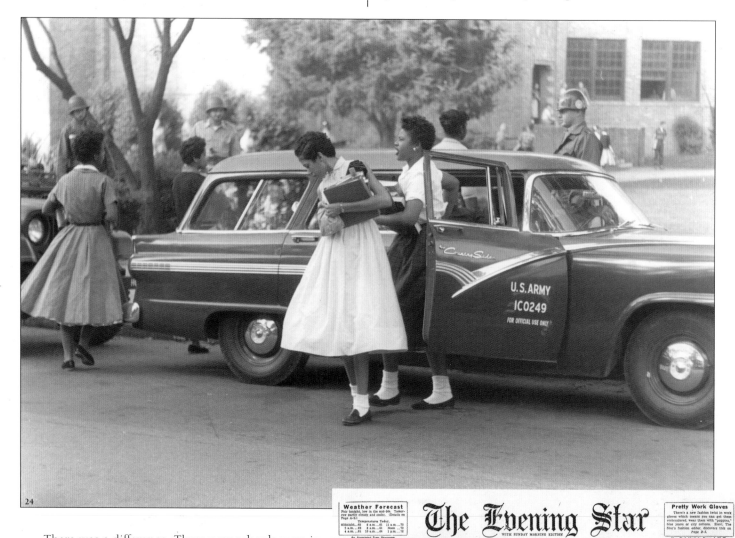

High Court Voids School Segregation; Upsets 'Separate But Equal' Doctrine

There was a difference. These new schools were in white neighborhoods. Meanwhile, schools in black neighborhoods continued to deteriorate. Options for black parents in the rural South were reduced to none. They could not vote in general elections (they were asked to read the Declaration of Independence on election day; many were illiterate); the distribution of power, and how

with pages missing. There was seldom any new gym equipment. During the winter, students wore coats in class, teeth clattering, noses running, due to inadequate heating.

Who knows how long these conditions would have continued had the Supreme Court not unanimously ruled

24. A few of the Little Rock Nine with a federal escort to Central High. (1957) **25.** victory in high places: *Brown v. Board of Education* headline.

Elizabeth Eckford on her first day of school at Little Rock:

I CAUGHT THE BUS and got off a block from the school. I saw a large crowd of people standing across the street from the soldiers guarding Central. As I walked on, the crowd suddenly got very quiet. Superintendent Blossom had told us to enter by the front door. I looked at all the people and thought, "Maybe I will be safer if I walked down the block to the front entrance behind the guards."

At the corner, I tried to pass through the long line of guards around the school so as to enter behind the grounds behind them. One of the guards pointed across the street. So I pointed in the same direction—and asked whether he meant for me to cross the street and walk down. He nodded "yes" so I walked across the street, then someone shouted, "Here she comes, get ready." I moved away from the crowd on the sidewalk and into the street. If a mob came at me, I could then cross back over so the guards could protect me.

The crowd moved in closer and then began to follow me, calling me names. I still wasn't afraid. Just a little bit nervous. Then my knees began to shake all of a sudden, and I wondered whether I could make it to the center entrance a block away. It was the longest block I ever walked in my whole life.

Even so, I still wasn't too scared, because all the time I kept thinking that the guards would protect me. When I got to the front of the school, I went straight up to a guard again. But this time he just looked straight ahead and didn't move to let me pass him. I didn't know what to do.

Then I looked and saw that the path leading to the front entrance was a little further ahead. So I walked until I was right in front of the path to the front door. I stood looking at the school—it looked so big. Just then the guards let some white students through.

The crowd was quiet. I guess they were waiting to see what was going to happen. When I was able to steady my knees, I walked up to the guard who had let the white students in. He didn't move. When I tried to squeeze past him, he raised his bayonet, and then the other guards moved in, and they raised their bayonets.

They glared at me with a mean look, and I was very frightened and didn't know what to do. I turned around, and the crowd came toward me. They moved closer and closer.

I tried to see a friendly face somewhere in the mob— somebody who maybe would help. I looked into the face of an old woman, but when I looked at her again, she spat on me.

I turned back to the guards, but their faces told me I wouldn't get any help from them. Then I looked down the block and saw a bench at the bus stop. I thought, "If I can only get there, I will be safe." I don't know why the bench seemed a safe place to me, but I started walking toward it. I tried to close my mind to what they were shouting, and kept saying to myself, "If I can only make it to the bench, I will be safe."

When I finally got there, I don't think I could have gone another step. I sat down, and the mob hollered, "Drag her over to this tree!" Just then a white man sat down beside me, put his arm around me, and patted my shoulder. He raised my chin and said, "Don't let them see you cry."

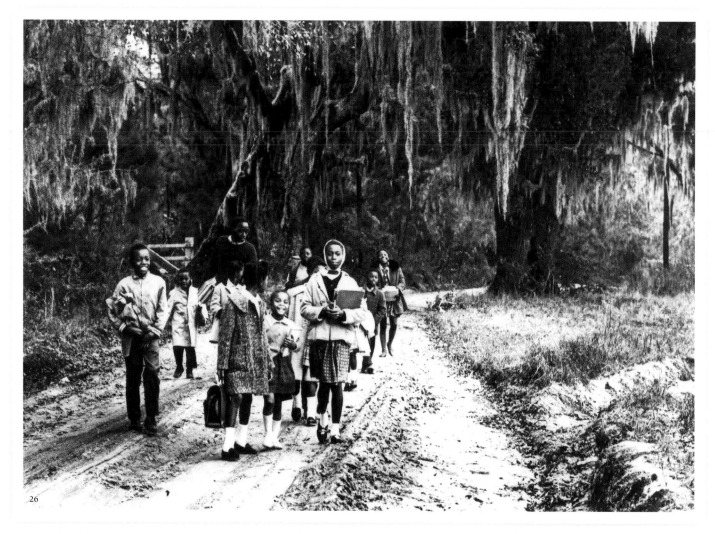

26

on May 17, 1954, that segregated educational facilities were inherently unequal in the landmark case *Brown v. Board of Education* of Topeka, Kansas, which overturned *Plessy v. Ferguson.* Three years later, nine gifted and talented young black children integrated Central High School in Little Rock, AR. When they were denied access to the school by Arkansas Governor Orval Faubus, General Eisenhower ordered federal troops to escort the children to school. Five years later, President Kennedy was forced to send army troops to Oxford, Mississippi, after a full-scale riot ensued among a white mob when James Meredith attempted to integrate Ole Mississippi.

Once integration of public schools was recognized by administrators and politicians, school busing, or the trans-

port of black and white children from one school to another created another national crisis. Although the media often concentrated on the reaction of bitter white parents who were opposed to sending their children to black neighborhoods, or to receive "colored" children into their schools, in black homes across the country, parents were concerned about the effects of busing on our neighborhood schools. Many of our best students and teachers were bused to schools outside our community, which left our schools without some of our best and brightest star instructors and young leaders. When local Scotland High School integrated in the late 1960s and early 1970s, I can recall several

26. The long walk home on the Sea Islands.

neighbors refusing to send their children to the high school, "on principle."

While the national debate concerning busing raged on—noise in our ears—we trudged through pine trees, and mud puddles on our dirt roads to school, where, for a time, most of our teachers were black, as was the student body and our assistant principal.

Our teachers appeared tall. They mostly wore glasses with chains, and we thought them incredibly smart. Their clothes were so clean that it took a moment for our eyes to recover. They were never late, never absent. I don't remember having a substitute. Our teachers pushed us—physically and mentally—to do well. They applauded us at talent shows, and congratulated us with awards at assembly. They could be stern. They didn't play. If we got

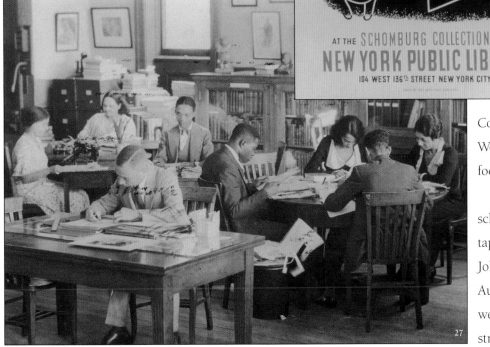

out of hand, we were taken to the assistant principal's office and paddled. This didn't change when white students were bused into our school from the east side of town. There were a few Native Americans who already attended our

school, but this would be the first time that many white kids were coming. They were supposed to come on a bus, although most of their parents brought them to school in cars. When they came into I. Ellis Johnson, our teachers did not call on us any more or less; they yelled at us and at them when they misbehaved. They, too, received paddlings.

Life went on. I would bypass the front page of the *Charlotte Observer*, which contained bitter headlines about busing, wondering what was the big deal. I was far more interested in more important matters: would the Wile E. Coyote ever catch the Road Runner? Would Charlie Brown ever kick that football from the heartless Lucy?

Every year, on the day before school, our administrators clumsily taped our "roll call" on the entrance of Johnson. On the third Sunday in August, we could discover which class we would spend a year with by taking a stroll up the street. Many of us had sleepless nights—would we be in the class with the bully who terrorized us through seventh grade? Would that

27. Serious studying: a Harlem library.

special girl or boy be in our class, the one we'd had a crush on since preschool but could never articulate it, beside little punches and giggles—would he or she finally be in our class? Ever the overachiever, I was consumed with my placement. Although our teachers went through great pains to try to shield us from the cruelties of the world, we knew that some children were smart and others were not. No one strived for the slow class, as it was

DeBerry, Milton Dockery, Todd Harrell, Raymond Leak, Renee McLeod, Ronnie Monroe, Renee Murphy, Sheila Pegues, and John Williamson, I almost floated home. On top of it, I recall that Joyce Harrington rotated to our class

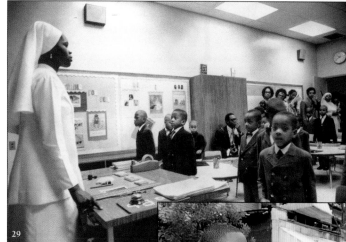

after recess. In my mind, these were the coolest black, brown, and beige faces, in their own way, in the history of the eighth grade. And leading us was Mrs. Alford, who would later show up at my parent's house and tell my mother that I was showing off in class. Not only did she not appreciate it, but it was unnecessary for a young man with such potential.

Every day of the eighth grade was interesting, filled with fun. The eighth grade was the moment when everything came together for me—the seeds of a writing career (I dreamed of being a critic) were

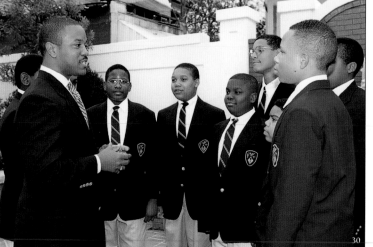

called. The seventh grade had not been my year. Math threw me off, and I daydreamed it away. Would I end up in the slow class? I walked to the class as if it were the green mile—when I looked up and realized that I would be in a class that included, among others, Ursula Brown, Vickie Chavis, Dwayne Clark, Dennis

planted, and I finally, finally, scored a basket in an intramural ballgame. It was akin to Charlie Brown's kicking the football from Lucy. And I realized the importance of staying in school, despite the temptations and frustrations that

28. Louis Martin celebrates with his family—all college graduates in the 1950s. 29. First-level mathematics at a Muslim school. 30. Young Leader's Academy of Baton Rouge, LA.

can trip us up, and make us fall off course. This was the last class that I would attend with this large a number of black folks, ever. In high school, I saw their faces on occasion. We spoke and remained friendly. Most of us went off to college, some of us completed undergraduate, and postgraduate courses, indeed, Milton Dockery is now a history professor.

Always in the back of my mind were stories of my mother and father having to walk five miles every morning to school. I thought this was plausible for my father, but my mother lived around the corner from I. Ellis Johnson, so I wondered why she had taken the long road to and from school. I imagined them walking to school in another era; perhaps a hundred years ago. I discovered just how close my parents' fight to attend school was to me while watching television on a lazy Saturday.

My family was devoted to reality television—especially *Mutual of Omaha's Wild Kingdom* (poor Jim!). Anything on a soundstage was anathema to them. My brother was watching a documentary about busing. There were young kids who looked like us—afros, bell-bottoms, V-neck sweaters, afro picks in back pockets—riding a yellow school bus, that was being struck by bricks and bottles. It was the first time that I had heard racial epithets minus the Southern twang. This was Boston, and these red-faced mothers and fathers were angry. The film dissolved from color into black and white. There were nine clean-cut black young men and women surrounded by a tall, attractive woman, Daisy Bates. The

film went into fast focus and settled into an episode that is forever etched into my memory.

First, a black man, a reporter, tall, lanky, well-dressed, was kicked, spat at, and punched by a crowd of suburban white southerners, both young people and adults. In a quick cut, the camera settled on a young black girl dressed in a white and gingham dress, white socks, and flat shoes. She was carrying a blue cloth notebook that was pressed to her chest. She had short hair that was pressed, and a tiny waist. She was wearing shades.

On a serene day without a cloud in sight, underneath blooming trees, on a suburban street, she walked, with a crowd of young men and women screaming, jeering, and yelling at her. Based on their clothes I could tell that this was the 1950s. The crowd continued to grow. It looked like a scene out of *The Blob*, but this was not a cheesy movie; it was a real-life horror story. I was stunned. My mother sat down quietly and told me that the episode I was watching happened just two decades or so ago. She explained the sacrifices that were made on my behalf, and why it was important to stay in school. Years later, I learned the young woman's name (Elizabeth Eckford—see the sidebar), as well as the gentleman's (Alex Wilson, a reporter for the *Memphis Tri-State Defender*).

Those separate incidents—a reporter being attacked for exposing the truth, a student being attacked by a mob for attempting to attend school—congealed in my mind. One could be attacked for writing, exposing the truth, and attempting to integrate a school. It would greatly impact my life—my decision to write and stay in school.

31

31. *Julia*, a popular 60s sitcom starring Diahann Carrol, receives the highest compliment a student can pay: a lunchbox.

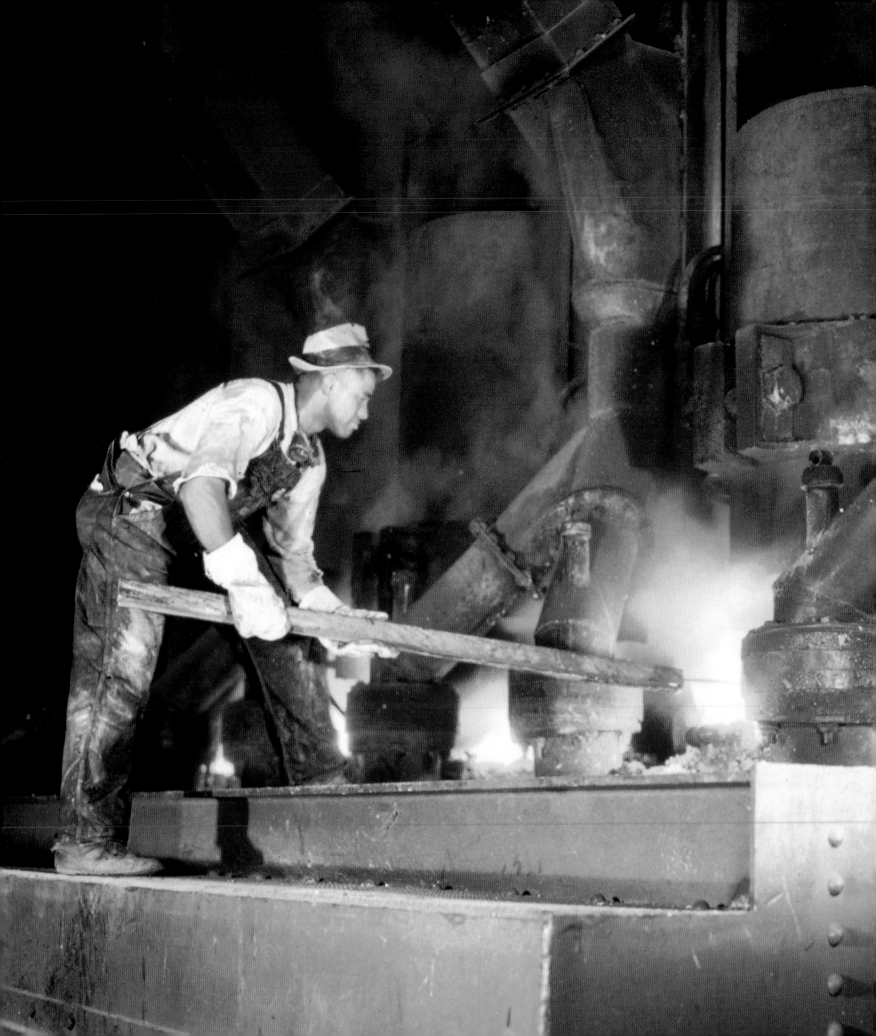

WORK

For us, work builds not only character but communities. Our jobs provide us with a sense of purpose and accomplishment. We work hard, and well. Whether

But one thing I am really glad that my mother and my father taught us [was] how to work. If they hadda let us been shackin' around and not workin', we wouldn't be what we are today. My kids work, too, and I hope they'll teach their children to work cause that means a whole lot.

—SARA BROOKS, FARMER

working from a corporate corner office or a cubicle in a strip mall, the assembly line of an automobile plant or a city clerk's desk, downtown, black folks continue to transform the global economy. We know that our minds and hands go far in changing, and in a few cases, saving, the world.

Today, we are represented in every division of corporate hierarchy charts (that staple of modern American business that we did not invent, but certainly redefined). We make the cold calls, pitch the ideas, initiate the mergers, set up the teleconference, transfer the funds from one account to the other, crunch the numbers, approve the loan, bind and collate the report, deliver the RUSH papers, confirm the reservations at four-star restaurants, close the deal, make the toast, and clean up the conference room.

We are everywhere: Airline pilots flying high above the earth, marine biologists sailing to the bottom of the ocean floor. We keep the peace as police officers and extinguish flames as firefighters. We drive trains, buses, taxicabs, and limousines. We are hospital administrators and Board of Education chairpersons. We wear redcaps on AmTrak and are skycaps at the airport. We own funeral parlors, insurance companies, beauty parlors, barbershops, and soul food cafes. We deliver flowers, packages, and

telegrams. We are computer programmers and personal shoppers. As secretaries and nurses, inside, we know that "we run the joint." We host talk shows and Amway parties. We edit magazines, newspapers, books, and Internet content. We create and represent intellectual property. We are social workers and fund raisers. We receive standing ovations for our Broadway debuts, music concerts, and fashion shows. We design and build corporate spaces.

Button-downed, pinstriped men and women stroll along Wall Street and Main Street advising clients on the hottest stocks, bonds and mutual funds. Young dot-commers—laid-back, dread-locked or natural, in cargo pants and Nikes—use their laptops and Palm Pilots to reinvigorate the New Economy from the "way-cool" section of town. Soccer moms—cell phone in one hand, a

To-do List in the other—maneuver their SUVs through thick rush-hour traffic, without ever losing their call to their home office, or their nerve.

"Historically, among people in Africa, labor was an expression of creativity and an extension of one's cultural identity. Yet, for centuries, people of African descent in the United States had limited professional and creative outlets. Nevertheless, in the fields of Georgia, slaughterhouses of Chicago, or on the stages of New York, we could create art, and invent useful, needful things, including the iron, the stoplight, the saddle, the cotton gin, and even multiple uses of plants. Although our jobs were often menial and difficult, we found meaning in our work."

Indeed, we supply a significant portion of the energy that keeps the American Dream thriving, which has been the case from the moment we arrived in this country in 1617 as indentured servants. Without doubt, it's a long way from having an expense account to having been accounted for on a slave master's ledger.

1. House call: woman doctor in Harlem. (1934) 2. Dr. Kim Williams, Director of Nuclear Imaging, University of Chicago Physicians Group. 3. Nurses during the 1940s.

4. Harry's Grocery Store, a popular pit-stop on the way to Idlewild, MI. **5.** Kent Davis, owner of Diamond Kuts barbershop in Brooklyn. **6.** Harlem Barber Shop on Main Street in Oxford, NC.

6

4

5

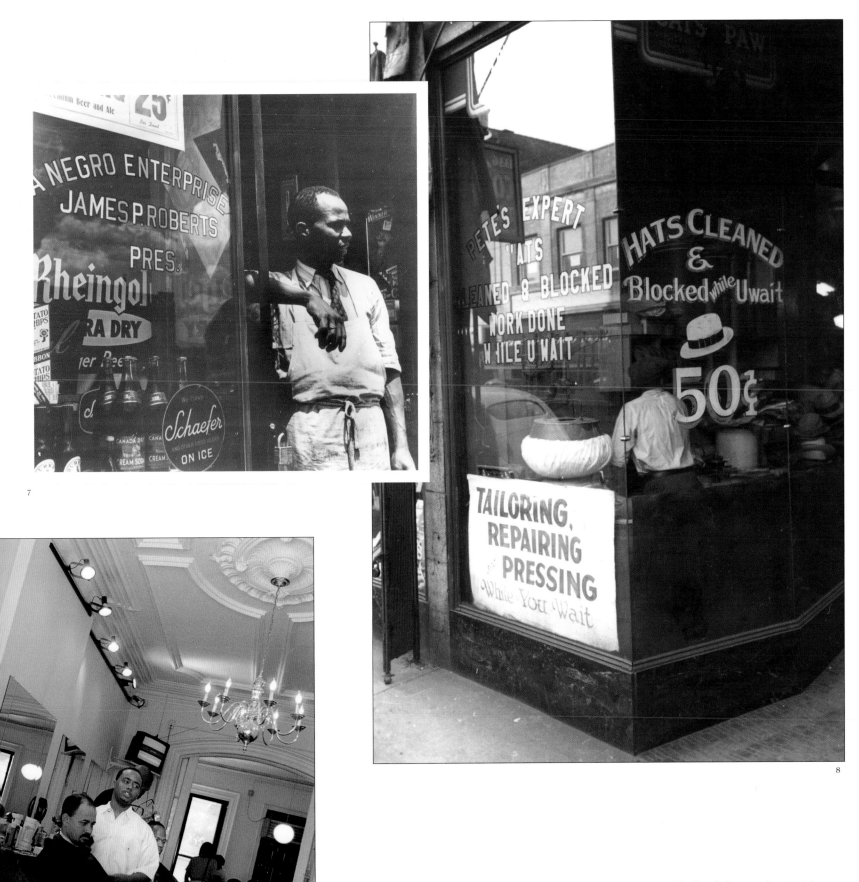

7. Negro Enterprise signs attract black clients. 8. A neighborhood cleaners. (ca. 1940s)

As the curtain closed on the twentieth century, we could look back at our progress in labor, and take a bow. Not only were we the CEOs of international conglomerates, but we were an integral part of a presidential administration that witnessed one of the longest periods of economic growth in our nation's history. Every night, watching the evening news, we saw the Secretaries of Commerce, Labor, and Energy, and the Surgeon General, men and women, reaching the pinnacle of their professions, advising, counseling, and informing the nation on matters crucial to our daily lives. They are the evidence of millions of the denied dreams of generations of African-Americans, whose ancestors were owned, outright, by among others, lawyers, politicians, and devout Christians. They owned every pore in their body, every strand of hair on their heads.

Millions, yes, millions, of our ancestors worked on farms and plantations in states that upheld enslavement. Black men, women, and children were held accountable for taming a bitter, stubborn, and moody earth, and all that came from it. Under an unforgiving sun—shirtless, barefoot, backs bent—they were charged with "cropping tobacco, shucking corn, cutting sugarcane, picking cotton, clearing land, burning underbrush, rolling logs, splitting rails, carrying water, mending fences, spreading fertilizer, and breaking soil." They worked not merely

from sunrise to sunset, but frequently long after dark. During harvest time the hours were longest since the planter was anxious to harvest the crop before it could be seriously damaged by inclement weather. Under such circumstances, they were driven almost mercilessly. In 1830, for example, 14 Mississippi slaves each picked an average of 323 pounds of cotton in one day.

Their labor was not restricted to farms and plantations. They built public and private office buildings, mansions and universities, gardens and parks, where they could neither reside, visit, nor attend. They sculpted monuments that were not in their own likeness. Artisans designed furniture, home decorations, and clothing that they could never recline upon, own or wear. Women were charged with taking care of their owner's children, with no assurance that their own babies would not be sold from under their arms. They prepared meals that

9. Entrepreneur Lillian Howard, frequently advertised in black press. 10. Slade's BBQ, first black business in Boston. 11. A Pittsburgh diner.

The hardships of war work become willing sacrifices to victory, not to victory for Democracy, but to victory by a country that some day, please God will win Democracy. In such a spirit, even some of the hardships are forgotten in the daily rewards of the job. After all, we are working today and drawing regular paychecks. And there is fun on the bus trips, even when you're half-frozen.

There is comradeship from working and traveling together, expressed in jokes and singing and laughter on the return trip. Sometimes we have parties on the bus, sharing candy or sandwiches, and even cutting a birthday cake bought from a roadside bakery. Frayed nerves and short tempers show themselves sometimes, and that's understandable, but a real quarrel seldom develops. Ill-tempered remarks are usually understood, and passed over without comeback. I imagine that our boys at the front develop the same kind of tolerance, the same kind of partnership, for the same reason. Wouldn't it be great if the white workers who are fellow fighters with us in war production, would develop more of the same spirit of partnership? What can we do to make them realize that colored people must be given equal opportunity in every walk of life to make that partnership real—to build an impregnable, free and democratic America? Well, that's why I stay on the job, and that's what this job means to me . . . I haven't been very well, and the constant strain and exposure have put me into bed too often for my doctor's satisfaction and my own comfort. But one thing is for sure, if I leave this job, I'll get another one in war work. Victory is vital and I'm vital to victory . . . I'm not fooling myself about this war. Victory won't mean victory for Democracy—yet. . . . By doing my share today, I'm keeping a place for some brown woman tomorrow, and for the brown son of that woman the day after tomorrow. Sterling Brown once wrote, 'The strong men keep a-comin' on,' and millions of those men have dark skins. There will be dark women marching by their side, and I like to think I am one of them.

—HORTENSE JOHNSON

they could not eat. To ensure that they would not eat the produce that they picked, some slaves were forced to wear iron masks while they worked.

Cruel Slave Codes, which varied from state to state, monitored their conduct, creative expression, and travel. "They were not permitted to leave a plantation without the written permission of their masters. For major offenses such as robbing a house or a store, (our ancestors) received sixty lashes, were placed in a pillory, where their ears were (soon) cut off." In essence, slaves were not recognized as living, thinking, intuitive people. Theirs was life as a slave, certainly not liberty nor the pursuit of happiness.

For six decades after the Emancipation Proclamation, newly-freed black men and women found work wherever, whenever they could, mainly through the Freedmen's Bureau. They walked, or the fortunate few, hitched their

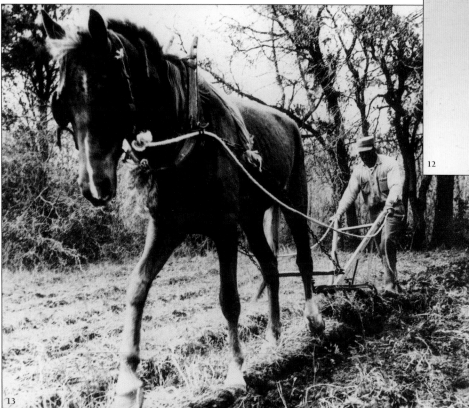

hopes on the backs of makeshift wagons out West, as far north as Canada, and parts in between. They worked as ranch hands, seafarers, railmen, in steel mills and slaughterhouses. In less than two decades, a wave of European immigrants began to settle in the northeast and Midwest. They may have understood poverty and political oppression, but few, if any, of these new Americans, knew the horrors of enslavement. And

When enslavement was declared unconstitutional in 1865, our ancestors left this abominable institution empty-handed. Dry-mouthed, wide-eyed, dehydrated, and destitute, their lives were shattered. While some former slaves kept their fragile feet on former plantations as share-croppers, others searched for work elsewhere.

whatever their barriers with language, there was a major benefit: they were not Negroes.

So the pursuit of life, liberty, and labor presented a new challenge for newly-freed slaves and their descendants:

12. Fisherman in Sea Islands. 13. Sharecropper.

racial discrimination. For the duration of a slave's life, he or she was guaranteed work. The complex nature of racism prevented most non-blacks from seeing our ancestors as their equal. Thus, there would be no parity in wages and roles. So most black folks accepted whatever work they could find, suffering in silence, understanding that a low-wage paying job was better than no job at all. However, they did not sit still for long.

Between 1870 and 1930, transformation in labor resulted primarily from the initiative of black men and women—the sharecroppers who abandoned the neo-slavery of the cotton field in favor of wage work in sawmills and 'public work' in southern towns, the domestic servants who left the kitchens of their employers to work long hours as tobacco stemmers, and the 1.5 million black southerners who migrated from

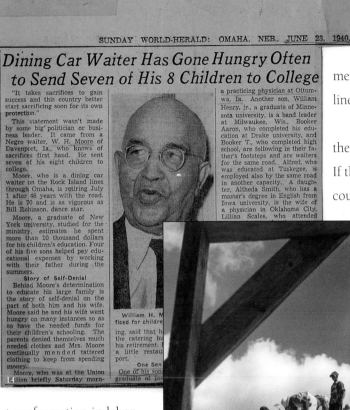

SUNDAY WORLD-HERALD: OMAHA, NEB., JUNE 23, 1940.

Dining Car Waiter Has Gone Hungry Often to Send Seven of His 8 Children to College

"It takes sacrifices to gain success and this country better start sacrificing soon for its own protection."

This statement wasn't made by some big politician or business leader. It came from a Negro waiter, W. H. Moore of Davenport, Ia., who knows of sacrifices first hand. He sent seven of his eight children to college.

Moore, who is a dining car waiter on the Rock Island lines through Omaha, is retiring July 1 after 46 years with the road. He is 70 and is as vigorous as Bill Robinson, dance star.

Moore, a graduate of New York university, studied for the ministry, estimates he spent more than 10 thousand dollars for his children's education. Four of his five sons helped pay educational expenses by working with their father during the summers.

Story of Self-Denial

Behind Moore's determination to educate his large family is the story of self-denial on the part of both him and his wife. Moore said he and his wife went hungry on many instances so as to have the needed funds for their children's schooling. The parents denied themselves much needed clothes and Mrs. Moore continually mended tattered clothing to keep from spending money.

Moore, who was at the Union ┤tion briefly Saturday morn-

a practicing physician at Ottumwa, Ia. Another son, William Henry, jr., a graduate of Minnesota university, is a band leader at Milwaukee, Wis., Booker Aaron, who completed his education at Drake university, and Booker T., who completed high school, are following in their father's footsteps and are waiters for the same road. Alfred, who was educated at Tuskegee, is employed also by the same road in another capacity. A daughter, Altheda Smith, who has a master's degree in English from Iowa university, is the wife of a physician in Oklahoma City. Lillian Scales, who attended

William H. M┤ficed for childre┤

ing, said that h┤ the catering bu┤ his retirement. ┤ a little restau┤ port.

One Son

One of his son┤ graduate of Iow┤

the South into northern cities between 1916 and 1930 to take jobs in steel mills and meatpacking plants, on automobile lines and in garment factories.

By 1930, the nation was in the throes of the Great Depression. If the nation was 'depressed,' one could imagine the strain that its black citizens were under. Relief, literally, came in the guise of patrician President Franklin D. Roosevelt, who established the Works Progress Administration (WPA) to resuscitate the American economy and spirit. A key component of the WPA was the New Deal, which, in essence, gave America a face-lift: miles of new highways and streets, bridges, parks, public spaces, available electricity and water to impoverished communities, many which had not recovered from the Civil War. Not only were black folks critical in the rebuilding of America, but, for the first time as long as any of them could remember, there was a sense of optimism. Roosevelt, after all, forbade discrimination in WPA Projects.

14. It takes sacrifice to gain success: newspaper clipping of the dining car waiter who sent his children to college. 15. Build me a home: construction workers. 16. Rolls-Royce Assembly Line, Detroit, 1940s.

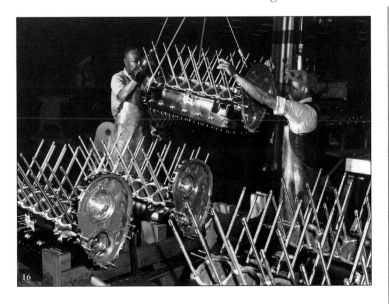

People of a certain age can recall their parents and grandparents shhing them as the entire family gathered around the radio to listen to Franklin D. Roosevelt deliver one of his national fire side pep-talks during World War II. While President Roosevelt encouraged the nation to collectively fight tyranny, black folks went to work fighting our enemies abroad and racism at home during the Double V campaign, which was initiated by the *Pittsburgh Courier*.

their chosen profession. When they arrived at interviews at predominantly white companies, their job applications were thrown in the trash with apple cores and carbon paper. Educators and engineers found jobs with black colleges or on the colored side of town. More than a few gifted and talented men and women (summa cum laude graduates) found work as elevator operators, Pullman Porters, and domestics. In 1940, half of African-American women were domestics.

As the Buffalo Soldiers and other service men were fighting in Europe, black folks went to work in defense related jobs in northern factories. While the enemy abroad was annihilated, the enemy at home became more troublesome than ever. Some unions forbade black membership, and ruthless entrepreneurs capitalized on racial tension to incite riots between union members and black workers who were on the bottom of the totem pole.

However, a new generation of black folks were not willing to maintain the status quo, and became foot soldiers in the burgeoning Civil Rights Movement to open opportunities for themselves and future generations of African-Americans in housing and employment. Despite marches and sensational murders of Civil Rights supporters, corporate America was reluctant to open its doors to large numbers of African-Americans.

Those black folks who attended Howard University, Hampton Institute, Fisk University and other prestigious universities, discovered that their hard-earned degrees could not guarantee them a job within

17. AFL-CIO banquet 18. Negro Labor Committee rally the faithful.

Indeed, one hundred years after the Emancipation Proclamation, "private employment agencies stamped the application forms of blacks with codes like NFU (not for us) and POK (people of color) to alert prospective employers."

It took affirmative action, a national policy requiring corporations and public agencies to intensify recruitment efforts, to allow us to get a foot in the door. Once there, we made tremendous strides. In less than three decades of active affirmative action, African-Americans have truly succeeded in business. My parents, who met while they were attending college, left the South in the early 1960s because there were limited economic opportunities. They moved to Paterson, New Jersey, a booming manufacturing city in the early 1970s, and my father quickly found work. He was not alone. Every morning on our way to school, my brothers and sister and our friends stood side by side with neighbors in uniforms and suits, heading off to their jobs as police officers, nurses, teachers, dentists, salesmen, professors, clerks, and craftsmen, like my father, who wore a starched blue uniform, with his name in red letters on a blazing white oval patch. His black lunch pail was as striking as his shiny black boots. My mother, a housewife, made such wonderful lunches that I forever wanted to be sick to experience her leftover meatloaf sandwiches and popovers.

Once we finished our homework, neighborhood children would run downstairs and wait for our parents to emerge from their cars. They held crumpled newspapers, briefcases, and groceries from Shop Rite and Pathmark. If we were lucky, they'd give us a quarter to buy candy. More than a few parents would jokingly tell us: "If you want candy, you'd better go to work." My brothers and I

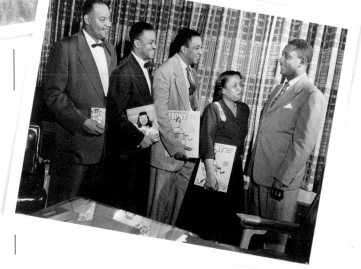

19. Well Done: Beauty magnate Esther Parham sales boys receiving awards. (ca. 1940s) 20. Poro Beauticians sales luncheon. 21. Madame C.J. Walker sales conference. 22. John H. Johnson and *Ebony* sales staff.

did. There were penny-ante schemes: selling flower seeds, collecting stamps, illustrating Spot on the back of the *TV Guide*. But we changed our minds with these "jobs" the same way we capriciously chose new best friends for the week.

When my family arrived in Laurinburg, in 1976, my mother explained that young children worked. In fact, she indicated that both she and my father worked at very young ages. And she didn't mean taking out garbage, or "busting suds" as a human dishwasher. No, young people could and did work. In fact, everyone in my family worked. Jobs broke down into two categories: a good job (teacher or factory manager) or a "damn" job.

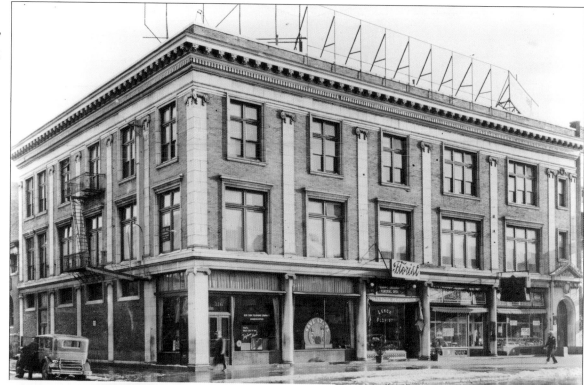

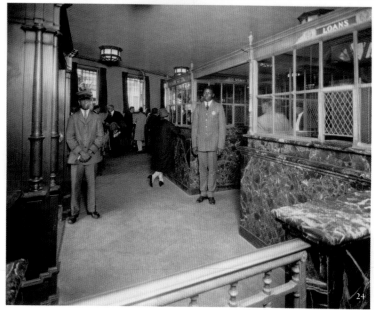

trinated into the world of "hard work." One night, perhaps at three or four in the morning, my grandmother pulled a long string that was attached to a light bulb in the middle room of her house. "Get up, you young'uns are going to work." "Where?" I asked. "In the fields," my grandmother yelled from the front room. Although the July

My grandmother, who went to work as a school crossing officer on the day that she drew her last breath, drilled within us that as long as she knew us, we would work.

Not long after we arrived down south, we were indoc-

sun in North Carolina is equator hot, we were given our grandfather's shirts, the sleeves draped over our hands. If I recall, I may have worn grandaddy's pants. We were given straw hats, luncheon meat and mustard sandwiches, and a jug of lime Kool-Aid. Just as we slipped into our sneakers, the horn of a pick-up truck honked three times. With that,

23. Black-owned United Mutual Life Insurance Company. **24.** Black-owned Dunbar National Bank. (ca. 1930s)

my brothers and I were piled on the back of a pick-up truck, and driven through the town, underneath a sky that had not fully come alive.

We rode through enough back roads that to find my way home, I was certain I'd end up in Maine. We stopped at rows and rows of corn stalks that were taller than the tallest basketball player. Soon after, a truck of people my brothers knew also pulled up. I was ten. We were given our instructions—we were supposed to de-tassel corn—or pull the stalks out. We would work until sundown. I was told that the day would go by quickly. In no time, it would be lunch. We stood on a giant machine, pulling tassels that looked like a cow's lip. There were men who could do this with their eyes closed. And then there was me. My sleeves were

constantly in the way. But if I rolled them up, I was bitten by the mosquitoes and bees that claimed this field as their own. If I rolled the sleeves down, I could not get the tassel.

I was ten.

After our first round of de-tasseling, I was told that now we were going to step it up some. Once the machine kicked into high gear, I knew it would be over. I was certain that I was going to be fired from my first legitimate

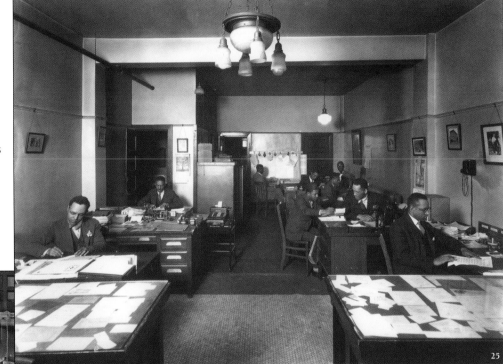

job, as a de-tasseler. But I thought about how proud Grandma and Grandaddy would be of me to finish this job. I bit into my bottom lip, and emulated everyone beside me. I ignored the snakes and baby lizards crawling through the fields, the wasps and grasshoppers on my sleeves, the gnats and sweat in my eyes. I was working. I thought of all the things I would buy with my money. . . the hundreds of dollars I would earn over the summer as a de-tasseler. I was ten, and I was working. I was king of the world.

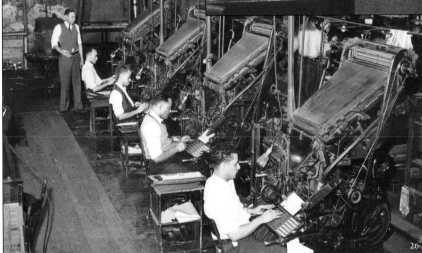

25. *Washington Tribune* newsroom. 26. Linotype typists, at the *Chicago Defender.*

27. Major General Bolden near a space shuttle replica. **28.** A present-day black woman scientist. **29.** The power of attorney. **30.** Cut! on the set of *Mo' Better Blues* with Spike Lee, Denzel Washington, and Wesley Snipes.

27

28

29

30

October 16-22, 1996

Breaking

Futures assured at Pr

By John H. Manor
CHRONICLE STAFF

The words "trust" and "sports agent" are rarely spoken in the same sentence in the world of high pressure, multimillion dollar sports contracts and endorsement deals. Flamboyant athletes are all but overshadowed by their more outrageous and ruthless agents, whose goal may not always be with the athlete's best interests at heart. But Professional Sports Planning Inc. (PSP) is working on breaking those stereotypes by giving its clients a sense of family and trust they won't find elsewhere.

Founded in 1989, PSP not only broke new ground with its management philosophy but is one of the few minority-owned and operated sports agent firms in the business. A business where the majority (80 percent or more) of athletes are Black, but only 5 percent are represented by Black agents. Kevin D. Poston, CEO and president of PSP, explained to the Chronicle from his Farmington Hills office that for the agent/client relationship to blossom and grow, agents must always keep the athlete's best interests at heart.

"The foundation of PSP is family," stated Poston. "Family values are important to the young men we represent. They were raised with strong morals and ethics, and it is that honesty and trustworthiness that PSP provided them in planning for their futures. We are concerned with more than just the deal at hand. We look at how it will effect this young man's life after sports and if this is a deal that is reflective of the type of person they are. Of course, we are going to aggressively pursue the most favorable arrangement for our client, but it will be with that young man's best interests in mind, for now and for their future."

Jimmy K

Poston who serve Houston-b their clients sidered like they repres frank respo represent w pectations for themse tons give assurance t best interes every aspe and private ing type of Carl Posto play regar clients on a

"These years or Poston. " pings of a contend w make an ef tential pitfa and help th tive aspec game. The achieved a upon them away in on

PSP boa NBA's Orl (Penny) H icks Jim Bucks' Sha nix Suns with the N

I soon lost track of time, me, feeling so accepted, working side by side with teenagers, who had afro picks in their back pockets and veins in their arms. By the time I left the fields for the summer, I too, would have muscles. And our supervisor was right, the time had flown by quickly. It was time to go to the truck and get our sandwiches and Kool-Aid. Rod, Greg and I would have to drink from the same jug, but it was okay. We'd worked hard. We were divided into two teams, and my team was the first to get through our field. The truck stopped. We slapped hands. I looked up at the sun.

"Wow, I can't believe it's time for lunch," I said, or something to that effect.

Our supervisor looked at me with his brow furrowed.

"Boy, it's only seven o'clock in the morning. You have six more hours of work. Look out there at all those fields."

My brow furrowed.

The yellow and green cornfields went on for miles and miles. It was more than a ten-year-old could take. I was sent to the truck. I would not return the next day. My brothers brought my check (I think it was for less than ten dollars—a dollar for every year on the earth) at the end of the week. I can't say that I thought about our ancestors at the time, but every morning, when I trudge to my computer to write, I first look at a sign taped to my mirror: *I work without fear so that I'll always have freedom.* And I never have corn for lunch if I can help it.

31. On the information superhighway. **32.** Today's black woman. **33.** Sports agent.

THE MICHIGAN CHRONICLE Page 1-B

perception about sports agents

rts Planning Inc.

Tim Biakabutuka, New England Patroits' Ty Law, Miami Dolphins' Terrell Buckley, New Orleans Saints' Brian Jones, New York Jets' Ron Carpenter and Kansas City Chiefs' Greg Hill and Tamarick Vancover.

"Recently, Tim Biakabutuka, running back for the Carolina Panthers, suffered a season ending knee injury," stated Poston. "I knew he had high hopes for his first season and was on his way to Rookie of the Year honors. He was surprised and pleased I came down to see him, but I told him that I understood his goals and wanted to make sure he was okay. I told him to remember why he was there and that by rehabilitating himself and becoming the best he can be he will have achieved more than any Rookie of the Year honors could measure. You can't help but develop a real concern for these young men. So, you see, I don't do this just because Tim's a client. We care about him and the rest of our clients as we would our own families. That is what PSP is all about."

In regard to marketing an athlete, what PSP has been able to do with Penny Hardaway is next to astounding. Arguably the third most recognized NBA star playing today, Hardaway has chalked up some impressive feats on and off the court. Starting with a contract negotiated by PSP that many sports professionals feel is the most creative in NBA history, and endorsement deals with a number of cluding Nike, Sara Lee, Coca-Cola, Post Cereals and Upper Deck, Hardaway has been able to create a very marketable image thanks to PSP. Its development of the tremendously popular "Lil' Penny" character has provided Hardaway access to markets that were previously closed to many athletes.

"Penny is like a son to me," said

KEVIN POSTON, CEO and president of Professional Sports Planning Inc., breaks the stereotype of what a sports agent is thought to be by following a strong corporate/family philosophy.

Poston. "He has the best attitude on and off the court. In creating marketing opportunities for Penny we were careful to keep his endorsements within the image he represents. When we developed

Poston explained that by focusing on the long-term needs of its clients, PSP was able to give the athletes it represents a sense of security, something that is uncommon in the world of sports today.

the proper amount of light and water on that seed, it will grow into something stronger and longer-lasting than you can imagine. It is that type of relationship we foster and grow with the young men we rep-

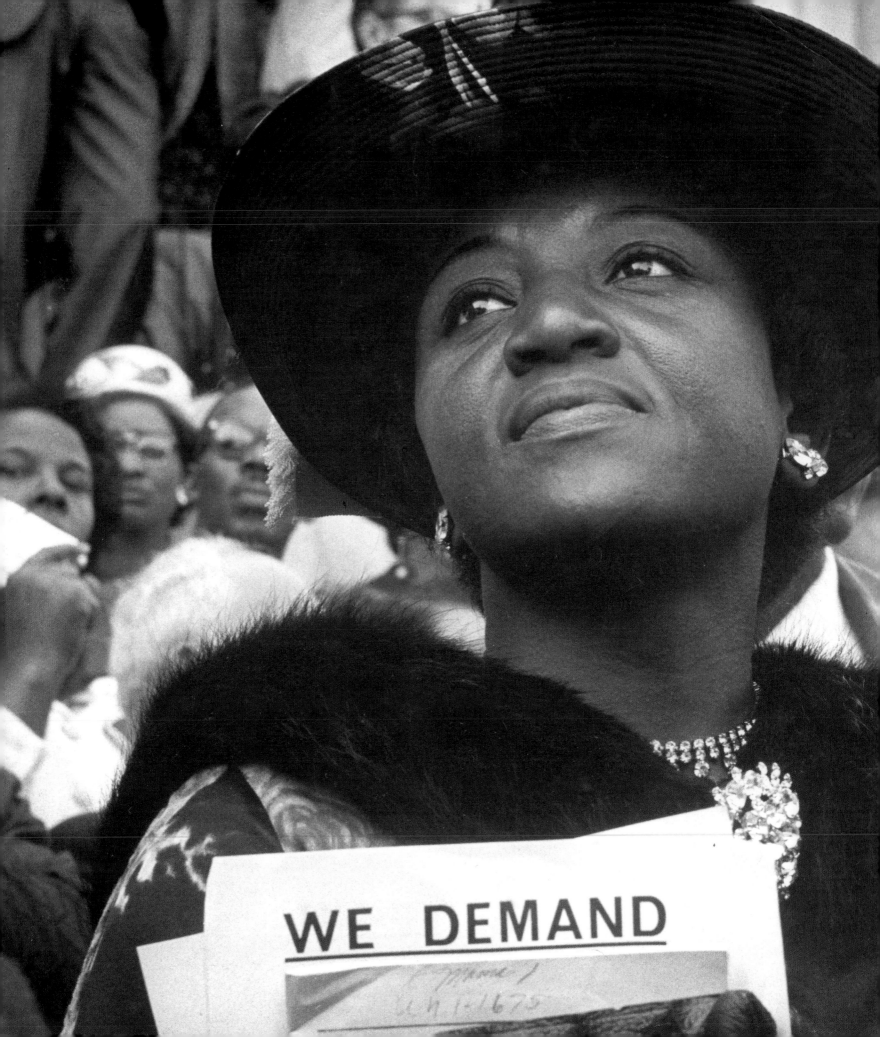

WE DEMAND

CIVIC DUTY

My father saves people, I often thought. People talked of what a fine social worker he was and how many people he had helped set in the right direction. He saved money for Y scholarships, helped the young find work, and provided guidance through the Y programs. He gave fine stirring speeches at meetings and banquets on the value of working hard for the Negro cause and helping Negro youth.

—ADRIENNE KENNEDY

The term "woman's club" usually conjures visions of sweet-faced ladies in flowered hats sipping tea, usually because they have nothing better to do with their time on a weekday afternoon. This image has never been particularly accurate, even of white women's clubs. With regard to black women's clubs it could hardly be further from the truth—except, probably, for the flowered hats.

—DR. DARLENE CLARK HINE

IN A WORLD of technological change, one thing that has not changed is the black-tie event sponsored by civic and charitable organizations. Every Thursday in black newspapers across the country, the smiling, glittering glamorous faces of modern-day humanitarians and personalities who attend these events beam back at us. They bear witness that African-American civic and professional clubs are as significant a part of black communities as ever.

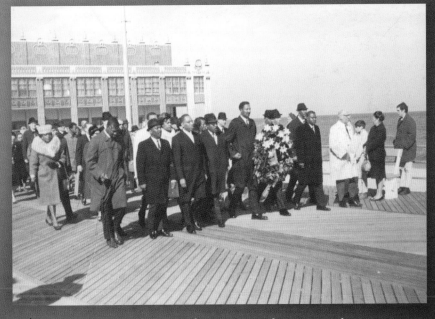

Established associations—fraternities and sororities, the Freemasons and the Order of the Eastern Star, the Links and Elks—continue to thrive, enlivened by a new generation of black professionals in finance, medicine, law, and entertainment. Trailblazers in the New Economy are

unconventional: they may raise capital for their favorite organizations on yachts, on golf courses, or at a backyard barbecue. Media moguls now sit shoulder to shoulder with some of the nation's most established families at board and

recognition of award recipients, whose triumphant testimonials often reduce ballrooms to a striking silence. The third hour may include a performance from a well-known or unknown song stylist, before the fourth hour concludes

with thank you's and recognition of the head table—that ubiquitous tribunal of chair-

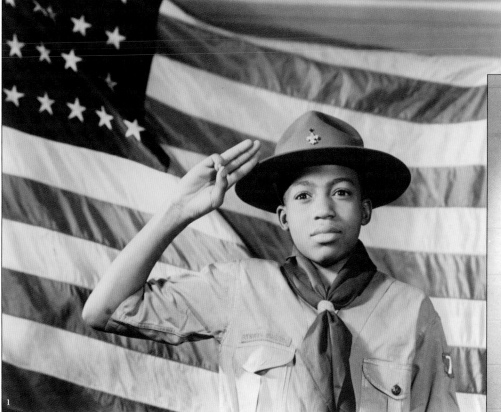

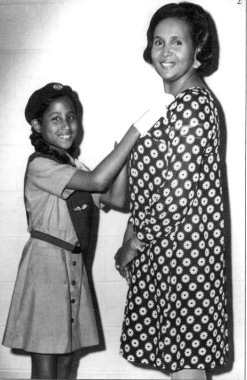

foundation meetings. There are still anonymous donors who prefer to provide support privately, but they are rare. Most folks relish receiving "Save the Date" cards, responding enthusiastically to invitations for annual scholarship dinners, formal dances, and gala banquets.

For the uninitiated, a black "function" is an experience. The first hour begins at the meet-and-greet, a spirited gathering of friends and colleagues, sharp in their tuxedos and beaded gowns, who play catch-up with one another. The second hour includes the

persons, honored guests, and distinguished board members, who may send a note to a table or two but otherwise look on the festivities with pride. In some communities, the head table is known as the dais, but to black folks of a certain age, the head table is something more. There is something comforting about seeing leaders in the community seated at the head table. Members of the head table are instantly recognizable: flamboyant hats, sleek suits, white gloves, fur wraps.

BOYS' CLUB OF CORONA, INC.
NON-PROFIT CORONA, N.Y. NON-SECTARIAN
Dedicated to the Youth of Our Community
THIS IS TO CERTIFY THAT
FRANK NOBLE
is a member in good standing
Expires Dec. 31, 1973 Commissioner
Robert M. Reid

1. Promise to do my best, to do my duty: Boy Scout saluting. 2. Girl Scout Janelle Jones pins her mother Blanche Jones. (ca. 1960s) 3. Boys Club of Corona.

Every fall, a young man or woman's college tuition is subsidized, in part or full, through these leaders' hard work. Support for these scholarships is often secured through a flurry of fund-raising activities supervised by these community leaders who enjoy rolling up their sleeves for cake and bake sales. They rally true believers in The Cause, making countless calls to organize gospel concerts and fashion shows, and dusting off their memories to recall proper protocol and etiquette for debutante balls and cotillions.

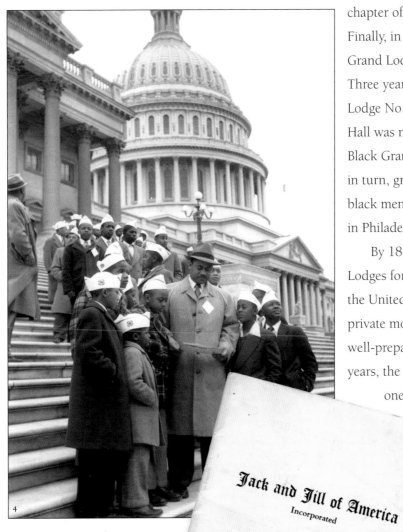

For three centuries, African-American civic organizations have allowed us to develop leadership skills. The Freemasons, one of the first known African-American organizations, tested not only our leadership skills but our patience as well. The first gathering of Freemasons took place a year before the American Revolutionary War. Ironically, the group was supported by the British, not by Americans. In 1775, Prince Hall, a minister from Barbados, and fourteen blacks joined a British army lodge, under the leadership of General Gage. Soon after, Hall's efforts to start a separate chapter of black masons were denied. Finally, in 1784, Hall's application to the Grand Lodge of England was approved. Three years later, Hall initiated African Lodge No. 459, near Boston. By 1792, Hall was named grand master of the Black Grand Lodge. Five years later, he, in turn, granted membership to thirteen black men, who established a lodge in Philadelphia.

By 1815, there were three Grand Lodges for African-American men in the United States. They "usually held private monthly meetings followed by well-prepared dinner socials." Over the years, the Freemasons would become one of the largest fraternal organizations for black men.

By 1857, the *Mirror of the Times*, San Francisco's lone black newspaper reported on the "installation of new officers at its Masonic Hall, Olive Branch Lodge." It was newsworthy that the lodge was installing new members, however, what was truly big news was that "Brother Joseph Wethington, Warden of the Grand Lodge for the State of Pennsylvania, had made the long

4. 4-H Club goes to Washington, D.C. 5. Jack and Jill manual.

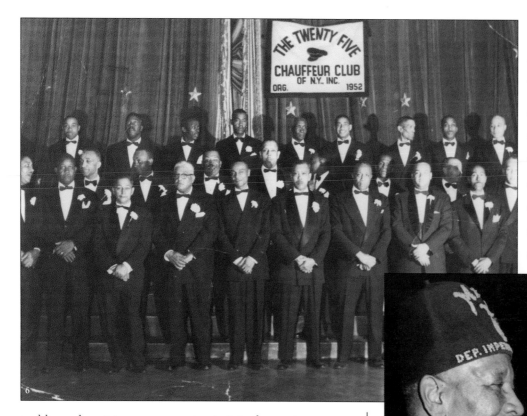

Church in 1830. The assembly produced one of the earliest black agendas: securing full citizenship for people of African descent. Today, there is not a convention or meeting that does not end without someone ensuring that members and delegates walk away with "an agenda" or "a plan."

and hazardous trip across country to join the west coast group for the installation ceremony."

Seeking kinship and economic support, freed blacks gathered as often as possible, and formed organizations that would prove beneficial to their needs. Concerned that white mobs would attack them if they met publicly, many burgeoning black organizations were forced to hold private meetings in safe havens, namely in their homes and churches. Although the fear of mob rule has abated, to this day, most organizational gatherings continue in homes and church. This, of course, is more a matter of comfort and convenience than of safety.

By the middle of the nineteenth century, other benevolent societies were organizing in northern cities, mainly to challenge enslavement and voting rights. The first national black convention, the American Society of Free Persons of Color, was held at Philadelphia's Bethel AME

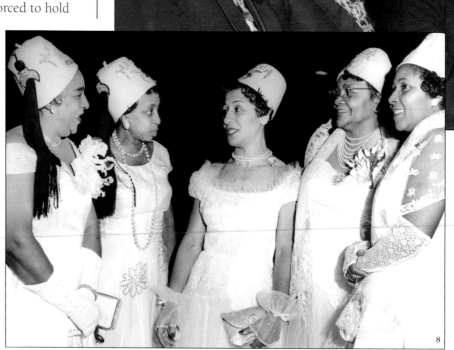

Beneficial and insurance societies such as The Workers Mutual Aid Association, which charged dues, provided members with invaluable business training. "A logical outcome of the mutual benefit societies was black insurance companies, which were more than social in their functions." The National Benefit Life Insurance Company, the North Carolina Mutual Life Insurance Company, and the Atlanta Life Insurance Company, which formed late in the nineteenth century, provided descendants of slaves something that enslavement could not: insurance.

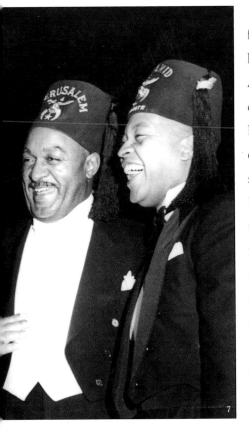

While black men found fraternal organizations, hundreds of African-American women formed clubs, literary societies, and leagues to improve the social, economic, and political status of black families. The National Association of Colored Women, formed in 1896, after the nation's most influential black women's organizations—the National Federation of Afro-American Women and the Colored Women's League of Washington, D.C.—merged. "Living up to its motto 'Lifting As We Climb,' the organization's local clubs set up girls' homes, hospitals, and other agencies." By the end of the nineteenth century, the Star in the East Association, the Daughters of Jerusalem, the Friendship Society for Social Relief, and various Phyllis Wheatley Society branches were organized by black women.

In the shadow of the *Plessy v. Ferguson* decision, which in essence endorsed a segregated society, concerned black folks realized that we would have to pull ourselves up by our own boot straps, supplying our own bootstraps, horse, and land.

At the dawn of the twentieth century, one of the greatest concerns for black men and women were securing economic and social opportunities for their children. Because organizations such as the Boys Scouts and Girls Scouts did not integrate until after 1920 (and even then, the chapters were largely segregated), black community leaders organized schools, kindergartens, and orphanages. Two of the few organizations that extended support to black men and women were the Young Men's Christian Association (YMCA) and Young Women's

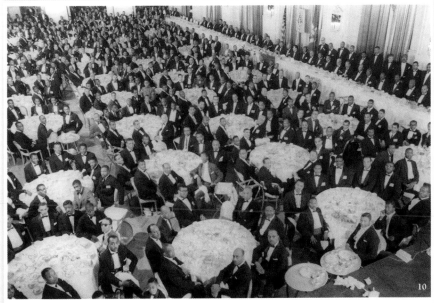

6. Twenty-Five Chauffeur Club. 7. Masons. 8. Order of the Eastern Star. 9. NAACP button. (ca. 1954) 10. Fraternity banquet with the head table.

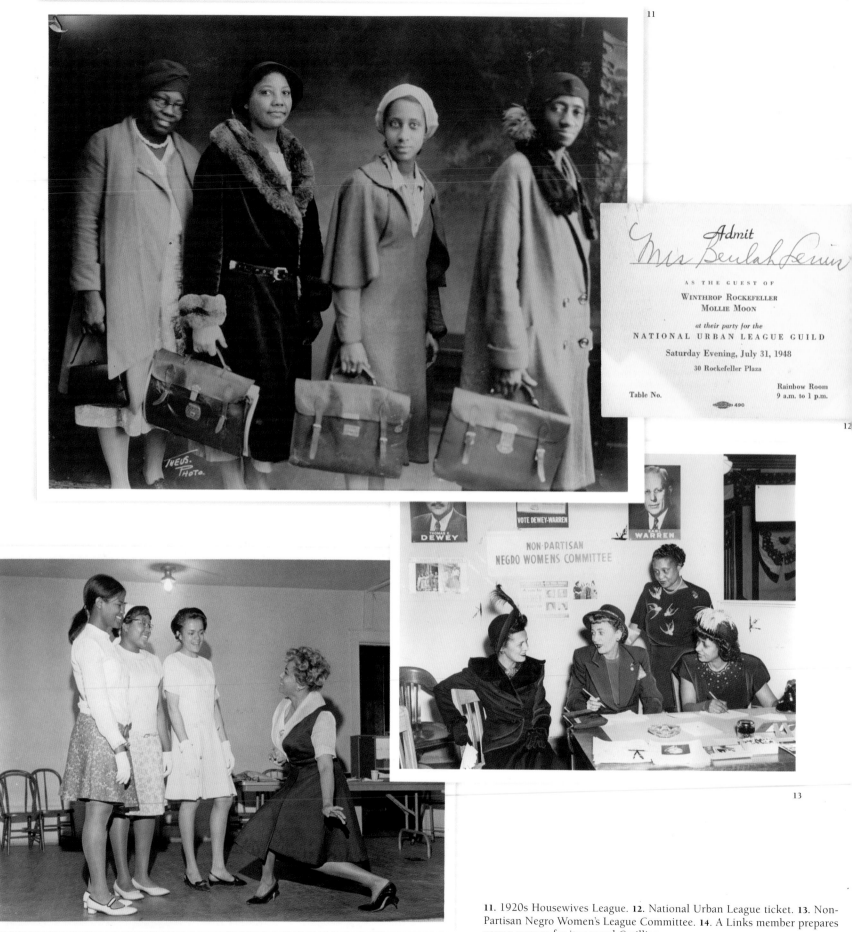

11. 1920s Housewives League. **12.** National Urban League ticket. **13.** Non-Partisan Negro Women's League Committee. **14.** A Links member prepares young women for its annual Cotillion.

15. Exercising our right to vote in Harlem. (ca. 1940s) **16.** *Crisis.* (1963)
17. *Crisis.* (1945) **18.** *Responsibility* magazine.

16

15

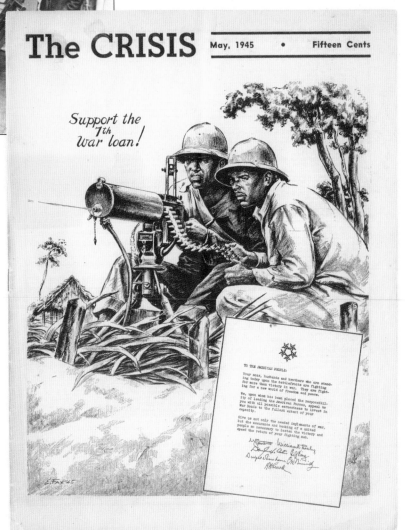

17

18

VOLUME XI

SPRING, 1953

PRICE

FIFTY CENTS

Christian Association (YWCA). In 1905, W.E.B. DuBois, and a group of radical and talented men and women met in Niagara Falls, New York—wearing bowler hats, bow ties, and bustles—to draw up an aggressive mandate, demanding an end to segregation. While not an official organization, the Niagara Movement was a bold meeting of minds of people, who understood that civic duty was not restricted to raising funds, but included consciousness and challenges to standard ideology and doctrines as well.

20

19

A year later several black male students at Cornell University formed Alpha Phi Alpha, Inc., the first African-American fraternal organization. A year later, a group of young women at Howard University formed Alpha Kappa Alpha, Inc. In subsequent years, the fraternities Kappa Alpha Psi (1911), Omega Psi Phi (1911), Phi Beta Sigma

21

19. May it never return: *Gone With the Wind* protest march. (1939) **20**. Anti-lynching protest. **21**. Black Panther button.

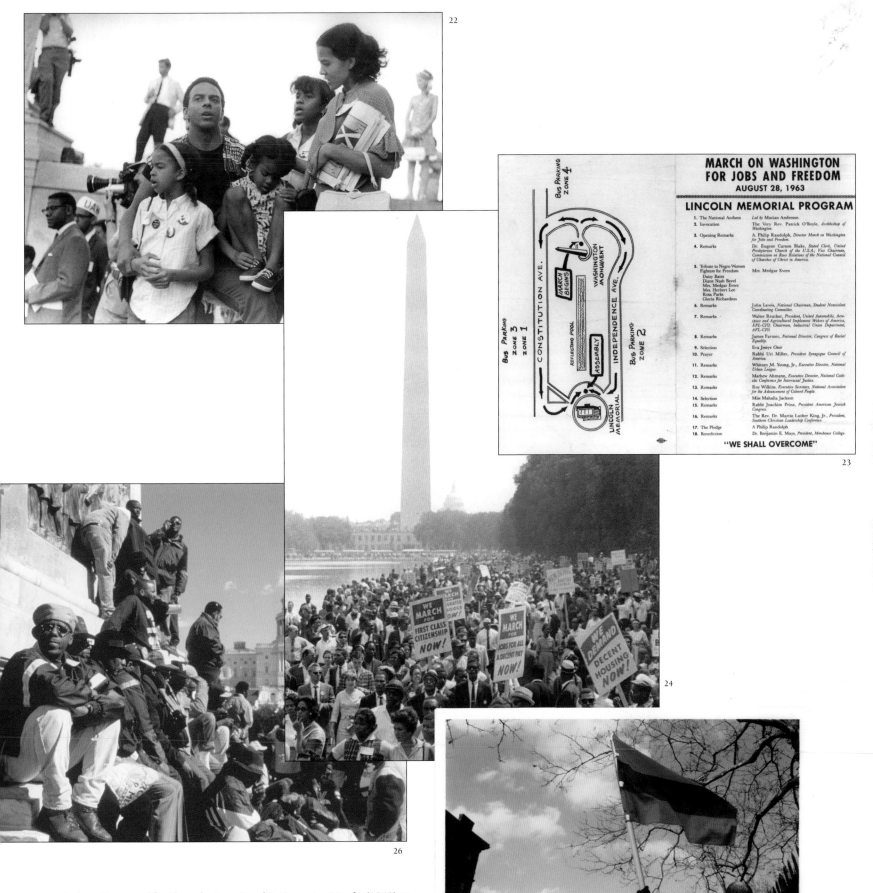

22. Andrew Young and family at the Poor People's Campaign March. (1968) **23.** March on Washington flyer. **24.** March on Washington. **25.** Colors of the People: red, black, green. **26.** Million Man March.

(1914), and Iota Phi Theta (1963), and the sororities Delta Sigma Theta (1912), Zeta Phi Beta (1920), and Sigma Gamma Rho (1922) were formed. The Divine Nine, as they are known, not only provided its members with brotherhood and sisterhood on black and white college campuses, but these organizations count some of the most prominent public and private sector professional members as past and present members.

Concerned with escalating attacks—skinnings, lynchings, and riots—on blacks in southern and northern cities, two of the nation's most influential civil rights organizations formed. In 1909, the National Association for the Advancement of Colored People (NAACP) was founded (with white and black members), and the National Urban League organized a year later. Both organizations were crucial in ending racial segregation. The NAACP Legal and Education Defense Fund's skilled attorneys would argue dozens of cases before the United States Supreme Court,

27. The Poor People's Campaign March. **28.** Jesse's *Time*, painted by Jacob Lawrence.

successfully challenging archaic laws that denied citizens their inalienable rights.

By World War I, a growing professional and labor class of black men and women—"physicians, dentists, pharmacists, nurses, attorneys, social workers, recreation leaders, morticians, and others"—who had been denied entrance into mainstream professional clubs and societies, began to form their own organizations. Several years into the Great Depression in 1935, professional black women formed The National Association of Negro Business and Professional Women's Clubs. The same year, Mary McLeod-Bethune brought a myriad of black women's organizations under the same umbrella and formed The National Council of Negro Women.

After World War II, a new professional class of African-Americans appeared. Civic duty was an extension of their professional lives. These teachers, social workers, business people, and physi-

cian's wives raised funds for local charities by hosting teas and dinner parties in their flawless homes. An invitation to one of these gatherings suggested that one had "arrived."

A charity tea was planned with the precision of a Broadway opening. Tablecloths were starched and ironed beforehand. Discreet wedding china and flatware were polished by young children who were also charged with cutting the ends of bread to make ladyfinger sandwiches.

Some women offered sandwiches in their sorority colors—pink and green and red and white. The gatherings were not complete without white gloves. Looking back, these gatherings were far more social than political. Attendees often discussed their children's futures, and

whether or not they would enroll their children at Camp Atwater, or who would chair the annual Jack and Jill dance. While well-intentioned, these elitist clubs created a schism in the community, especially to those folks whose noses were pressed to the windows; watching folks with their noses in the air. While these moments produced wonderful, tender moments for those on the inside, they also left behind hurt and broken feelings for those on the outside.

Thankfully, by the early 1960s everyone could rally around the Civil Rights Movement. Watching children get

29. Serving my country: Vietnam vet.

sprayed with hoses or bitten by dogs, people held their breath, and closed their eyes, while some cursed and punched their hands. Ordinary folks were moved to march. Late into the evening, they gathered at churches to compose signs and hear sermons. Eating cornbread and pinto beans, laughing, joking, and dancing, they left church, motivated, and ready to march. How they must've shaken inside their souls coming face-to-face with the

who lost their sons, or fathers who needed to bail children out of jail. This was no ordinary time. The 1950s and 1960s were times of enormous change. Blood was shed; lives were lost. But freedom was gained. Let freedom ring.

Today, it is our civic duty to speak out, in whatever way we know how, whenever injustice, rears its ugly head. Civic duty is more than meetings. It is a meeting of the minds.

clenched mouths, eyes, and fists of their detractors: officers in blue uniforms, mothers holding babies, fathers with their sons hoisted on their shoulders. All that we had were our voices. And we used them, singing "Lift Every Voice and Sing," and "Ain't Gonna Let Nobody Turn Me 'Round" and "We Shall Overcome" loudly. No matter what happened at the march, we met up at the church. Testimonies were applauded, collections were taken up for mothers

It is an acceptance of our differences, which are many. During the 1960s and 1970s not everyone changed their names; not everyone attended or held consciousness-raising meetings; not everyone donated to the Free Angela Movement when Angela Davis was proclaimed America's Most Wanted Woman in the early 1970s. Not everyone

30. 41 shots: Amadou Diallo protest march.

trashed their fluorescent clothes in exchange for black leather jackets and berets to support the Black Panther Power Movement. Not everyone wore green ribbons in the 1980s to protest the murdered young boys of Atlanta. Not all of us attend marches when black men are accidentally shot in the back by police officers, or when elderly black women are beaten or accused of theft by shopkeepers. We should understand that many are called, but few answer, during tough times. But we all have a role. We can all do something, even if it means stepping aside, and not blocking progress, when someone does decide to march.

I know all too well about the power of marching—and of standing still. In early October 1995, while I was attending graduate school, several men, much younger than me, asked me if I would attend The Million Man March in Washington, D.C. I'd heard about the March, but I didn't think there would be any interest on our college campus. I was moved when Pierre Bonet and Chakaras Johnson told me that they would appreciate it if I came. I said yes.

I didn't question why I was going to this march. Rumors began to circulate that this was a hate march. I couldn't imagine two men less hateful than Pierre and Chakaras. They were both clean-cut and dapper young men, with impeccable reputations. Then, I heard that the March was anti-women. I know that no one could possibly love and support black women as much as I did, and do. As the date of the March approached, I began to see editorials in newspapers critiquing the March because it was being organized by Louis Farrakhan. There were charges of bigotry and hatred hurled. I thought of my grandmother Sarah Gibson Lytch, a devout Christian, who had the utmost respect and tolerance for all religions, and passed this belief on to her children and grandchildren. I reasoned that I could not be alone. Certainly, I was not the only person attending this March, who attended because two good friends asked me to come and support them with my presence.

I was not wrong. One million black men felt the same as I did. They were exercising their civic duty. Fathers and sons, uncles and nephews, brothers and stepbrothers, friends and colleagues, young and old men gathered to make a statement: black men not only support other black men, but love their families, communities, and country. On the ride home from the March, I looked around the van at seventeen black men, some young, a few mature. Someone asked, "What was that all about?" Without missing a beat, someone responded:

"It's about You. It's about Us."

31. Clean-Up Committee/Neighborhood Empowerment Council, New Jersey.

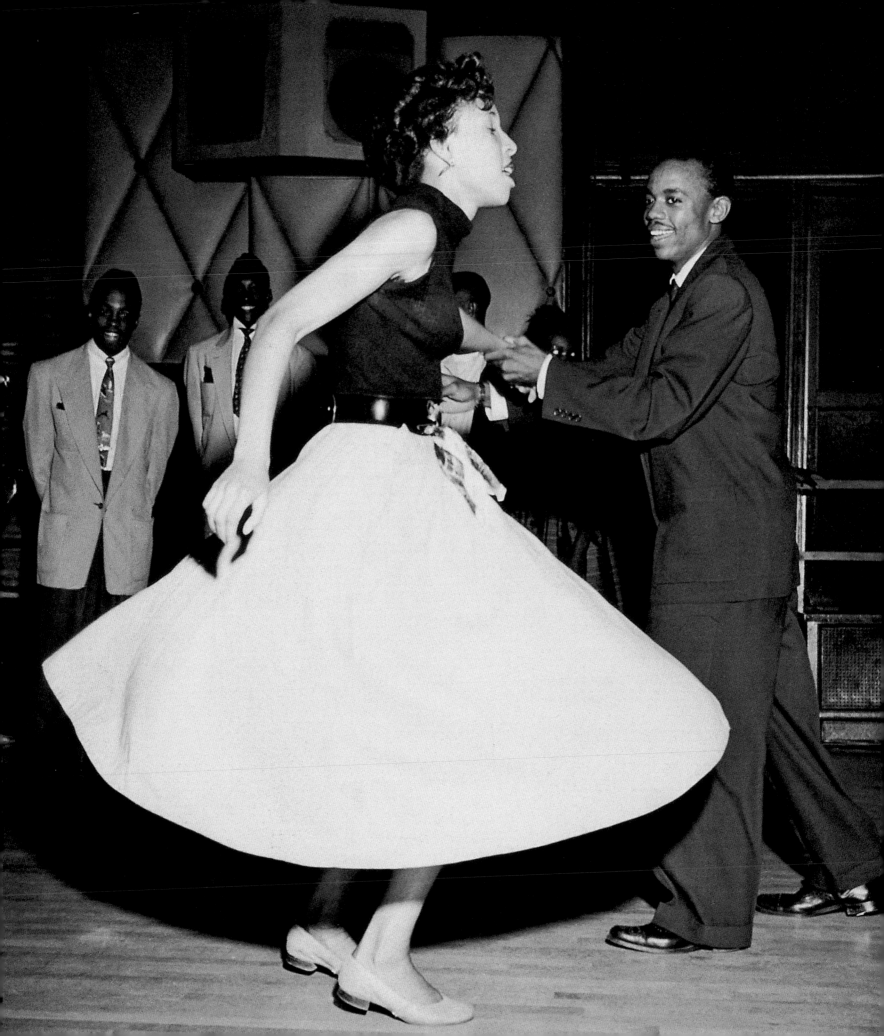

NIGHTLIFE

FOR SOME, a Saturday evening "on the town" may end sometime between dawn, Sunday school, and never.

All the beautiful people came to life at night—the sharpest-dressed people I had ever seen—jewelry flashing, furs—something else. When Sugar Ray Robinson or Billy Eckstine came to town, they became part of the scene. John R. Street was jumping with clubs like Sonny Wilson's Garfield Lounge, the Chesterfield Lounge and, nearby, the Frolic Show Bar.

—BERRY GORDY

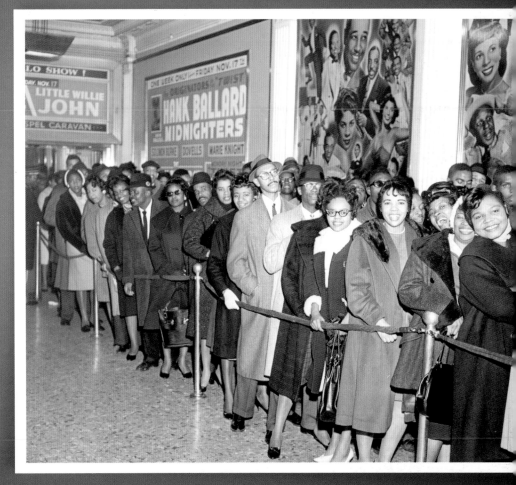

Whether at Zanzibar (pick your city), a poetry slam, the Elks Lodge, a downtown First Friday par-tay, or Ladies' Night at an uptown lounge, there is no shortage of opportunities for folks to "set the jam off right" after dark.

Having a great time is the ultimate rebellion. Wherever the "function," when we throw our hands in the air, and wave 'em like we just don't care, we are not merely "partying." We are continuing a tradition that began in our homeland, a tradition that was crucial to our ancestor's survival, during and following enslavement.

The tradition? Dancing.

Indeed, dancing was one of the few leisure activities that, when alone, our ancestors could use to express themselves freely. The politics of dancing run deep and real. Dancing was taboo on many plantations. Several nineteenth-century black newspapers discouraged readers from dancing at balls and banquets. An editor of the *Freedom's Journal* wrote: "The obloquy and contempt which have heretofore been heaped upon us, as a body, for our much and continual dancing, will, we hope, cause many who are persons of reflection to think some upon the propriety of spending so many valuable hours in this amusement."

On the contrary, the time that freed blacks spent dancing, lost in music at balls and in their homes, was probably some of the most cherished and memorable hours of their lives. Freed blacks were not alone in their quest to revel underneath the moon. After the Civil War, the proliferation of juke joints—tiny, rural back-wood shacks, with barely enough room for a band, much less patrons—provided southern blacks with a space to "socialize, listen to music, and dance" without hindrance.

Inside juke joints, sharecroppers, folks working "in-service," and the fortunate few who worked on railroads could present their best-dressed selves to one another, sharp as a blade of freshly cut grass.

If the juke joint—with its down-home blues and wooden floors—presented the height of country chic, the northeastern and midwestern dancehall epitomized the pomp and sophistication that accompanied the Jazz

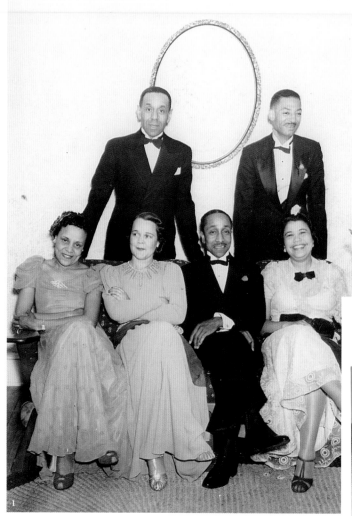

CARNEGIE HALL
7th AVE. at 57th ST., N. Y. C.
2 NIGHTS ONLY FRI.-SAT. 8:30 P.M. DEC. 26-27
ADMISSION — $4.80 — $3.60 — $2.40 — $1.80 — $1.20 Tax Incl.
IN PERSON ELLINGTON *Festival*
Duke
ELLINGTON
and his famous orchestra
WILLIAM MORRIS AGENCY
NEW YORK · CHICAGO · BEVERLY HILLS · LONDON
STEINWAY PIANO

1. On the town. 2. Duke at Carnegie Hall.

3. Connie's Inn.

4. The hottest ticket in town.

Saturday Evening
WHITE — GOLD
The Aluettes Social Club
——presents its——
FOURTH ANNUAL DANCE
"APRIL SHOWERS"
at the Beautiful
Connie's Ballroom
129th Street and Lenox Avenue New York City
APRIL 15 1967
FROM 11 P.M. — 3 A.M.
Music by CONNIE ALL STARS
Subscription including Tax and Reservation - $3.00
Packages Permitted
N° 025

Age. "The dancehall became one of the nation's most influential social institutions," notes John Edward Hasse in *Beyond Category: The Life and Genius of Duke Ellington*. "The kind of dancehall that drew the largest attendance was the dance palace: huge, brilliantly lighted, elaborately decorated with gilt, drapes, columns, mirrors, and ornate chandeliers, often with two bands, became synonymous with glamour and romance. The most celebrated dance palaces included Roseland and Savoy in New York City; the Trianon and Aragon in Chicago; the Graystone in Detroit; and the Indiana Roof Garden in Indianapolis," among others.

Those with pinched pockets could delight in all-night rent parties, which flourished in New York, Chicago, Detroit, and other large cities during the 1920s and 1930s. Often held on Friday or Saturday, rent parties started on Thursday, when hosts started to clean "hawg-mawgs" (chitterlings) and chop collards. Invitations were not required, just donations that were tucked in a shoebox, jar, or someone's décolletage. The goal of the rent party was twofold: pay the landlord and party till the last drop.

MUSIC
July 1947
Magazine OF The 8th Annual AMERICAN MUSIC FESTIVAL

5. O' What a night! Carver Hotel opening. **6.** The Canteen: military dance. (ca. 1940s)
7. Couples on the town, New York City. (ca. 1940s) **8.** G.I. Ted Poston shares a soda
with his sweetheart. **9.** Swinging at New York's Savoy Ballroom. (1947)

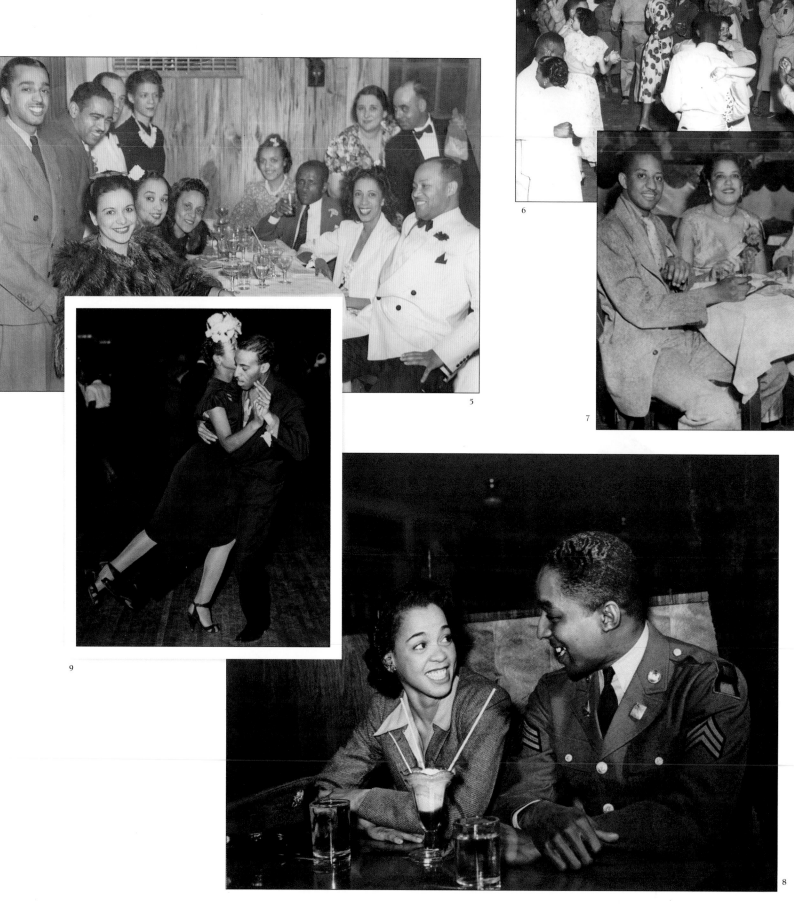

10. Cafe Zanzibar photo card. 11. Ad for Chick's Bar and Restaurant.
12. Small's Paradise supper menu. 13. Harlem hot spot Small's Paradise ad.

Down South, folks pulled out their tuxedos and tulle dresses for festivities like the June German Ball, "a sundown-to-sunrise shindig attended by thousands of frolickers who come from as far north as Maine and as far south as Miami to revel in a large Rocky Mount, North Carolina tobacco warehouse." Once a society affair, the June German ball was open to the public. For $3, patrons in formal gowns or "tennis" sneakers swung, strutted, and bopped underneath the dried tobacco. "It's a grand chance for local colored people to let down their hair and have a fling," said one local attendee in *Ebony*.

Out West, the all-male Pacific Town Club was the "swankiest, costliest and most modern (black) club in the United States in the early 1950s." Designed by black architect Paul Revere Williams, the West Adams Boulevard establishment, built as a "gathering place for its 120 members" was "something out of the Buck Rogers world," with its push-button gadgets and circular furniture that held some of Los Angeles's most influential black leaders.

On Fridays in

14

Detroit, disc jockeys urged housewives to meet their husbands at auto factories before quittin' time to claim their "cut" of their husband's paychecks, before their men hit local lounges and cabarets.

After World War II, economic opportunities and social mobility produced a sybaritic class of black folks unlike any the world has ever witnessed: the Cadillac Set. Their exploits were widely reported by the black press as they traveled from scene to scene in their tomato-red El Dorado Cadillacs and "gold" Lincolns. Many members of the Cadillac Set were instrumental community activists, especially doctors, lawyers, and university presidents.

They had front-row seats and backstage passes when Sarah Vaughn performed with the Earl Hines Band, Dinah Washington sang with Lionel Hampton, and Ella Fitzgerald scatted with Chick Webb. They held theater parties before attending *Jamaica*, *Hothouse Flowers*, *No Strings*, and *A Raisin in the Sun*. Two decades later, their children would attend performances of *Purlie*, *Pippin'*, *The Wiz*, *Dreamgirls*, *Sophisticated Ladies* and *Jelly's Last Jam*.

Not everyone had the means to get with the "getting crowd." *Our World* reported that "a $60 a week secretary

14. "The Red Dress," inspired by Abbey Lincoln's sizzling performance in the film *The Girl Can't Help It*. **15.** *Fine Brown Frame*.

15

(paid) $10 a week on a Paris gown to wear to Brooklyn's ultra-swank Comus Ball; a prominent physician's wife wore 'hot' clothes, bought from 'lifers who boldly displayed their goods at private showings'; and a well-regarded society matron was forced to pay for her elaborate parties on an installment plan.

It wasn't all good. These brave folks had little cause to party during the Emmett Till trial, the tragic bombing of four little girls in a Birmingham church, and the murders of hundreds of nameless black children and adults during the Civil Rights Movement.

This was no ordinary time. It was a time of the "youth-quake" movement. Anyone over thirty was not trusted. Op art and Pop-Art. Mini-skirts and maxi-skirts ruled. It was a time when my parents were newlyweds in Paterson, NJ. They loved the night. To them, it was owned by lovers. As a child, I remember my parents getting dressed before they hit house parties in town. My mother, wearing an afro, hoop earrings, and black stockings with a mini-skirt; my father in his black turtlenecks, wing-tip collars, and sharkskin jackets. They went to the Village Vanguard, the Brooklyn Fox, and the Apollo Theatre. Their house parties were memorable. My mother served plates of Ritz crackers with cream cheese and olive slices, wine, maybe some fried chicken, cold cuts, and of course, potato salad and collard

16. Sammy Pugh Quartet.

greens. My relatives in New York hosted informal affairs in Brooklyn and Harlem, where "grown folks" talked about "power to the people," Watergate and inflation, to the strains of Al Green, Barry White, Isaac Hayes, and Aretha Franklin records.

When my parents really dressed up, we knew that they were "going out." We had no concept of what "going out" meant, other than that it involved a great deal of

preparation. My father began his evening by spit-shining his shoes the moment that he arrived home from work. After a long shower, he would place several shirts along-side matching ties, all the while checking and rechecking his jacket against the shirt and his pants. Once, while "going out," he taught my brothers and I how to tie a Windsor knot. My mother, on the other hand, dreaded going out. She was attracted to simple, small affairs. The most time that she put into a long evening out was

when she arrived home and removed her makeup with Ponds cold cream.

When my parents went out, I would listen to clues about their evening during their post-party conversations. They were filled with mystery and allure. They would talk about so-and-so "slow-dragging too long," and this one "tying one on."

When we moved down South, my parents seldom socialized. Every odd summer or so, my mother would host backyard barbeques for "family" (which included our neighbors Baby Sister, Willie John, and the unstoppable Miss Barbara Burgess, who always looked forward to these gatherings). While the food was always on the table, there was always a relative who would come over to "show out" once the sun settled for the evening. As a matter of fact, the same three relatives "acted out" from one get-together to the next.

17. Man with two women going into a Negro Ball. **18.** Jackson Five ticket stub from Madison Square Garden. (ca. 1973)

Growing up in small-town Laurinburg, North Carolina, we did not have an R&B radio station. We depended on *Soul Train*, *The Midnight Special*, and *Right On* to keep us abreast of who was hip. Then too, if anyone from Laurinburg went "upnorth" for a week, everyone Cross the Creek (our section of town) relied on them to bring back a cassette from Frankie Crocker on WBLS. Our local stations fed us a steady playing of songs by Captain and Tenille and Seals and Croft. And then, of course, Grandma would make us turn the radio off because it was drowning out Lawrence Welk. We

felt we were ill-prepared to "go out" when the time would present itself. What could we do? Square dance.

In the early 1980s, a boom box and a mix tape from our Brooklyn cousin "Boop" changed our lives. A mix tape with Grandmaster Flash's "The Message" hit us like a bomb. Finally, music from young people about young people. And there were dances accompanying the beat: popping, locking and break dancing. And clothes: Kangol hats and Adidas sweatsuits.

Nightlife options in Laurinburg were limited to say the least. There was the Hut, the Bird's Nest, the National Guard Armory, the Laurinburg Institute, and a spattering of small clubs in the Bennettsville, South Carolina area.

Yet in those cramped spaces, something marvelous happened. As the music vibrated, and we threw our hands in the air and waved them like we just didn't care, we were becoming adults. Our bodies were changing, and so too were our minds. Friends began to express themselves as they pleased, including their clothing and hair.

The year I turned seventeen was my best yet. I woke up one morning and before my eyes there was MTV. My brother's favorite singer, George Clinton, released "Atomic Dog." Rufus and Chaka Khan parted with

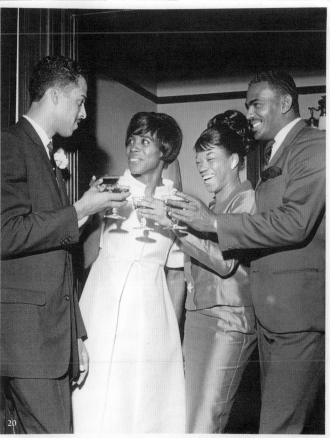

19. Don't disturb this groove. **20.** Four couples toasting a night on the town.

The
PLAYBILL
for The Empire Theatre

THE MEMBER OF THE WEDDING

21

"Ain't Nobody," to me, one of the greatest songs ever. After three failed attempts, I was finally allowed on the newspaper staff at high school, and I was taking baby steps to find my voice as a writer. And for one memorable, magical night, I was invited to go to a nameless nightclub (was it Studio 55?) somewhere in South Carolina. There, with an ultraviolet light that showed an X on the back of my hand, sitting around friends drinking Champale and smoking Kools, I felt so mature, so alive.

We danced until our feet ached. And then we stopped at Hardee's for an early morning sausage biscuit. I wondered if the nightlife always held this much promise. Seventeen years later, I have attended many nightclubs, here and abroad, but nothing will ever compare to my first night on the town with friends, in that club without a name, with one way in and one way out, and the thought that personal freedom was right in the palm of my hands.

PLAYBILL
IMPERIAL THEATRE

DREAMGIRLS

23

PLAYBILL
St. James Theatre
the national magazine for theatregoers

HELLO, DOLLY!

22

24

26

21-23. Playbills. 24. *We've Come a Long, Long Way.* 25. *Motortown Revue* poster. (ca. 1960s) 26. *Sepia Cinderella* in black and white.

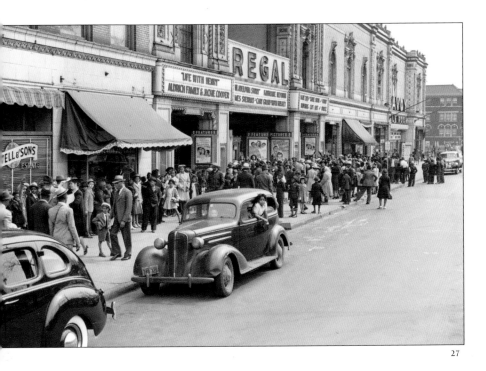

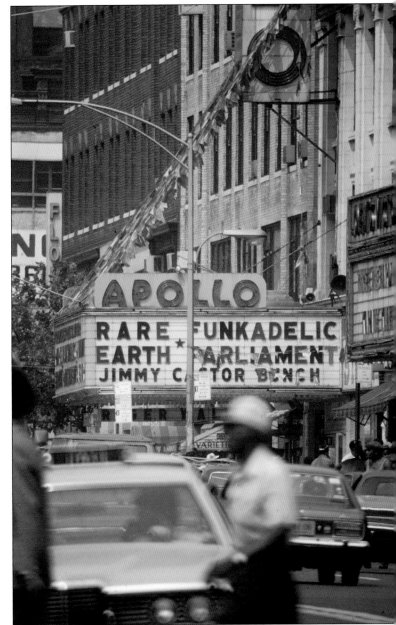

27. *The Philadelphia Story* plays well in Chicago. (ca. 1940s) 28. We Want the Funk.
29. Poetry slam. 30. Public Enemy.

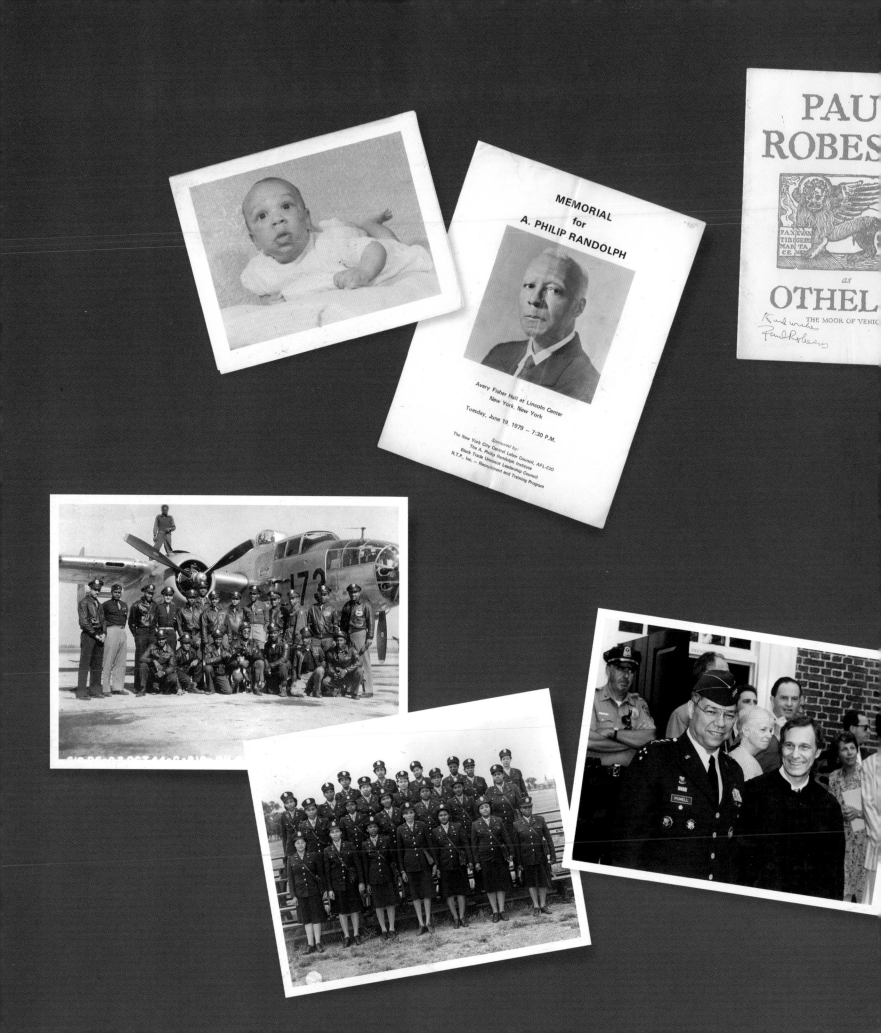

PAU
ROBES

MEMORIAL
for
A. PHILIP RANDOLPH

FAX EVA
TIDIGER
MAR TA
CE ME

as
OTHEL
THE MOOR OF VENIC

Avery Fisher Hall at Lincoln Center
New York, New York
Tuesday, June 19, 1979 — 7:30 P.M.

Sponsored by:
The New York City Central Labor Council, AFL-CIO
The A. Philip Randolph Institute
Black Trade Unionist Leadership Council
R.T.P., Inc. — Recruitment and Training Program

173

POWELL

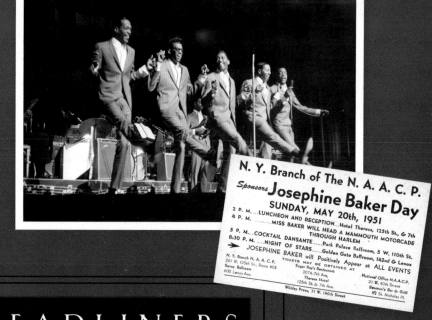

HEROES & HEADLINERS

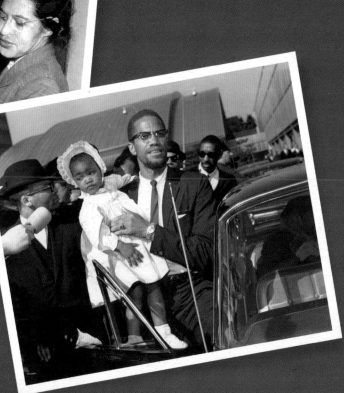

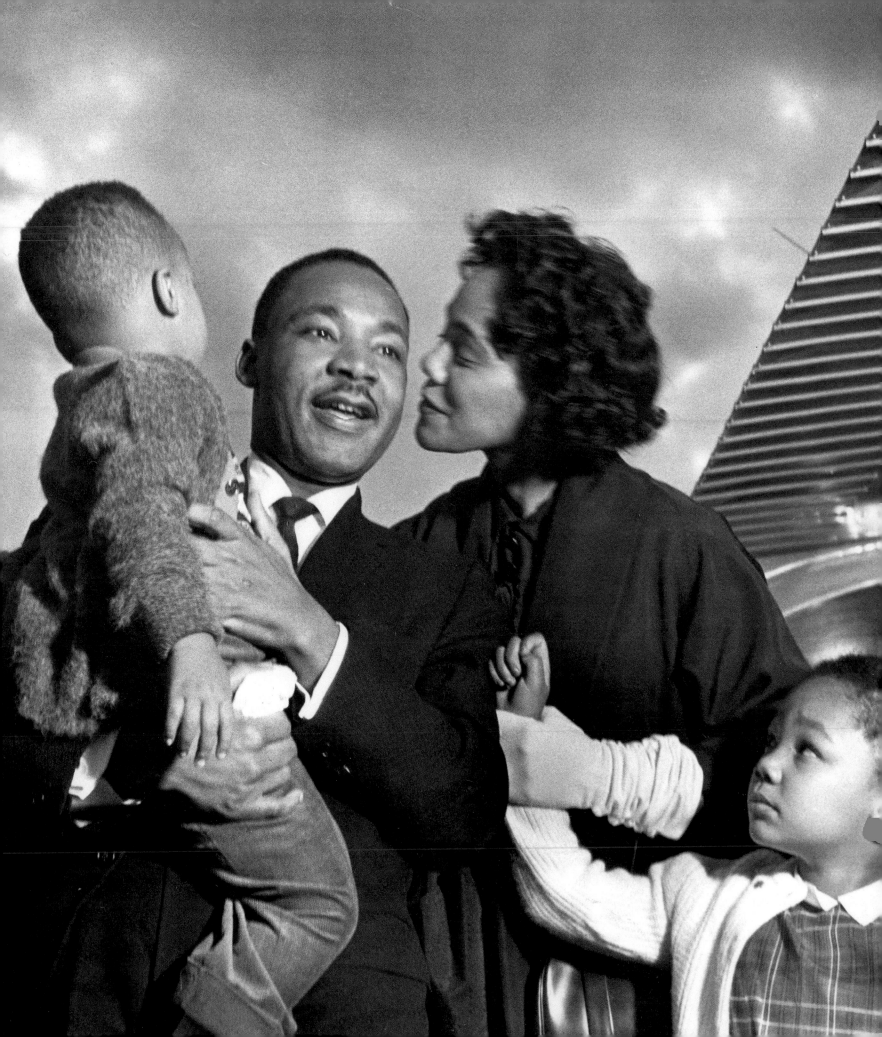

LET US NOW praise famous black men and women: heroes and heroines, trailblazers and trendsetters who advanced the Negro Cause from World War II through the

It took [Lena Horne] a long time to overcome feelings of being trapped behind the role model, and feeling "unworthy" of the part at that. On the positive side, being "symbolic" may have saved her from the ordinary pitfalls of Hollywood life, the stuff of Hollywood Babylon. She was never permitted the common mistakes, bad habits, or ego trips, there were too many people watching—all those Pullman Porters, for example.

—GAIL LUMET BUCKLEY

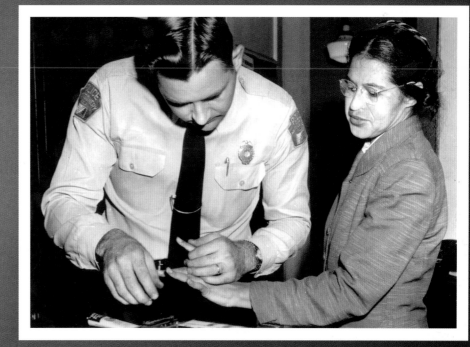

Civil Rights Act of 1964. Today, thanks to them, there is little ground left to be broken. Through their grace and talent, they challenged the conventional wisdom of their day and reshaped our future, forever.

It wasn't easy.

They had assistance.

Not just from parents, guardians, and spouses but the community-at-large: nameless, faceless black folks, who

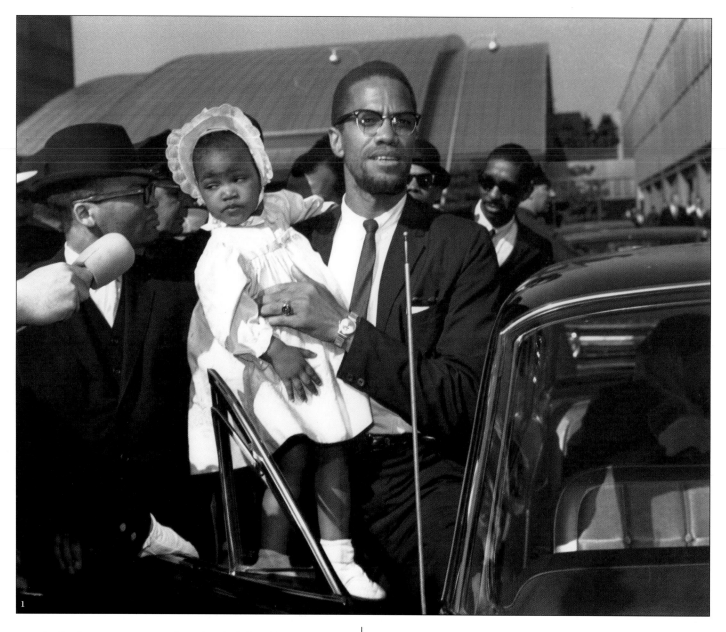

marched when necessary and applauded, loudly, each time they scored a major victory. And there were many victories. So many successes, in fact, that a few of these courageous Americans were forgotten, as a new generation stood proudly in their shoes, reinvigorated the masses, broke records, and strolled, confidently, into another era.

Indeed, over the past fifty years, individuals of African descent have made enormous strides in politics, entertainment, sports, and culture. Black folks are visible in nearly every branch of American government. There are few national sports in which black men and women are not present as coaches or players. We have chipped away at the glass ceiling of Fortune 500 companies. In the summer of 2000, one of the most important seasons in the film industry, three African-American films grossed more than $100 million at the box office. Military general Colin Powell, media mogul Oprah Winfrey, basketball legend Michael Jordan, and Nobel Prize-winning author Toni

1. Malcolm X, one of black America's favorite sons, was also a devoted husband, father, and community leader.

Morrison consistently rank among the most admired, respected, and recognizable Americans in polls and surveys. No doubt, their success has far exceeded their most imaginable dreams.

For those of us who are black, the importance of dreaming "big" can never be underestimated nor be taken for granted. Dreams—active, alluring, alive—are a birthright, to fulfill them is a mission, a calling. Our dreams are the one thing that we can claim as our own. During enslavement, our children could be taken away from us, our lives could be controlled through terror and violence, but no one, not a living soul, could tell us what or how to dream.

In this chapter, we pay homage to ladies and gentlemen who dared to dream "big" and to see those dreams through. Dreams were probably far more secure than these people's day-to-day reality. Two or three generations removed from enslavement, they'd survived a world war and a depression, not to mention lynchings, skinnings, and race riots. With the will of a winter storm, they used their unique gifts to affect people, to move them in ways that they could not dream.

They combined courage and charisma with a strong sense of civic duty and pride in their communities, which was evident during their speeches, standing-room-only performances, and sparkling special events. No matter how far success took them, they could always come home. And they did, since most were down-to-earth. Some were outrageous, haughty, audacious, while several were misunderstood, not at all easy to embrace. What they had in common was a loyal black community . . . hungry for heroes, since few if any of their triumphs were echoed in daily newspapers, magazines, and radio programs. Young

2. Baseball legend Jackie Robinson with Rachel on their son's special day.
3-4. Amazing Adam Clayton Powell, Jr., Hazell Scott and "Skipper."

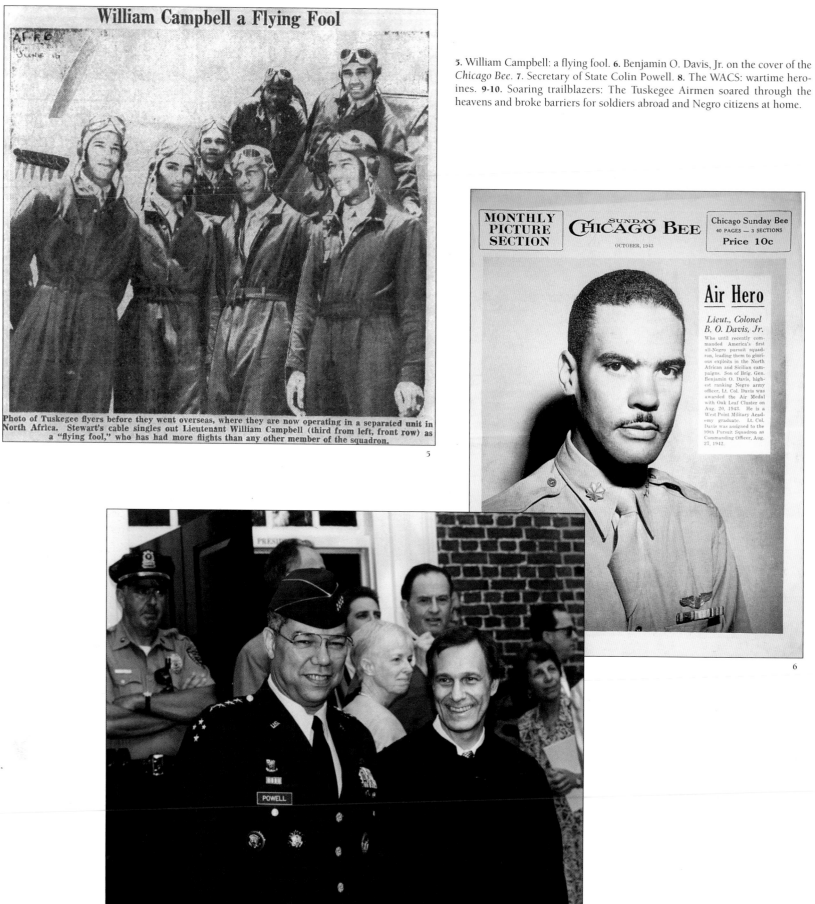

William Campbell a Flying Fool

Photo of Tuskegee flyers before they went overseas, where they are now operating in a separated unit in North Africa. Stewart's cable singles out Lieutenant William Campbell (third from left, front row) as a "flying fool," who has had more flights than any other member of the squadron.

5

5. William Campbell: a flying fool. 6. Benjamin O. Davis, Jr. on the cover of the *Chicago Bee*. 7. Secretary of State Colin Powell. 8. The WACS: wartime heroines. 9-10. Soaring trailblazers: The Tuskegee Airmen soared through the heavens and broke barriers for soldiers abroad and Negro citizens at home.

MONTHLY PICTURE SECTION	SUNDAY CHICAGO BEE OCTOBER, 1943	Chicago Sunday Bee 40 PAGES — 3 SECTIONS Price 10c

Air Hero

Lieut., Colonel B. O. Davis, Jr.

Who until recently commanded America's first all-Negro pursuit squadron, leading them to glorious exploits in the North African and Sicilian campaigns. Son of Brig. Gen. Benjamin O. Davis, highest ranking Negro army officer, Lt. Col. Davis was awarded the Air Medal with Oak Leaf Cluster on Aug. 20, 1943. He is a West Point Military Academy graduate. Lt. Col. Davis was assigned to the 99th Pursuit Squadron as Commanding Officer, Aug. 27, 1942.

6

7

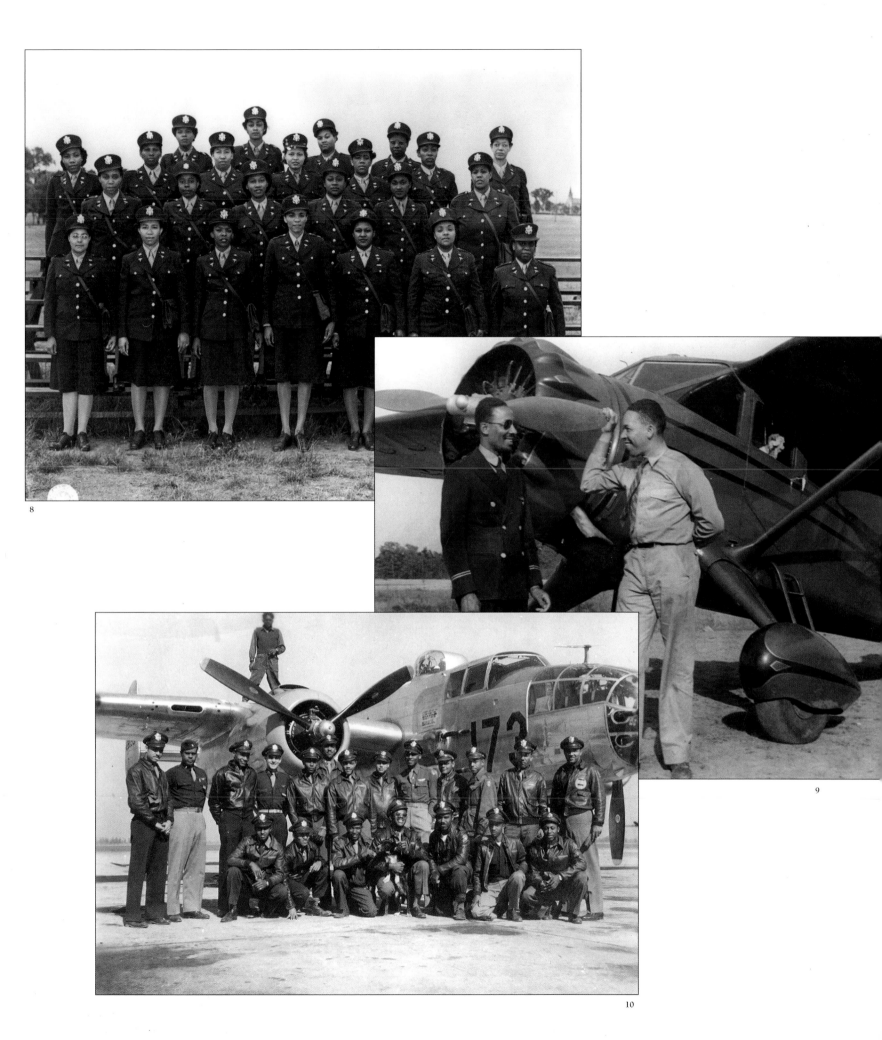

8

9

10

children in search of heroes at the Saturday matinee were sorely out of luck. Sitting in segregated balconies of movie houses, their eyes took in images of Tarzan, valiant cowboys, and wily detectives—all white—who saved the day, got the girl, and restored order. That is until 1938, when doe-eyed boxer Joe Louis a.k.a. The Brown Bomber, would score a knockout for racial pride, defeating German boxer Max Schmeling. His victory was a watershed moment. Black folks huddled around radios in northern brownstones, and southern shotgun

MEMORIAL
for
A. PHILIP RANDOLPH

Avery Fisher Hall at Lincoln Center
New York, New York

Tuesday, June 19, 1979 — 7:30 P.M.

Sponsored by:
The New York City Central Labor Council, AFL-CIO
The A. Philip Randolph Institute
Black Trade Unionist Leadership Council
R.T.P., Inc. — Recruitment and Training Program

11

shacks and juke joints, suspending their dinners, keeping their hands busy with needlepoint and cigarettes, hoping, praying for a Louis victory.

When he won, black folks could not contain their joy. Louis was a matinee idol who didn't have to appear on the silver screen. Although Louis was rebuked in some corners when he handed over the entire purse for his victory over Buddie Baer in 1942 over to the war effort, today he remains a heralded sports hero. Louis paved the way for the swanky welterweight Sugar Ray Robinson, who knocked out Jake LaMotta during the St. Valentine's Day Massacre of 1951, and a brash and bold young fighter

11. Memorial for labor leader A. Philip Randolph. 12. Roy Wilkins inducting the newest member of the NAACP.

named Cassius Clay, who would win a Gold Medal at the Olympics in 1964. After the Olympics, Clay would change his name to Muhammad Ali, and become, arguably, the greatest athlete of the twentieth century. Blending movie star magnetism with "big talk," Ali delivered on his promises. And when he didn't always come through, he handled defeat with remarkable restraint.

Prewar and postwar black folks would wait and watch for their next hero, the next person who would command the spotlight on the world stage. Pastors would weave these heroes' names into sermons; folks conjured their names at beauty parlors and barbershops. Men and women emulated

12

them, wearing porkpie hats, pageboy haircuts, and mink wraps. Undoubtedly, one of the most beloved sports heroes of all time was baseball superstar and astute businessman Jackie Robinson. Long before Robinson shattered barriers in professional sports when he put on a Brooklyn Dodger uniform in 1947, folks in Kansas recalled him as a standout member of The Monarchs, one of many stellar baseball teams of The Negro Leagues, which prepared Robinson for formidable competition. After all, the Negro Leagues featured some of the nation's most talented baseball players, including

13

pitcher Satchel Paige, whose sixty-four straight scoreless innings during the Negro World Series is a record that still stands. But for reasons that included his athletic skills, Robinson was The One. On and off the field, Robinson was a class act: wellspoken, clean-cut, and a proud family man. He wore responsibility like a second skin.

Because of Robinson's success, racial barriers were tumbling like the Walls of Jericho. The shocking murder of Emmett Till in Mississippi energized the black press. Reporters and editors from the *Chicago Defender*, the *Pittsburgh Courier*, and the *Atlanta Daily World* offered incisive and insightful reports on every major event of the Civil Rights Movement: the *Brown v. Board of Education* decision, radiant Rosa Parks refusing to give up her seat to a white man in Montgomery, sparking

15

the successful Montgomery bus boycott, the integration of Central High School in Little Rock, enforcement of civil rights laws by a team of NAACP lawyers, including

14

13. Future Supreme Court Justice Thurgood Marshall. 14. Nobel Prize-winning humanitarian Ralph Bunche: a profile in courage. 15. Dr. Charles Drew: a credit to African-Americans and savior of the human race.

Constance Baker Motley, church bombings, midnight murders of young black men, who were dragged from their homes into the night, sit-ins at lunch counters throughout the South, Mississippi sharecropper Fannie Lou Hamer's riveting, spine-chilling testimony before the Democratic Credentials Committee in 1963, questioning an American political process that denied its black citizens the right to vote. Overnight, high school and college students, professionals and blue-collar folks who challenged injustice became heroes in the press. Their stories often bumped entertainers, athletes, and socialites off the front pages. Black newspapers and magazines—*Our World*, *Ebony*, and *Jet*—offered a forum for political and civic leaders that was not available in other media. As a result readers felt a kinship with their leaders.

Adam Clayton Powell Jr. was more than a congressman to his Harlem constituents, he was "a church boy." The namesake of his father, the minister of famed Abyssinian Baptist Church, Powell was a brilliant politician who possessed a wicked sense of humor. Like so many leaders during his day,

Powell walked the walk, and talked the talk. When he led a boycott in 1940 against McCrory's department store on Harlem's famed 125th Street to protest their racist hiring policies, he drew attention to black spending power. Today, one of the tallest office buildings in Harlem bears his name, and every now and then, one can hear a Powell speech blasting from the stereo of one of Harlem's high-rise apartments. The black press reported on virtually every case that Thurgood Marshall argued before the Supreme Court (especially the landmark *Brown v. Board of Education* decision), when he was a founding member of the NAACP Legal Defense and Education Fund. Once he was appointed to the United States Supreme Court in 1967 (its first black member), the press reported on every consenting and dissenting vote that he cast.

16. Magnificent Mollie Moon with Walter White, Mrs. Marshall Fields, Henry Lee Moon, and Edward Perry. 17. The Urban League's glittering Beaux Arts Ball.

Asa Philip Randolph, director of the 1963 March on Washington and founder of the powerful Brotherhood of Railroad Porters union, was seen as an avuncular elder statesmen in the pages of the press. And NAACP president Roy Wilkins, whose profound political skills were crucial to the passage of the Civil Rights Act of 1964 (and the subsequent passing of the Voting Rights Act of 1965 and the Fair Housing Act of 1968), was photographed at every community luncheon and banquet, cosmopolitan as ever.

Dr. Martin Luther King Jr. and his breathtaking bride Coretta Scott King was black America's super-couple.

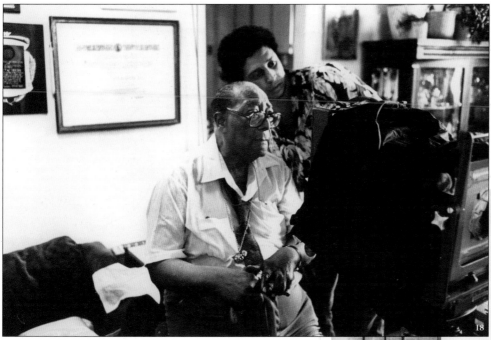

When one discussed the great civil rights leader, it was with his entire name—beginning with "Dr." and ending with "Jr". Anything less and one was certain to be corrected. Like most of the black folks who were in the public eye, the Kings were always impeccably dressed. Folks who grew up during segregation can recall with alacrity the ritual of dressing up to go "downtown," which meant an interaction with white folks. Clothes were laid out the night before as if one were going to church or a funeral. Every day, King led a group of civil

rights supporters who came to march in their Sunday best. Also a "p.k." (preacher's kid), King knew how to communicate with every strata of black America. Few went untouched by his passion for justice and unconditional love for humanity.

The black press provided a glimpse into the private lives of black celebrities. Readers of the *Afro-American* knew the elegant and dashing Duke Ellington well before he became one of the most popular bandleaders and composers in the country thanks to such ditties as "It Don't Mean a Thing" and "Sophisticated Lady." Ellington was a perennial favorite on the Best Dressed List, originated by travel editor and entrepreneur Freddye Henderson.

Hattie McDaniel, the first black woman to win a Supporting Actress Academy

18. Photographers James VanDerZee and Anthony Barboza. 19. An American classic: writer Langston Hughes.

Award, for her role as Ma'amy in *Gone with the Wind*, may have played sassy maids on the big screen, but as black newspaper and magazines revealed, she was a serene presence at black women's club meetings and charities. And McDaniel, like many of the fortunate few working black actors and actresses of her day, went to great lengths to present her best self to her adoring fans.

Once pioneering *Pittsburgh Courier* columnist Evelyn Cunningham called Louis "Satchmo" Armstrong, known for his raspy voice and revolutionary trumpet playing at home, and discovered that he was listening to Beethoven. "Y'know, I play a lot of it," he told Cunningham. "You can learn a lot from them cats." Cunningham, who used to sashay in the *Courier*'s New York offices sporting "dyed red hair, a mink coat, and attitude," interviewed every black celebrity on either side of the Mississippi, and often showed

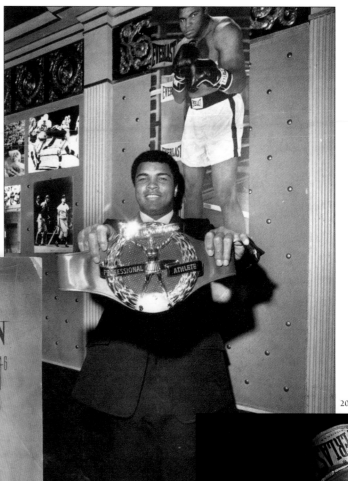

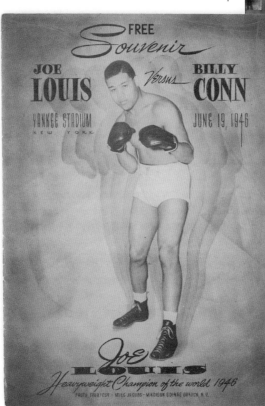

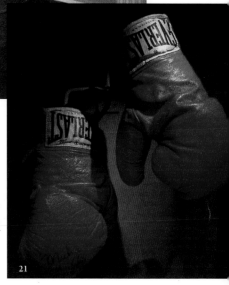

them living their best lives. Later, Cunningham would earn the moniker "Lynching Editor" for her aggressive reports on the burgeoning Civil Rights Movement in the South in the late 1950s and early 1960s.

But there was no shortage of society columnists who breathlessly reported on brunches, teas, and dinner parties hosted by such socialites such as "Mrs. Count Basie," wife of the famed bandleader, or "Mrs. Nat King Cole," or "Mrs.

Roy Campanella," wife of the Dodgers catcher, or "Mrs. Sugar Ray Robinson." Also covered were soirees coordinated by Edward Perry, an event planner who apprenticed under the fabled impresario Elsa Maxwell.

According to *Ebony*, "No one in America was closer to the pulse of black folks than the society editors of the Negro press." Determined and disciplined, "through their columns, they did more to interpret the social patterns of

20. Muhammad Ali—to many, the greatest athlete of the 20th century.
21. The Greatest's gloves. **22.** Joe Louis, "The Brown Bomber."

the community than sociologists or psychologists." Many of the social editors lived a caviar and cashmere life, even if they didn't always enjoy it. *New York Age* editor Betty Granger was "a suburbanite who carried an extra change of clothes when she went off to work." Well-known *Pittsburgh Courier* editor Toki Schalk Johnson, who had a distaste for pretension, summed it up best: "To be a social editor, you must have a strong constitution, cast iron stomach, a private income, lots of good clothes, and the ability to say, 'dahling.'"

One of the staples of their columns was Mollie Moon, "the handsome wife of NAACP publicist Henry Lee Moon." Moon's "glittering Beaux Arts Ball" for the New York Urban League was hands-down, Harlem's "top social event," and "Negro socialites and whites from all over the country, including British members of Parliament, Dr. Ralph Bunche, Lena Horne, writers Alan Paton and Langston Hughes" were in attendance. Alongside the columns were images of fashion models, according to *Ebony*, "representing every color in an assortment of Fannie Farmer chocolates." Some were well-known singers such as the bombshell Barbara McNair. Most were graduates of the Grace Del Marco Modeling Agency, founded by Ophelia DeVore, who had an eye for talent. DeVore discovered Diahann Carroll years before Rodgers and Hammerstein would create a Tony Award-

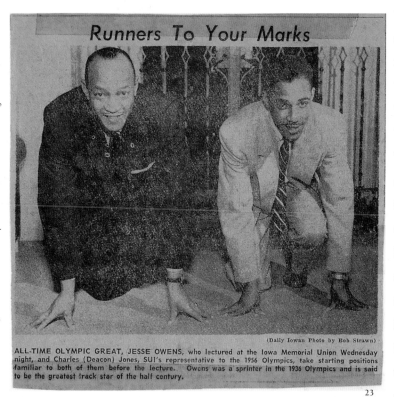

Runners To Your Marks

(Daily Iowan Photo by Bob Strawn)

ALL-TIME OLYMPIC GREAT, JESSE OWENS, who lectured at the Iowa Memorial Union Wednesday night, and Charles (Deacon) Jones, SUI's representative to the 1956 Olympics, take starting positions familiar to both of them before the lecture. Owens was a sprinter in the 1936 Olympics and is said to be the greatest track star of the half century.

23

23. Olympic hero Jesse Owens.

winning musical (*No Strings*) in her honor. Former model Audrey Smaltz allowed many young black girls to dream that they could model when the traveling *Ebony* Fashion Fair came to their towns. The brainchild of Eunice W. Johnson, the Fashion Fair brought European couture to cheering black audiences across America. As the fashion commentator, Smaltz, who never once read from notes, redefined the fashion show and turned the evening into an experience. Young women in rabbit coats, wearing their mother's White Shoulders and Youth Dew perfume, emerged from theaters, twirling and strutting down the streets, or imagining that they could create an Ann Lowe original. Lowe, a Bostonian, designed Jacqueline Bouvier's wedding dress worn when she said "I do" to John F. Kennedy.

The postwar period ushered in a cavalcade of sensational performers who sang in the nation's top nightclubs, and appeared on Broadway and the big screen. Lena Horne, the first black woman under contract with a major studio, was the epitome of Hollywood glamour. Refined and exquisite as porcelain, Horne was a pinup for black GIs overseas and a popular role model for young black women who emulated her upswept hair, immaculate makeup, and chic wardrobe. Her heartbreaking rendition of "Stormy Weather" in the all-black musical *A Cabin in the Sky* was copied in talent shows and debutante pageants for decades. When roles in Hollywood diminished, she

took to the road, joining such show-stopping performers as Sammy Davis, Jr., Billy Eckstine, Pearl Bailey, Della Reese, Ella Fitzgerald, and Sarah Vaughn, who dazzled audiences with their chart-topping tunes, and demanded to play before integrated audiences.

Some of these performers came into our living rooms via a new invention called the television. Whenever a black person appeared on television it was a Big Deal. Folks would eagerly scour through black newspapers and *Jet* magazine in anticipation of a "colored" person's appearance on the small screen. Often appearing on variety programs, where they seldom interacted with the host, nonetheless, with a look, one note of a song, or a dance step or two, they left viewers in a trance. On "Colored Person on T.V. Night," folks gathered around their living rooms, or more likely at a neighbor's house, and talked through countless plate spinners, polka

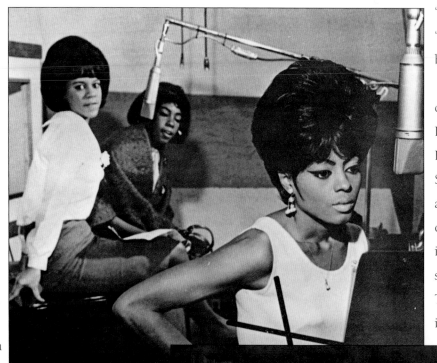

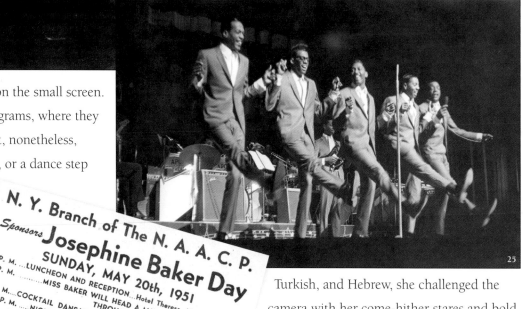

dancers, and jugglers on *The Ed Sullivan Show*. But once Sullivan, who was as animated as frozen peas, would point that stiff arm and introduce "Eartha Kitt," "Nat King Cole," "Dinah Washington," or "Louis Armstrong," all bets were off.

A former member of the famed Katherine Dunham dance troupe, Eartha Kitt, born in South Carolina, was an enigma. When she opened her mouth, it was if she were a spokesperson for the Tower of Babel. Singing in French, Portugese, Turkish, and Hebrew, she challenged the camera with her come-hither stares and bold sexuality. She was one of many black women who found success in Europe before unleashing her talent stateside. Like Josephine Baker, Joyce Bryant, and Mabel Mercer, Kitt was an enchanting chanteuse whose over-the-top antics

24. The sophisticated Supremes, America's favorite girl group. **25.** The tantalizingly hot and totally together Temptations. **26.** A notice for Josephine Baker Day.

made her a staple in gossip columns. Kitt was a standout on Broadway in *New Faces of 54*, and later starred alongside Nat King Cole and Ruby Dee in *St. Louis Blues*, a musical based on the life of jazz musician W. C. Handy.

What Jackie Robinson was for baseball, Nat King Cole was for entertainment. Along with his eponymous *Trio*, the velvet-voiced Cole crossed over from the "race charts" to the pop charts with such smash hits as "Mona Lisa," "Route 66," and "Unforgettable." Cole opened the doors for equally suave music stars such as Harry Belafonte, Billy Eckstine, and crooner Johnny Mathis. Cole broke ground when he hosted his own variety show in 1956 on NBC. He wasn't the first black performer with a television program, however. That honor went to Hazel Scott, the then-wife of Adam Clayton Powell, and Billy Daniels. But Cole's program was the most memorable. Inviting guests such as Kitt, Horne, Eckstine, and Fitzgerald to appear on his show, it was too much for the segregated southern television viewers, and the show was abruptly canceled after less than a year.

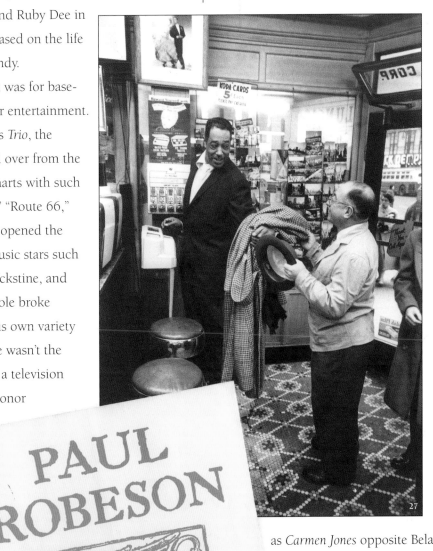

Every spring folks would again crowd around their television sets, fingers crossed, during the Academy Awards. They prayed hard that Juanita Moore, nominated for Best Supporting Actress in *Imitation of Life*, and Ethel Waters, who received two Best Supporting Actress nods for her roles in *Pinky* and *A Member of the Wedding* would win. It didn't happen. And who wasn't disappointed that dynamic Dorothy Dandridge lost her bid to become the first black woman to win a Best Actress Oscar for her leading role as *Carmen Jones* opposite Belafonte. Dandridge, a tender and fragile beauty, never took her black fans for granted, and often declined roles that reinforced negative stereotypes. *A Raisin in the Sun*, writer Lorraine Hansberry's award-winning Broadway play starring Sidney Poitier, Ruby Dee, the electrifying Diana Sands, and the memorable Claudia McNeill, was nominated for several Academy Awards when it made the leap to the big screen, but folks

27. Duke Ellington on the mellow side. **28.** Paul Robeson as Othello program.

knew better. They suffered in silence when the movie went home empty-handed.

However, their suffering turned into screams of joy when Sidney Poitier captured the gold in 1963 for his role in *Lilies of the Field*. Poitier broke box-office records and fluttering hearts of female fans with his proud, dignified,

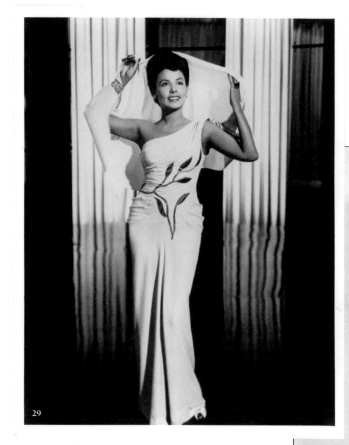

29

and three-dimensional characters in such classic films as *In the Heat of the Night*, *To Sir, With Love*, and *Guess Who's Coming To Dinner?*

In the early 1960s, black teenagers prayed for a musical sound of their own. From a small recording studio in Detroit, aptly named Hittsville, U.S.A., their prayers were answered. Duplicating the assembly line automobile process that was the backbone of the Detroit economy, young entrepreneur Berry Gordy, with a loan from his family, attracted young black men and women from Detroit and the surrounding areas, and transformed

them into sleek, chic, charming "hit-making" groups. They received instructions in stage performance and etiquette from charm-school teacher Eleanor Powell. She groomed them well. The Four Tops, the Miracles, the Marvelettes, Marvin Gaye, and Martha Reeves and the Vandellas energized sock hops with the sound of young America. Every Saturday, with babysitting money in hand, black teenagers ran downtown to buy the latest "Motown" hit. Few could predict the impact that The Temptations—six tall, talented, tantalizingly terrific, totally together black men— would have on young Americans when they appeared on *Hullabaloo*, dancing and singing in perfect unison, with

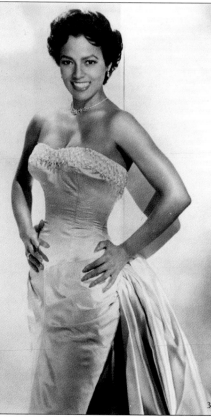

30

moves as sharp as a shark's fin. Finally, young black men had "brothers" to emulate.

And no one, but no one, could've foreseen the impact that three teenage girls from the Brewster Housing Projects in Detroit would have on popular culture when they became The Supremes. Florence Ballard, "the quiet one," Mary Wilson, "the sexy one," and Diana Ross, "the one,"

hypnotized the world with their perfect harmonies, and addictive songs "I Hear a Symphony," "Baby Love," and "Stop! In the Name of Love." The Supremes headlined at every top-tier nightclub in America. They appeared on

29. Lena Horne. **30.** Dorothy Dandridge.

The Ed Sullivan Show that he often referred to them as "the girls." They created fashion trends with their mini-skirts, maxi-skirts, sleeveless dresses, and Cleopatra-style makeup.

By 1965, young men and women could stand before their teachers and proudly tell them that they wanted to be the next Althea Gibson, who scored tennis victories at Wimbledon and the U.S. Open, or Wilma Rudolph, who won three Olympic gold medals in track and field at the 1960 Olympics. They could recite poems by Pulitzer Prize winner Gwendolyn Brooks or the prolific Langston Hughes. There were other heroes and headliners, including the best dancers at talent shows, and school-teachers who remained after school with us to make sure that we understood a math problem or knew how to dia-gram a sentence. Some folks were heroes to us, and we didn't know it or see it until they were long gone.

Every Saturday, without fail, sometime around noon, my Aunt Lillie Mae walked past three houses on McGirts Bridge Road in rural Laurinburg, North Carolina, to join our family on the front porch. In a town where folks could let themselves go after a certain age, Aunt Lillie Mae was committed to maintaining her thin figure. Her lightly-toasted almond complexion was clean and always clear. No matter the weather, she always wore shades, and more often than not, Jackie O-style goggles. She stood out from

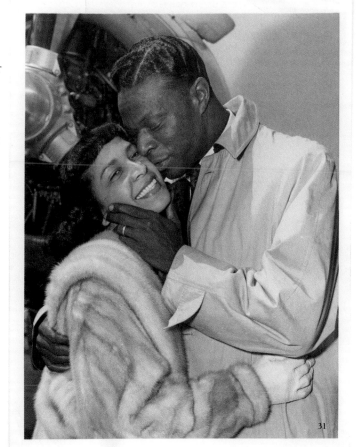

31

us in so many ways. We were real; she was ethereal. We were proud; she was proper. As children, we would sometimes giggle when Aunt Lillie Mae came down the road to sit on the front porch. We didn't know how to respond to her. But with age and experience, I began to appreciate Aunt Lillie Mae's outlook on life. She did as she damn well pleased.

Now, I realize that she was a very special guest, and a necessary one. She was our only link to a time when black folks had the audacity to enjoy the world and their place in it. I never knew precisely what she did for a living in New York. I thought she was a model. Later, I learned that she was a cook on Long Island. Apparently, the lady of the house did a lot of entertaining. It made sense to me. When Aunt Lillie Mae entertained, her attention-to-detail was astonishing. Whereas at other gatherings, we improvised when some-body in the family forgot a key ingredient in a pie, handed out "mismatched" dinnerware, or ran out of ice, Aunt Lillie Mae was a perfec-tionist and a flawless hostess. She entertained only once or twice a year, but it was always a big event.

Like so many people during her time, Aunt Lillie Mae soaked up the atmosphere of her employers and reinter-preted it when she was at home. On Thursday nights, after

31. Nat "King" Cole and Maria Cole.

everybody had been paid for working long and hard hours at the local factories, folks on the black side of town, or "Cross the Creek," could be counted on to have a good time, with lots of music, and plenty of laughter. No one laughed louder or with more bravado than Aunt Lillie Mae. Growing up around superstitious people, Aunt Lillie Mae encouraged me to take a bite out of the world. As I left for college, she was nearing her sixties, but she had the energy of a coed. Before sunup, she'd already bathed, cooked dinner, and stored some leftover food for the next day. She enjoyed company. And

when you visited—there were always coasters, tumblers, napkins, and seconds—she knew everything that was happening in the world. As the evening wore on, she'd sprinkle in a "dahling" or "mahvelous" throughout her conversation, a sign that she'd lived and thought outside the box. While I'm sure she missed New York, she understood, like so many wise folks do, that it's not when or how you arrive but knowing what time to leave—like a true hero, who needed time to think and dream.

32. Bill Cosby and Oprah Winfrey at The *Essence* Awards. (2000) 33. Sidney Poitier with Audrey Smaltz.

EPILOGUE

For more than 160 years, we have documented our lives—moments of triumph and treasured memories—in our photographs. Whether in Polaroids, duotones, snapshots, slides, or film from a disposable camera, these images are precious, priceless, and irreplaceable. Images of family, neighbors, friends, and strangers who become friends illuminate our daily existence. Visual images allow us to never forget the people, places, and things that we love, experience, and cherish.

Indeed, photographs do more to lay bare our relationships than any other visual medium. No matter how often we witness the love between a bride and groom, the poignancy of a grandparent cradling a grandchild in their arms, siblings sharing a meal or engaged in mischief, in a picture these relationships take on a special relevance. They become something more.

We wonder why the camera—a seemingly innocuous, benign contraption—wields such power. What is it about a photograph that can alternately transfix and transform us? Theories differ. But what we do know for certain is that a photograph not only touches nearly all of our senses, but it also effects the way others see us, and the way we see each other.

Once a picture is taken, its image is frozen, forever. The identity of the subject is sealed within the borders of the photograph. All that will change are reactions to it. Through a photograph, not only is an image borne, but so too, is a fixed identity.

Photography and its end result—image—has done much to protect and sustain the American identity. But in the end, we know that people will see what they choose to see.

And so we owe a debt of gratitude to those brave men and women, black and white, who continue to focus their cameras in close-up and wide-angle on people, without prejudice.

To those of us who are black, particularly those of us who live in black communities, a camera may well be our safest assurance to protect both our image and identity. The images in our photo albums, on our walls, atop our pianos, and in our shoeboxes, comfort us.

Looking at our photographs, we see the unrecorded, unspoken moments of our lives. They come as natural to us as breathing and walking. Acts of kindness. Laughter. A touch. A smile. A warm embrace between two friends on a city or country street. A wink. A nod. A stare. We see each other plain. We see each other pretty. We see moments that move us to pray. We see each other proud. We see each other in private. We see each other privileged. We see each other parade, prance, and party. We see each other imperfect. In a photograph, we see each other as we are, and as we want to be, someday.

AFTERWORD

⚬⚬⚬

WHEN I FIRST SET OUT on this journey to compile what would become this photo album of African-American community life, I imagined myself and my co-author on the road; traveling from state to state, collecting stories and mementos of lives well-lived, while photographing faces well-worn with age and experience. What I realized very soon, however, was that much of the legwork had been done, and the journey had been taken long before my recent rediscovery of the community that shaped me.

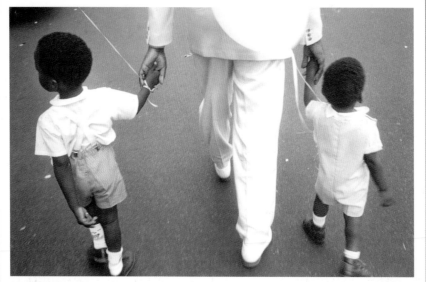

My family home since the 1960s has the warmth of a womb, thanks to my mother. I think that losing her own mother so early in life led her to create a safe environment for her family, where we never felt a sense of want. Our African-American parents, not unlike any other group of Americans, taught us the value of moderation, importance of family, the power of the spirit, the pursuit of the American Dream through hard work and education. Our "class structure" wasn't defined by income, but by the values we held dear.

Family gatherings were always filled with music, and often revolved around a theme: a birth, a death, or a reunion. My father was the unifying force of these gatherings. An NYU-educated Jazz musician who was blind since childhood, he could often be found in a sport jacket or suit (not unlike most men of his day), with his head held high and his feet firmly planted in his community. His music, 10 years after his death, still evokes stories and moves men to tears. Our music—blues jazz, gospel and soul—was the thread in our quilt that wove us tighter as a community. The Impressions told us that "We're A Winner", James Brown urged us to "Say It Loud, I'm Black and I'm Proud", Stevie Wonder told us about our heroes in "Black Man". The Supremes in glamorous evening gowns, and the Temptations in well-cut, narrow-legged suits sent us running to the TV for our first glimpse of the elegance that we, too, could possess. We repeated their choreography and harmonies in our talent shows, which took place at the same community centers where we first learned ballet, met our oldest friends, and became "scouts".

Our community nurtured and protected us. Before integration, African-American maids and butlers lived alongside teachers and lawyers. The shopping district, which anchored our neighborhood, also provided residents with services, employment, and ownership in our community. But that was

before urban renewal, and before the killing of Dr. King sparked riots, which raged from the East Coast to the West, which in turn caused an exodus from our neighborhoods from which we have yet to fully recover.

My journey from my small New Jersey hometown took me first to college in Brooklyn, NY, where I also lived for almost fifteen years. Although urban in its setting, my neighborhood of Fort Greene provided a similar environment to the one I was used to back home, comprised of a diverse group of working and middle-class African-American families and professionals. It was also here where the seeds for this book took hold, as I began to make friendships, including co-author Patrik Bass, which would provide the inspiration. As I began to travel, whether for work or for pleasure, I found that in each state there was always a thriving African-American community. From San Francisco to New Orleans, from Martha's Vineyard to Detroit, where the auto industry provided employment and prosperity; where houses of worship like Word of Faith provided strong spiritual leadership; where Motown provided the world with a cultural legacy; where great schools like Cass Tech developed great minds. These communities, though seasoned with cultural differences, mirrored my own—yet the stories had not been told.

It was within these communities, these histories, where I began to find my inspiration as an artist, designer, and photographer, and it was here where I started on my journey for this book. There were very few images in the popular culture that seemed to represent the sense of pride we felt within our communities, or reflect the ideals of the African-American baby-boomer. I had found myself collecting photos and clippings over the years that made these emotional connections for me.

Our common threads as a community were also revealed in the prized family albums and memories I was privileged to explore as I began this project, like that of Dr. Caesar Marshall and family, whose brother-in-law, Wade Hampton McKinney, was a Tuskegee Airman. Like Philip L. Brown and his wife, both of whom were educators who fought alongside Thurgood Marshall for the equal rights of Maryland teachers—many of whom were better educated than their white counterparts. Like those of Lana Turner, prominent long-time Harlem resident

who found several items—now in her collection of artifacts—discarded outside her building.

Libraries and historical societies added a wealth of information, as did photographers across the country. Many, like the Schomburg Center in New York, the Moorland-Spingarn research library in Washington, DC, or the Maryland State Archives, preserved photographs which, for years, have remained unpublished. Some photographers began to form a network of contacts which provided exposure to other photographers previously unknown to me, as was the case with David Johnson in California, who contacted Kerry Coppin in Florida, who had beautifully photographed African-Americans throughout the midwest. Still other photographers, like Gordon Parks and Anthony Barboza, provided much needed generosity and words of encouragement when they were needed most.

Yet, I was often dismayed and alarmed by what I found when inquiring about photos of African-Americans from many other sources. At some archives, I found that photographs of African-Americans were often in disrepair, not archived like their mainstream counterparts, and thrown together in unmarked folders. Other archives, while profiting from the sale of our images, make no effort to retain the photograph's source (like those which came from black newspapers—many of which are now defunct), or even the photographer's name. Many state archives, while African-Americans have been a long-standing and integral part of their state's history, have no photos of African-Americans at all, while some families have reported throwing their old photos away.

It has occurred to me that the stories, pictures, and mementos which are gathered in this book, become, when sewn together like a quilt, the motif for a strong African-American community. Preserving our photos and memorabilia means preserving the truth about our history, which is still in a state of being revealed. I also realized that my journey had indeed been made, alongside many others, whose lives were never glorified within the pages of *The Saturday Evening Post* or *Town & Country*; yet who continue to live with enough dignity, pride, and grace to inspire the world.

—KAREN PUGH

REFERENCES

Armstead, Myra B. Young *Lord, Please Don't Take Me in August, African Americans in Newport and Saratoga Springs, 1870-1930* (University of Illinois Press, 1999).

Anderson, James D. *The Education of Blacks in the South, 1860-1935* (The University of North Carolina Press, 1988).

Billingsley, Andrew (Ph.D.). *Climbing Jacob's Ladder: The Enduring Legacy of African-American Families* (Touchstone, 1992).

Bontemps, Arna and Conroy, Jack. *Anyplace but Here* (University of Missouri Press, 1966).

Buckley Lumet, Gail. *The Hornes: An American Family* (Alfred A. Knopf, 1986).

Clark Hine, Darlene and Thompson, Kathleen. *A Shining Thread of Hope: The History of Black Women in America* (Broadway Books, 1998).

Counts, Will; text and photographs; Campbell, Will, Dumas, Ernest, and McCord, Robert S., essays. *A Life is More than a Moment: The Desegregation of Little Rock's Central High.* (Indiana University Press, 1999).

Dann, Martin E., comp. *The Black Press, 1827-1890: The Quest for National Identity* (Putnam, 1971).

Feldman, Lynne B. *A Sense of Place: Birmingham's Black Middle-Class Community, 1890-1930* (The University of Alabama Press, 1999).

Finkle, Lee. *Forum for Protest: The Black Press during World War II* (Fairleigh Dickinson University Press, 1975).

Franklin, John Hope and Moss, Jr., Alfred A. *From Slavery to Freedom: A History of African Americans* (Alfred A. Knopf, 2000).

Garreau, Joel. *Edge City: Life on the New Frontier* (Anchor Books, 1991).

Gordy, Berry. *To Be Loved: The Music, The Magic, The Memories of Motown: An Autobiography* (Warner Books, 1994).

Griffiths, Susan B. "3 R's and More: A Chore of Love", *Cleveland Call and Post*, 1993.

Harris, Emil R. "Growing in Glory" (*Emerge*, April 1997).

Hasse, John Edward. *Beyond Category: The Life and Genius of Duke Ellington* (Simon and Schuster, 1993).

Holly, Ellen. *One Life: The Autobiography of an African-American Actress* (Kodansha International, 1996).

Honey, Maureen, ed. *Bitter Fruit: African-American Women in World War II* (University of Missouri Press, 1999).

Hutton, Frankie P. *The Antebellum Black Press and The Quest for Inclusion: Ideals and Messages of Social Responsibility, Class and Style* (Rutgers, the State University of New Jersey, 1990).

Jones, Jacqueline. *American Work: Four Centuries of Black and White Labor* (W.W. Norton & Company, 1998).

Johnson, Thomas L. and Dunn, Phillip C., ed. *A True Likeness: The Black South of Richard Samuel Roberts 1920-1936* (Writers and Readers Publishing, Inc., 1986).

Kennedy, Adrienne. *People Who Led to My Plays* (Theatre Communications Group, Inc., 1987).

McDowell, Deborah E. *Leaving Pipe Shop: Memories of Kin* (W.W. Norton & Company, 1996).

Miller, E. Ethelbert, *In Search of Color Everywhere: A Collection of African-American Poetry* (Stewart, Tabori & Chang, 1994).

Moutoussamy-Ashe, Jeanne. *Viewfinders: Black Women Photographers* (Writers & Readers Publishing, Inc., 1993).

Parker, Gwendolyn. *Trespassing: My Sojourn in the Halls of Privilege* (Houghton Miflin Company, 1997).

Robinson, Eugene, "Looking Homeward at Four Generations", *The Washington Post*, 1982.

Rymer, Russ. *American Beach: How Progress Robbed a Black Town— And Nation—of History, Wealth, and Power* (HarperCollins, 1998).

Simmons, Charles A. *The African American Press: a history of news coverage during national crises, with special reference to four black newspapers, 1827—1965* (McFarland & Co., 1998).

Stewart, Jeffrey C. *1001 Things Everyone Should Know About African-American History* (Doubleday, 1996).

Smart-Grosvenor, Vertamae. *Vibration Cooking or the Travel Notes of a Geechee Girl* (One World/Ballantine Books, 1992).

Suggs, Henry Lewis, ed. *The Black Press in the Middle West, 1865-1985* (Greenwood Press, 1996).

Walker, Alice. *Anything We Love Must Be Saved* (Random House, 1997).

Weldon-Johnson, James with an introduction Wilson, Sondra Kathyrn. *Black Manhattan* (Da Capo Press, Inc., 1991).

White, Shane and Graham. *Stylin: African-American Expressive Culture from its Beginnings to the Zoot Suit* (Cornell University Press, 1998).

Willis-Thomas, Deborah. *An Illustrated Bio-Bibliography of Black Photographers 1940-1988* (Garland Publishing, 1989).

Wright Edelman, Marian. *Lanterns: A Memoir of Mentors* (Beacon Pess, 1999).